HAUNTED NAPERVILLE

HAUNTED NAPERVILLE

Diane A. Ladley

ARCADIA
PUBLISHING

Published by Arcadia Publishing
Charleston SC, Chicago IL, Portsmouth NH, San Francisco CA

Printed in the United States of America

Library of Congress Control Number: 2008940506

For all general information contact Arcadia Publishing at:
Telephone 843-853-2070
Fax 843-853-0044
E-mail sales@arcadiapublishing.com
For customer service and orders:
Toll-Free 1-888-313-2665

Visit us on the Internet at www.arcadiapublishing.com

*This book is lovingly dedicated to the memory
of the best parents in history, Walter and Norma Ladley.
And to beautiful Kismet.*

CONTENTS

ACKNOWLEDGMENTS

The problem with publicly thanking the numerous Naperville residents who told me of their true encounters with the paranormal is obvious: they do not want the public to know who they are. They dread the thought of their friends, neighbors, coworkers, and acquaintances looking askance at them and wondering if they are nuts—or worse, wild exaggerators or shameless fibbers. To all those people I offer my heartfelt, yet discreet, gratitude. You know who you are, and you know that what you experienced was real.

Still others furnished unstinting assistance in more mundane, yet equally valuable, historic research. My deep thanks goes to Bryan Ogg, the research assistant extraordinaire at Naper Settlement; Kimberly Butler, archivist at North Central College and Patricia Hard, editorial librarian at the *Naperville Sun*, both ladies of infinite kindness and patience; and a tip of the hat to a host of others, including Pat Sabin, Jo Fredell Higgins, Karen Mencotti, and the immortal, artistic spirits of Genevieve Towsley and Les Schrader. Special thanks to Jack Phend, Kelly Tiberi, Cathy Bouchard, Donna Haddad, Jim Shoger, the Byer family, Sandra Penrose, Ursula Bielski, Troy Taylor, and all the terrific, dedicated folks at the DuPage Heritage Gallery, Naperville Heritage Society, the *Naperville Sun*, Positively Naperville, and Nichols Library.

Thanks to all my childhood and teenage friends who shared their spookiest stories of Naperville during countless slumber parties. Thank you to my editor, Jeff Ruetsche, at Arcadia Publishing and to all my dearest friends who helped me through the worst of times, especially Lorrie, Steve, Mike and Lona, Mike and Lisa, Dan, Doug, Marcia, Sue, Linda, Chris, Craig and Margie, and of course, my furry family of Dante, Banshee, and Kismet. There are so many others to thank, and I ask their forgiveness for not naming them personally—this book would be the size and retail price of a dictionary if I did so.

And lastly, I wish to thank and honor my parents, Walter and Norma Ladley, who loved Naperville, North Central College, and each other with all their hearts—from the moment the World War II navy veteran first saw a beautiful farm girl from Michigan laughing uproariously while running headlong down the hill on Chicago Avenue and thought to himself, "That's the woman I'm going to marry."

INTRODUCTION

Mary Cooper started it.

My best friend in the third grade at the then newly built Prairie Elementary School was the first to tell me a Naperville ghost story. One night, as her mom was driving us past the Naperville Congregational Church at the corner of Seventy-fifth and Washington Streets, Mary suddenly gasped and pointed out a burning red glow in the sanctuary window. "It's the ghost!" she said, ducking down in the back seat (yes, this was in the days before mandatory seat belts and child seats). In a muffled, although excited, whisper she explained that a jealous pastor's wife murdered the lovely, innocent organist as she sat at the sanctuary organ practicing a hymn late in the night. "Ever since then, whenever you see a blood-red light in the window, you know her ghost is there, playing the organ just like she did at the moment of her death!"

I was awed, scared, thrilled—and I was hooked. My decades-long journey to compile and record the ghostly legends and lore of my haunted hometown Naperville had begun. Down the years I listened hungrily to such classic old Naperville ghost tales as Charlie Yellow Boots, Dead Man Walking, the ghosts haunting the old Kroehler Furniture building, the phantoms at Pfeiffer Hall, the dancing lights in Naperville Cemetery, and so many others. Added to those legends were firsthand accounts of the paranormal, inexplicable UFO sightings, and bizarre events told to me in whispers by friends and acquaintances, who swore on the Bible that what they had witnessed was real.

Such a rich treasure trove of spooky stories right in my hometown! But, to my surprise, it seemed that Naperville, and indeed the entire far western suburbs of Chicago, was a black hole in the paranormal literature of Illinois. Of the dozens of published books on true Illinois hauntings, only a very precious few of them contained any of the stories that I had grown up with. This book, *Haunted Naperville,* is the proud result of decades of my patient work and is the first time that the authentic ghost legends and true encounters of Naperville have ever been compiled and appeared in print.

I hope you get a chance to go on one of my Historic Ghost Tours of Naperville walking tours to hear my stories firsthand. It is a part-time pursuit; I do it partly for money, partly for exercise, and wholly for the love of telling and passing these stories on from person to person, generation to generation, ensuring they will not ever be lost.

Oh, and about that story Mary Cooper told me about the organist? In the summer of 2005, I interviewed an employee at the Naperville Congregational Church about that old ghost story I once heard as a child. She laughed and said, "Goodness, I've never heard about the ghost of an organist! How gruesome! No, no one was ever murdered here. I don't believe that ghost story is true, not for a minute."

We both had a good laugh over the absurdity of wild rumors and old stories. But then she paused and said something that made my jaw drop to the floor. "Well," she said, "I mean, we do *say* we have a ghost here, opening and closing doors all down the hallway. I'm sure it's just the wind; but I never heard anyone say that it was the organist!"

Happy hauntings.

—Diane A. Ladley

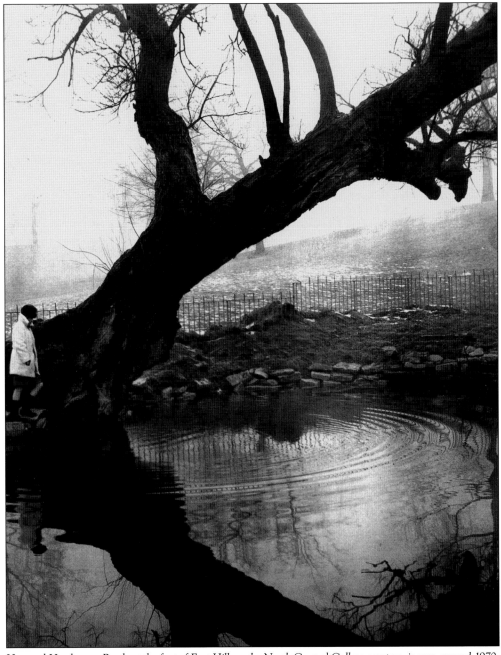

Haunted Heatherton Pond, at the foot of Fort Hill on the North Central College campus, is seen around 1970. (Courtesy of the Naperville Sun and Fox Valley Publications.)

One

HAUNTED
NEIGHBORHOODS
THE OTHER SIDE OF THE TRACKS

People always ask me, "Ghosts in Naperville? How can that be? It's such a perfect town!
Top schools, awesome shopping, beautiful homes, low crime rate—it's so quaint and charming yet so
sophisticated at the same time. How could there possibly be ghosts in Naperville?"
To those people, I remind them of that old saying, "The brighter the light, the darker
the shadow it casts." And Naperville shines a very bright light indeed.
— Ghost host on the Historic Ghost Tours of Naperville

THE AMOROUS APPARITION OF FIFTH AVENUE STATION

April 25, 1946, 1:03 in the afternoon. The Northern Pacific train called the No. 11 *Advance Flyer* was on its way from Chicago to Omaha, filled with passengers, many of whom were servicemen returning home at long last from Europe and the South Pacific after their victory in World War II. Just as they approached the Naperville train station, crew members of the *Advance Flyer* saw a large object shooting out from underneath one of the coaches. They had to make an unscheduled stop at the Loomis Street crossing to check for damage.

Three minutes behind and on the same track was the Chicago, Burlington and Quincy Railroad (CB&Q) No. 39, the *Exposition Flyer*, speeding on its way to San Francisco. The train engineer of the *Exposition* did not see the red signal lights warning him that a train was stopped dead ahead. And by the time he saw the *Advance Flyer*'s brakeman frantically waving a red warning flag from the back of the stopped train, it was too late.

The *Exposition Flyer* tore into the rear of the *Advance Flyer* at 85 miles an hour. The collision was so violent, so titanic, that the last car of the *Advance Flyer* was peeled like a banana, ripping it right down the middle. Still the *Exposition*'s locomotive did not stop, ramming halfway into the next car like a telescope collapsing in on itself. This car was shoved with such unimaginable force that it surged up at a sharp angle and hung, teetering, in midair. The third coach was thrown on its side like a toy, while the remaining coaches were derailed.

Forty-seven people died, most of them mangled so horribly the only things left were severed body parts and unrecognizable lumps of shredded meat. Eyewitnesses reported seeing flesh oozing out from rips in the metal window frames from victims crushed to death by the grinding steel. Insulation from the train cars floated down like snow. Rescue workers did their best to identify the dead with jewelry or clothing, but many were so far mutilated that no means of identification was possible.

In addition to the dead, 125 people were severely injured. One man, a decorated Marine coming home from the front lines in the South Pacific, had gotten up from his seat to get a drink

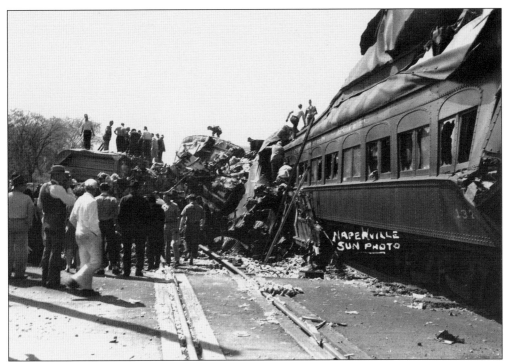

Minutes after the CB&Q No. 39 train plowed into the rear of the Northern Pacific No. 11, Naperville Sun editor and publisher Harold E. White used his newly purchased camera to take these stunning photographs of the Great Naperville Train Wreck of April 25, 1946. Forty-seven people were dead—most in the dining coach of No. 11. (Courtesy of the Naperville Sun. Reprinted with permission.)

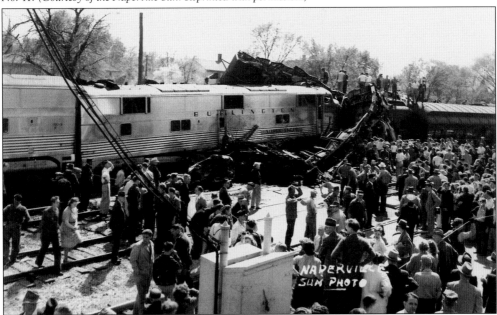

This photograph vividly shows the titanic force of the collision. The Exposition Flyer's locomotive peeled the last car of the Advance Flyer like a banana and rammed it up into the next car like a telescope collapsing in on itself. (Courtesy of the Naperville Sun. Reprinted with permission.)

of water moments before the trains collided. It saved his life. He broke down into tears when he learned that the two passengers in the seat across the aisle from him—a mother and her little baby—had been crushed to a pulp, the young mother's head decapitated.

Peter Kroehler, owner of the Kroehler Manufacturing Company across the railroad tracks on Fifth Avenue, closed the factory for the day so the employees could aid in rescue efforts. The large central area was utilized as an emergency triage for the wounded. Students from North Central College took the mattresses off their dormitory room beds to use as impromptu stretchers. Ambulances—motorized and horse drawn—dashed back and forth to the hospitals in Aurora and Wheaton all the rest of that day and well into the night.

The dead were carefully laid out side by side on the lawns of the homes along Fourth Avenue parallel to the railroad tracks. The row of corpses stretched almost a full block, from Loomis Street up to the Naperville train station. And the line would have grown longer still; but at 3:00 p.m. the school bell rang at Ellsworth Elementary and children came running down the street, morbidly eager to see the disaster. Horrified, rescue workers scrambled to move the corpses and severed limbs across the tracks into the Kroehler furniture company. They were reportedly laid out in a room on the far west side of the massive brick building.

To this day, the Great Naperville Train Wreck of 1946 still ranks as one of the worst train disasters in American history.

Do the tragic spirits of those train passengers still haunt the area where their bodies lay in the first hour of their deaths? Had their deaths been so sudden that they are unaware they are dead? Do they wander along the street or into nearby homes, lost and confused? Do they desperately try to get our attention by knocking on doors or touching our arms? Do they cry out to us, "What has happened to me? Why won't you answer?"

There is some evidence to suggest that the ghosts of the Great Naperville Train Wreck are very aware of our presence and are eager to communicate with us. Two blocks in particular along Fourth Avenue consistently record high levels of paranormal activity—from whispered rumors of hauntings to strange electrical-magnetic energy readings that leave even electricians scratching their heads. Busloads of amateur ghost hunters visit here with their tape recorders, cameras, and flashing, beeping electromagnetic field (EMF) meters to record unusual energy fields. They are usually not disappointed. One young man on his first trip out clearly saw and recorded a misty white orb in the screen of his night-vision video camera circling slowly around his mother. But the robin-sized ball of light could not be seen with the naked eye. Psychics all agree they feel the presence of numerous earthbound spirits on that stretch of road by the tracks. Paranormal investigator Pam Turlow from Elmhurst reported a hair-raising incident in 2006. She asked aloud, "If there is a presence here who wishes to communicate with us, please cause this EMF meter to beep five times." Promptly it beeped—five times. It paused, then beeped another five times, and yet another five times before it fell silent. Was this just an odd coincidence? Perhaps. Or perhaps there were the ghosts of three dead World War II soldiers standing there, unseen? For in the very next moment, Pam's companion screamed and jumped, swearing that she had just distinctly felt a man's large hand caressing her hair, though no one had touched her.

Others say that the old Kroehler building is haunted. The original building along Fifth Avenue near the Loomis Street railway crossing was first built in 1897. It was home to the Naperville Lounge Company, noted for its superior-quality, handcrafted lounges and couches. James Nichols I (of Nichols Library fame) convinced a former star college student of his, Peter Kroehler, to handle the business end of the new enterprise. By 1895, the founders of the company, Fred Long and John Kraushar, sold their shares to Kroehler, glad to hand over the reins to such a competent manager. But on March 24, 1913, strong winds devastated the entire west wing of the factory. After the reconstruction, in 1915 the firm's new name was emblazoned along the entire south exterior wall of the restored building—Kroehler Manufacturing Company.

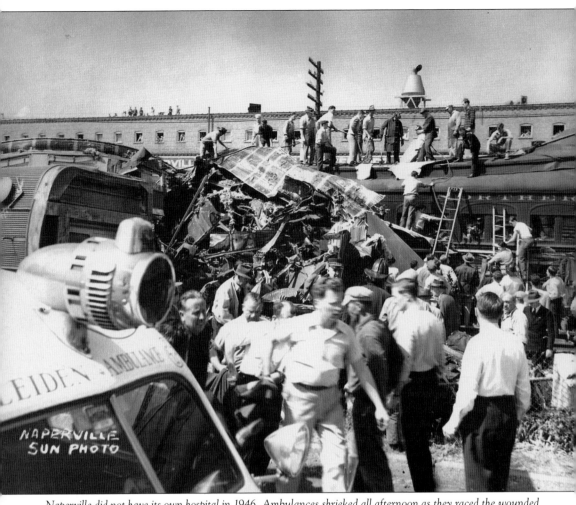

Naperville did not have its own hospital in 1946. Ambulances shrieked all afternoon as they raced the wounded to hospitals in Aurora and Wheaton. (Courtesy of the Naperville Sun. Reprinted with permission.)

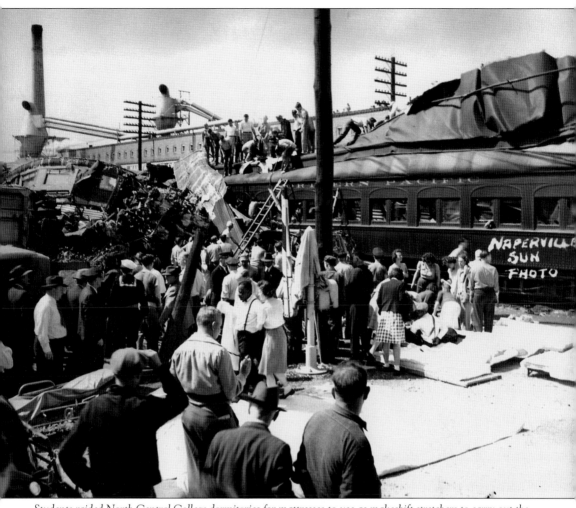

Students raided North Central College dormitories for mattresses to use as makeshift stretchers to carry out the dead and wounded. (Courtesy of the Naperville Sun. Reprinted with permission.)

Haunted Naperville

Under Kroehler's brilliant business acumen and leadership, the thriving furniture company achieved worldwide renown for its beautiful leather sofas, divans, and bed lounges. Kroehler Manufacturing Company was the leading employer for Naperville's growing population, serving as a strong financial backbone for the small town's economy. But cheap mass-production soon replaced meticulously handcrafted furniture, and by 1982, the factory closed permanently. It stood empty for years, the windows and worn brick walls targets for vandals and graffiti.

Local developers saw immense potential in the abandoned old factory due to its ideal location opposite the downtown Naperville train station. Rather than tear it down, they realized the modern appeal of the timeworn wood floors, aged brick walls, and high, beamed factory ceilings. They envisioned a multifunctional shopping mall, restaurant, and loft-style apartment complex—a carefully restored showpiece redolent with antique charm and ultramodern luxuries, where sophisticated young commuter couples would line up to live. After a multimillion-dollar restoration and renovation, the Fifth Avenue Station was opened in 1988 amid much fanfare and excitement in the community. It was placed on the National Register of Historic Places in 1985.

In 2003, Amy and David Byers spent a lively year in their Fifth Avenue Station duplex condominium with a ghost—an amorous apparition who appeared to have a romantic attachment to Amy and a wild jealousy toward her husband David!

Their apartment was a prized two-story duplex spanning the third and fourth floors of the Fifth Avenue Station apartments, facing the Burlington Northern train tracks. The living area and kitchen were on the third floor; the bathroom and two bedrooms were on the fourth. Both Amy and David are professional, highly educated, no-nonsense people. They are levelheaded, skeptical about the paranormal, guided by solid common sense, and not at all inclined toward flights of fancy or hysterical cries of "Ghost!"

When they first moved into their new apartment, there was no indication of an unwelcome spectral roommate. Perhaps it was Amy's beauty that awoke the interest of a ghostly presence slumbering in the weathered old brick. Whatever the reason, the unexplained events began slowly, with small, curious occurrences that left Dave and Amy puzzled and uneasy.

Both David and Amy had seen a man-sized, moving shadow at the corner of their eye that vanished when they looked directly at it. On any number of nights, Dave heard footsteps coming from the upstairs hallway outside their bedroom door. Thinking that Amy was still awake he would climb the stairs to check on her; but the footsteps would stop abruptly, and his wife would still be sound asleep in bed. Inexplicable cold spots would come and go in random areas of the apartment. The television would turn on or off by itself, and their Bose stereo radio in the bedroom would suddenly flip through stations as if someone were searching the airwaves (for some romantic Frank Sinatra or Barry White tunes, perhaps?). The Byers were baffled as to what could be causing the expensive, state-of-the-art radio to act so erratically, though it never had before.

Particularly disturbing were the times when Amy would be home alone taking a shower. Suddenly the bathroom doorknob would turn and the door would swing open wide, but no one would be there. Still, Amy would get the uncanny, unnerving sensation that *someone* was standing there, watching her shower from the empty doorway. Despite these unsettling experiences, Amy still refused to believe that their beautiful duplex condominium was haunted—until one shocking encounter changed her mind.

Late one evening Amy snuggled into bed, having turned in early while waiting for Dave to come up after Jay Leno's monologue. Their two-story apartment was quiet tonight, thank goodness. Between the footsteps, radio, and other unexplained noises, it was not always so.

Sooner than she had expected, Amy felt the mattress dip as Dave climbed into his side of the bed. The covers shifted and she felt the weight of his body settle in behind her. Then he slipped

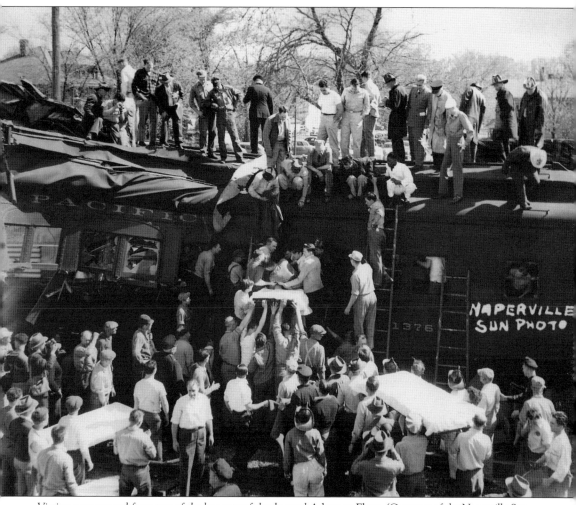

Victims are removed from one of the last cars of the doomed Advance Flyer. (Courtesy of the Naperville Sun. Reprinted with permission.)

Lounge Factory, Naperville, Ill.

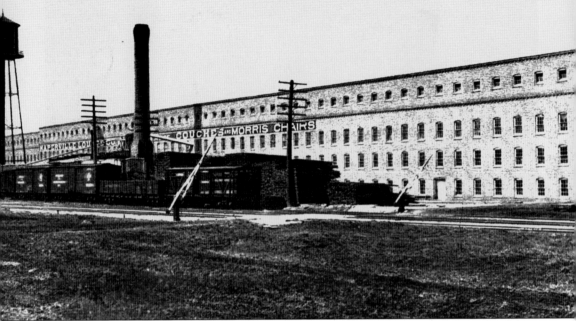

The original name was the Naperville Lounge Company, as shown in this c. 1905 illustrated card. (Courtesy of the Naperville Heritage Society Collection at Naper Settlement.)

From the original factory in Naperville, Peter Edward Kroehler's modest business grew into the largest upholstered furniture manufacturing company in the world today. The home office in now based in Conover, North Carolina. (Courtesy of the Naperville Heritage Society Collection at Naper Settlement.)

Kroehler Manufacturing Company was renowned worldwide for its unique bed lounges, as mentioned in this 1917 advertisement posted in a souvenir booklet of the Naperville Homecoming, May 29 to June 1, 1917. (Author's collection.)

an arm around her waist, spooning with her in a tender, romantic fashion. Amy smiled to herself, thinking, "Mmm, what a wonderful husband I have!" He was being so careful and quiet so as not to wake her—so very, very quiet.

Amy decided to let him know that not only was she still awake, but she was also interested in showing him just how wonderful she thought he was. So Amy stretched her bare foot back to sensuously caress the calf of his leg with her toes. But where was his leg? She searched with her foot until an alarming revelation dawned on her—there was no leg back there! But *somebody* was! Just then the arm around Amy's waist vanished, the covers billowed down, and the mattress sprang back up as if the male body that had been lying there, lovingly spooning with her, had simply disappeared. "My heart was racing like I'd never felt before!" Amy said. "I just reached my leg back to touch him, and everything vanished instantly!"

To say that Dave was skeptical of Amy's insistence that their condominium was haunted would be an understatement. He did not doubt her truthfulness for a second but instead was certain it had merely been a vivid dream. There had to be perfectly normal explanations for Amy's surprise encounter and all these other odd happenings. But since Dave was not an electrician, heat and air-conditioning repairman, or dream psychoanalyst, he just did not know what those explanations could possibly be. So he shrugged the subject aside, refusing to let a few perplexing, yet entirely natural annoyances bother him. But then Dave had an encounter of his own that made him change his mind—15 seconds of sheer terror late one night when Dave came face to face with the supernatural for the first time.

Dave was preparing to go upstairs to join Amy in bed when once again he heard heavy footsteps treading steadily back and forth along the creaky second-floor hallway. Thinking that Amy perhaps had another bad dream and was pacing the hallway to calm down, Dave climbed up the stairs, concerned for his wife. He almost reached the top step when suddenly a towering black shadow materialized from nowhere at the top of the stairs. It loomed over Dave, barring the way, waves of threatening menace and icy cold rolling from the thick, dense cloud to freeze him in mid-step. Fifteen seconds passed like an eternity, and then the hovering black shadow vanished. Dave's entire body was drenched in cold sweat, shaking from shock and an overwhelming sense of dread. It took every last shred of courage for Dave to climb that last step, pass through the spot (now once again at room temperature) where the shadow had stood, and hurry to the bedroom—only to find Amy sound asleep.

In the morning Dave admitted to Amy that their apartment was indeed haunted, though he could scarcely believe the words were coming out of his mouth. It was absurd, ridiculous, insane! There are no such things as ghosts! But there was no doubting it anymore, especially when Amy broke the news to their daughter, who was living out of state at college. Her exasperated reply was, "Well it's about time that you saw it! We all knew something was there."

From that time on the ghost became much more lively. One afternoon, Amy stepped out of the shower and screamed to see a man in a sports coat distinctly imaged in the fogged mirror. The face was a blur, but she could clearly make out three-dimensional features of the shoulders, the lapels, and even the fact that the coat was neatly buttoned. Amy put her foot down and demanded that the ghost never watch her in the bathroom again—and he did not. The black shadow often appeared at odd times, once to their daughter when she was visiting from college. She saw it out of the corner of her eye, but there was no mistaking the familiar, dark presence that shared the apartment with them in relative harmony.

David saw the shadow several times after his encounter, but it never again menaced him like that first time. It was as if the ghost came to an understanding that David was his rival for Amy's affections. For the most part Dave was tolerant of it, except for the times when Dave would be in bed and the covers would slowly be pulled off him—as if the audacious ghost were telling Dave to please get out of bed so he could snuggle with his wife! The ghost was certainly persistent. On

one unforgettable night the covers were pulled off Dave's side of the bed a total of three times within 30 minutes. Each time Dave would growl, grab the covers, yank them back up, and hold them tightly under his chin, only to feel them being tugged down again within minutes.

Does the tragic spirit of one of those train passengers still haunt the building where his body lay in the first hour of his death? Had he perhaps been a World War II soldier on his way back home from the war-torn South Pacific to his sweetheart in Omaha and, in the traumatic confusion of his sudden death, transferred his affections to Amy Byers nearly 60 years later?

This quirky paranormal love story has an epilogue. When Amy and Dave moved out in September 2004 after living in their Fifth Avenue Station apartment for only one year, the ghost made his displeasure known. They had just finished loading up the moving truck for the final run to the new house when they went back to the apartment to get the last box. But the apartment door was mysteriously locked. Amy and Dave were both absolutely certain that it was unlocked when they made that last trip down to the truck. It was as if their ghost—now a spurned lover—had slammed shut the door and locked them out of their apartment in a fit of pique.

It is unknown whether or not the new tenants in that two-story duplex at Fifth Avenue Station are experiencing ghostly phenomena like the Byers family. According to the management company there have been no reports or complaints about the condominium. Perhaps the amorous apparition finally moved on to his final destination. Or perhaps this beautiful, luxury duplex condominium stands empty, yet occupied by a lonely spirit. Is there a single woman out there looking for a wonderful roommate who never leaves the toilet seat up, never leaves clothes lying around, is strong, protective, and romantic, and who loves to cuddle and spoon in bed late at night while listening to Frank Sinatra and Barry White?

No memorial commemorates those who died in the great Naperville train disaster, and until very recently, no complete list of the 47 victims' names was known to exist. With special thanks to Bryan Ogg, whose meticulous research has done much to correct this grievous historical omission, the roll call of victims is as follows:

Arthur Abbott of Berwyn, dining car steward
Dorothy Lindzion Aman of Omaha, Nebraska
August H. Anderson of Lincoln, Nebraska
Joseph Bentler of Donnellson, Iowa
Delbert Boon of Luray, Missouri
Ralph Vance Brown of Chicago
Daniel Nathaniel Carr of Chicago
Charles Chamberlain of Chicago
Charlotte W. Collins, 71, of
 Hannibal, Missouri
Eugene Everett Conner of South Bend, Indiana
Marian Johanna Crafts of Quincy
E. H. Crayton, 45, of Galesburg, the fireman
 on the *Exposition Flyer* who leapt from the
 train before impact
Kenneth W. Dickhut of Quincy or
 San Diego, California
Mary Alberta Farley of Omaha, Nebraska
Kay L. Flotkoetter of Chicago
Richard E. Howard of Stillwell, a discharged
 sailor in uniform

Elvis A. King of Chicago
Albert J. Lane, 56, of Chicago, chief
 investigator of Hartford Insurance
Mary Langen, 45, of Quincy
Matthew Lawrence of Escanaba, Michigan
Margaret Lawrence of Escanaba, Michigan
Elza Lett Jr. of Kenova, West Virginia
Harry W. Long, 21, of Burlington, Iowa,
 U.S. postal badge serviceman No. 50819
Mayme Mennen of Burlington, Iowa
Al N. Miller, 37, of Chicago
Leo P. Moos of Moorehead, Minnesota
Rose Moos of Moorehead, Minnesota
Mr. Nian (unknown)
John Nicholas Ralston of Des Plaines
Fred Robinson, 62, of Council Bluffs, Iowa
Abraham Rohr, 75, of Chicago
Lizzie Rohr of Chicago
Leona Saylor, 27, of Washington, D.C.,
 government employee
Emma B. Schetz (or Emily Schutz) of Lombard

E. Read Sherwood of New Orleans,
 Louisiana, salesman for Consolidated
 Millinery Company, who was registered at
 the Stevens Hotel Chicago
Sophie Sromovsky, 29, of
 Plymouth, Pennsylvania
Howard Clinton Stimson of Carman
Lucy Takashima, of Quincy, student nurse at
 St. Mary's Hospital
Bernard H. Voss of Quincy, seaman first class

Eleanor Whitehead of
 Weymouth, Massachusetts
Russell L. Whitehead, 19, of Hereford, Texas
Mrs. A. J. Wiley of Burlington, Iowa
Marlin Wiley, 27, Burlington, Iowa
Randall Wiley, 2, Burlington, Iowa
Terry Lee Wiley, 4, of Burlington, Iowa
Florence Wilson of State
 College, Pennsylvania
Clifford Yarbrough, 58 of Alton

May they rest in peace.

DEAD MAN WALKING

Tragic, sudden death is the meat and bones—or perhaps we should say the spirit and ectoplasm—of any grisly good ghost story. But another key component is the element of pathos, the poignant sadness that touches our hearts with a cold chill when we hear of a lost soul wandering far from the heavenly plane, weary and bewildered that time has passed on by while they still perform the tasks they did in life. Such is the sad case of the Dead Man Walking.

The handsome white farmhouse stood along Bauer Road, the bustling hub to a grand farm that sprawled more than 100 acres surrounding the house and main barns. The farmer's name is lost to time now, but once it had been a well-respected, prosperous name in the tiny new community of Naperville back in the mid-1800s. Two things that were best remembered about him were that he loved his farm and loved his work. Every night he would walk for miles around the property, tirelessly checking fences, inspecting the crops, gazing out with quiet pride at the fat, healthy livestock and sleek-coated horses.

It was autumn of the year that tragedy struck. The farmer and his hired hands had just finished cutting and bundling the last of the hay for the season and were hoisting the heavy hay bales up high into the barn loft for the winter. They had rigged up a pulley-and-hook system to the barn. The hired hands would set a hay bale onto the hook and pull the ropes to send the bale soaring upward, then locking it in place while the farmer stood in the open loft door to steer it in, unhook it, and stack it up high. It was a chore they had performed many times before, and they moved with precise, flowing rhythms that made the hard, hot labor pass by quickly. But that day something went terribly wrong.

It all happened so fast. One moment the farmer was freeing a hay bale, and the next moment the heavy metal hook snagged onto the collar of his blue and white checked shirt. It threw him off balance, and before the horrified farmhands below understood what was occurring, the farmer slipped and fell from the high loft door. There was the sickening sound of neck bones snapping as the rope slack came to an end with his feet dangling a few inches from the ground. The farmer was killed instantly.

People said that he died so quickly and unexpectedly that his soul had no idea that his body was dead and buried. Because every night for the next week, the farmhands would rush in from the fields, their eyes wide and hair standing on end, yelling that they had just seen the farmer's ghost walking the property. Several of the bravest men decided to go on out and see if the story was true.

Late on a full moon autumn night, the men stood vigil for the ghost of their former employer. Suddenly, precisely at 11:00 p.m., one farmhand clutched the arm of another. "There! Isn't that him over by the barn?" They all looked, and sure enough, there was the farmer. There was no mistaking him. He was a tall man for those times, standing about six feet, wearing a woven straw hat over his close-clipped brown hair. He had been in his 30s when he had died, and he was still

wearing the same blue and white checked shirt and dusty jeans that he had worn the day he died. If they had not just buried him earlier that week they would have sworn he was alive and breathing, ready to give them the day's chores!

The farmer's ghost walked soundlessly past the frightened farmhands without a word or nod of acknowledgment. The eerie expression on his face haunted them for years afterward—a lost, distant look in his eyes as if the farmer were walking through an impenetrable haze. Gathering their courage, they followed the farmer's ghost as it walked, and walked, and walked. For a full hour he walked, hiking the wide acres of his beloved property as he had done in life, ensuring even after death that everything on the farm was safe, secure, and in its proper place.

As the ghost walked, the farmhands noticed that he appeared less solid the further away from the house he went. With every acre he walked the farmer became mistier, more translucent—until there was nothing left but a vague, ghostly outline, which eventually vanished into thin air between one stride and the next, leaving the chilled and awestruck farmhands behind.

Area residents still whisper that the hanged man's ghost has appeared exactly at 11:00 p.m. every night for over 150 years, in all kinds of weather, rising up from the gloomy shadows where the old white barn once stood. He walks and walks for many miles without making a single sound until the stroke of midnight, when he simply fades away.

If by chance you should pass him on the street some night, you will be forever haunted by the strange expression on his face—the lost, distant look in his eyes as the ghost of the hanged man eternally walks the misty world between life and death.

CHICAGO AVENUE MARY

Why did the ghost cross the road? To get to the *other side.*

Bad jokes aside, the E. E. Miller house that stood on the corner of Chicago Avenue and Ellsworth Street until its demolition in 2007 is home to a tragically romantic ghost known only as Mary. Although the Millers did have a daughter Mary, whether she is the same woman in the legend is unknown. For decades, longtime Naperville residents claimed that every year on the anniversary of her death, a young woman would walk through the door of the house—and I mean literally *through* the door—down to the sidewalk, then turn right and walk to the corner. Then she would cross Chicago Avenue and walk down the hill into the darkness.

What makes this story of Chicago Avenue Mary so startling is the uncommonly detailed description of her. Every detail of her clothing and hair has been clearly noted, staying remarkably accurate from sighting to sighting. Legends are rarely this precise, a fact that may lend credence to the tales of Mary's phantom walks. Mary's ghost is seen in the clothes that she wore on the day she died. Witness accounts describe her as wearing a *Little House on the Prairie* outfit, a long, ankle-length blue jumper of a denimlike fabric worn over a white short-sleeved blouse with puffy sleeves, similar to the fashions of the mid-1800s. Mary herself is described as an attractive young woman in her early to mid-20s with curly, light brown hair.

But of those who have claimed to have seen her, what haunts their memories most is the look on her face, an expression of unspeakable pain and devastation—vacant, deathlike, hypnotic—as if she had just watched her whole world die.

The most well-known sighting was in the late 1970s. Two college students were driving their car east on Chicago Avenue after a date when suddenly, out of nowhere, a woman walked right in front of their car. The driver slammed on the brakes but there was no way they could stop in time. The car collided with her—but there was no impact. And as soon as the car had touched her, the mysterious young woman had simply vanished. The couple got out of the car and searched but they could not find any sign of her. They just had a startling encounter with the ghost called Chicago Avenue Mary. Who is she? What is her story? Where does she walk to, down the hill and into the dark?

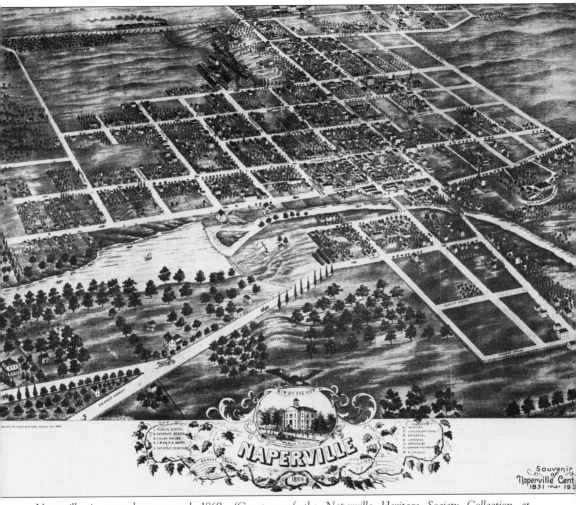

Naperville is seen here around 1869. (Courtesy of the Naperville Heritage Society Collection at Naper Settlement.)

This is the E. E. Miller house, as seen in the 1917 Naperville Homecoming souvenir booklet. (Author's collection.)

As local legend has it, sometime back in the mid-1800s, a sweet Naperville girl named Mary was deeply in love with a handsome young Naperville man (his name is lost). Mary and her beloved were sharing a seat on the cast-iron bench at the edge of Heatherton Pond, a natural freshwater spring at the base of Fort Hill off Chicago Avenue. This lovely, tree-shaded spring had quenched the thirst of Naperville residents ever since the Potawatomi first journeyed there. Fort Payne had stood on the hill above the spring, supplying crystal-clear water to early settlers and soldiers alike. But by Mary's day, the fort was long gone, eventually replaced in 1902 by the magnificently graceful Heatherton mansion, owned by Judge John and Mary Goodwin. Only the spring remained—a rectangular pool thick with water lilies and ringed with limestone rock from the local quarry owned by George Martin II. A limestone milk house straddled the spring's brook, shaded by a hoary old tree that arched over the dark water, keeping dairy products fresh and cold. It was Mary's most favorite spot in the world, for that is where Mary and her boyfriend loved to sit and gaze out across the water, hand-in-hand; and that was where he got down on one knee and proposed marriage to her. She was the happiest girl in the world—because he was her world.

But their happiness would end in one tragic instant. One fine day, Mary and her fiancé were at their favorite spot again, discussing their future and their wedding plans together. He was balancing along the limestone edge of the pond, horsing around, but suddenly he slipped and fell into the water. Mary laughed and laughed, but her giggles slowly died when he did not stand up and join in on the laughter. Mary looked into the water and saw her beloved fiancé lying very still at the bottom of the pool, blood spreading out from his body to stain the water red beneath the lily pads. As he fell, his head had hit the limestone edge and cracked open. He was knocked unconscious and, helpless to save himself, he drowned in just three feet of water. Drowned while Mary laughed.

She could not forgive herself for that. Her entire world shattered in that moment. Inconsolable, Mary went to the pool every day before the funeral. She would come out from her house across the street, walk down the sidewalk, cross Chicago Avenue, walk down the hill, and sit on the cast-iron bench and stare with tragic, tear-filled eyes at the dark water that had been the death of all her dreams. She would not eat, she would not drink, she would only sit and stare at the water in a shell-shocked state until her parents would come late at night and take her hand to lead her back into the house.

On the day of his funeral, directly after the ceremony and graveside service, Mary went back home, shut herself in her bedroom, and committed suicide so that she could be with her love for all eternity. The legend is unclear as to the method she used to take her own life, but poison is most commonly cited. Grieving anew a second time, Mary's anguished family buried her alongside the grave of her fiancé in Naperville Cemetery.

But Mary's ghost found no peace in her earthen bed lying beside her lover. Exactly one year to the day after her death, Naperville residents were aghast to see Mary exiting out from the door of her home on the corner of Chicago Avenue and Ellsworth Street, walking down the front steps, crossing Chicago Avenue, and drifting down the hill to sit on the cast-iron bench and gaze down into the pool. She appeared the next year, and the next. The bravest would try to speak with her, but she would vanish before their eyes when they came close. An iron fence with a latched gate was erected around the pool, hoping to keep others from meeting the same fate as Mary's fiancé. But it never stopped Mary. She would simply walk through the spiked iron posts as if they were not even there, to sit in spectral solitude by the dark, tree-shadowed spring. It was whispered that Mary's spirit would eternally grieve without rest for the unforgivable sin of taking her own life. Mary was Catholic, and suicide is a mortal sin. And so she is doomed for all eternity to relive that terrible journey every year on the anniversary of her death, walking from her house, across Chicago Avenue, and down the hill to gaze at the pond where her lover drowned over 100 years ago.

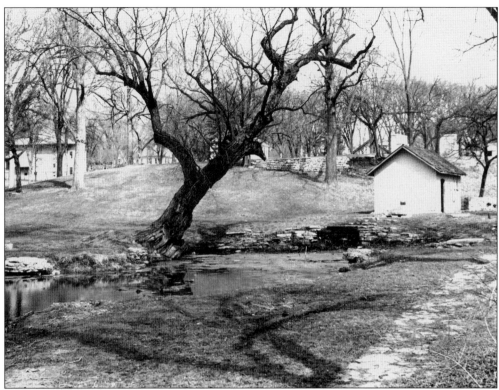

This view is of Heatherton Pond, facing east, with the limestone milk house at the right. (Courtesy of the North Central College Archives.)

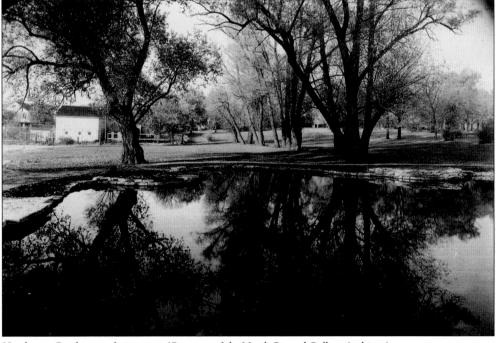

Heatherton Pond is seen facing west. (Courtesy of the North Central College Archives.)

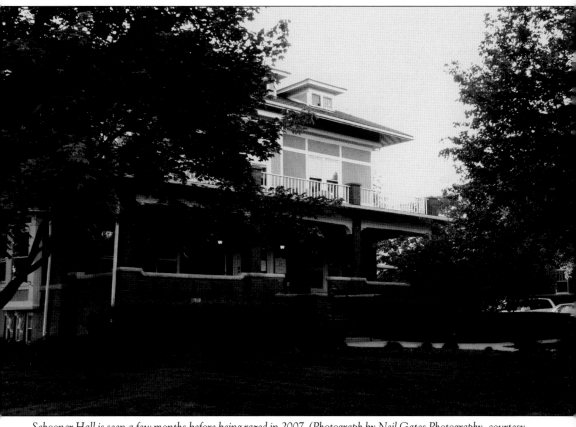

Schooner Hall is seen a few months before being razed in 2007. (Photograph by Neil Gates Photography, courtesy of Historic Ghost Tours of Naperville.)

Locals say that Mary's ghost has been seen every year, stepping from her home, crossing Chicago Avenue, and keeping her lonely vigil by the pool quite consistently through the 1960s. Then her appearance became sporadic, and her last supposed sighting was in 1984.

Today the spring has been extensively redesigned into a larger pond complete with a fountain, immaculate landscaping, memorial plaques to notable North Central College alumni and donor classes, and tall cattails where families of ducks make their summer home. The milk house, hoary old tree, and filigreed iron bench that faithfully watched over the spring are gone. Patterson Residence Hall was built directly in the path where Mary has reportedly walked every year for over a century. The college purchased Mary's house in 1994 and named it Schooner Hall; but in 2007, it was torn down to make way for the spectacular new Wentz Fine Arts Center. All that remains of the original spring that once graced the lawns of Heatherton are the elegant water lilies that serenely float on the dark water and tales of a ghost known as Chicago Avenue Mary.

Now, perhaps, not even the ghost of Mary remains behind here, what once was a special place for her and her dearest love. So many years have passed, and so many changes have dramatically altered the landscape, we can only hope Chicago Avenue Mary has finally forgiven herself and found peace at last. After all, no one has reported seeing her for two decades now.

Or have they seen her and did not know it?

Mary was supposedly only in her late teens/early 20s when she died. Her clothes and appearance are so unexceptional, so classically undated, she could easily pass for just another North Central College upper-class student crossing at Chicago Avenue and Ellsworth Street deep in the night. Perhaps any numbers of drivers stopped at the corner streetlight have seen an attractive young lady passing in front of their car; and if she appears somewhat insubstantial and ethereal in the moonlight, they blame it on a trick of the shadows or that last glass of beer at the Lantern one block away. Does Mary still walk to this day? Could the new Wentz Fine Arts Center already be haunted? Let us hope not; let us hope that Mary has finally found some peace. But stay alert and watch. If you see a young woman gazing down into the water of the pond south of Patterson Residence Hall, it just might be Chicago Avenue Mary searching for her lost love and mourning the life she never had.

There is one last interesting addendum to this bittersweet Naperville ghost tale that bears mentioning. Hand-in-hand with Mary's tragic love story from beyond the grave is a romantic college legend once told to me by my parents, Walter and Norma Ladley, both graduates of North Central College. The legend states that if a young lady is asked for her hand in marriage while seated on that beautiful cast-iron bench beside the spring, their marriage will be an unusually long, happy, and fruitful one. Perhaps on those occasions the ghost of Chicago Avenue Mary would stand over the lovers and grant her blessing on the romantic couple, ensuring them the wedded happiness that she herself was denied. The whereabouts of that lovely, legendary cast-iron bench is currently unknown.

Update: New research findings may have revealed Chicago Avenue Mary's true identity. The first house built on the corner was owned by Capt. Morris Sleight and his wife Hannah. The E. E. Miller mansion was later built up around the core of the original house. The Sleights had a daughter, Rosalie, who died on February 9, 1853, at the age of 23 years and 5 months. The cause of death is unlisted, which can imply a suicide. Also, her age at the time of death and the prairie-style clothing of the period would certainly fit the eyewitness descriptions of the ghost that local legend calls Chicago Avenue Mary.

THE WEEPING BRIDE

For 10 years, I lived in a two-story apartment on the corner of School and Ellsworth Streets in the Historic District. It was late in the summer of 2000 when I was awakened by the sound of horse's hoofbeats coming down School Street. It was 3:00 in the morning—I thought to myself,

"What idiot would be riding a horse in Naperville's historic district at 3:00 in the morning!?" I got out of bed and padded over to the window that overlooked the well-lit intersection, craning my neck to see up and down the street just who would be nuts enough to ride a horse at this hour. It was a quiet, still night with a hint of autumn in the air, and the old-fashioned lampposts clearly illuminated the street. The sound of hoofbeats grew louder as they came up School Street, passed right outside my window and through the intersection, then stopped suddenly before the sound grew any softer by distance. But I swear, by all that I hold good and holy in this world, I saw nothing. No horse, no rider, nothing moved outside my window at all. Yet the hoofbeats had rung out clearly and unmistakably in the silence of the very early hours.

It was only a week later I discovered a Naperville legend that I had never heard before in all my 40-plus years of living in Naperville. It was the legend of the Weeping Bride—who rides her horse through the old parts of town!

As a professional storyteller specializing in ghost stories, I decided that since the bride had come all the way from the other side to introduce herself to me, I would tell her story to my audiences. Strangely, the words just did not come—until the idea of telling her story as a ballad popped in my head, in the tradition of the old Irish murder ballads. Then the words poured out as if being whispered in my ear by the ghost, and I wrote the entire ballad and tune in less than 30 minutes. It is not half bad for my first-ever ballad, if I say so myself.

Fair young Bonnie lived in Naperville-town in eighteen seventy-three.
Eyes soft as a fawn, lovely as a rose,
Her hair a dark rain of ebony, Bonnie,
Her hair a dark rain of ebony.

A man came to town one hot summer's day as the maple trees whispered of thirst.
He had gleaming blue eyes, slicked-back yellow hair
And a smile that was well rehearsed, rehearsed,
A white smile well rehearsed.

They met at a dance and he swept her away from the moment he stroked her bare arm.
He wooed her with kisses and words sweet as wine
To steal father's money with charm, to harm,
To steal her Da's money with charm.

"I love you!" cried Bonnie when he asked her to wed, and sealed her fate with a kiss.
The love light shone from her face like a pearl
And his glinting blue eye she did miss, in her bliss
His gold-hungry eye she did miss.

The finest of weddings loving parents did plan, with music, food and champagne
Her father did give her a horse pale as mist
With roses blood red in its mane, a chain
of roses entwined in its mane.

On a chill Autumn day that pale horse she did ride to the steps of Saints Peter and Paul.
A vision of joy in white satin and lace,
Innocent of the grief that would fall, befall,
Innocent of the grief that would fall.

Legend says that the ghost called Chicago Avenue Mary would walk from this house. (Photograph by Neil Gates Photography, courtesy of Historic Ghost Tours of Naperville.)

The ghost would cross Chicago Avenue at the Ellsworth Street intersection. (Photograph by Neil Gates Photography, courtesy of Historic Ghost Tours of Naperville.)

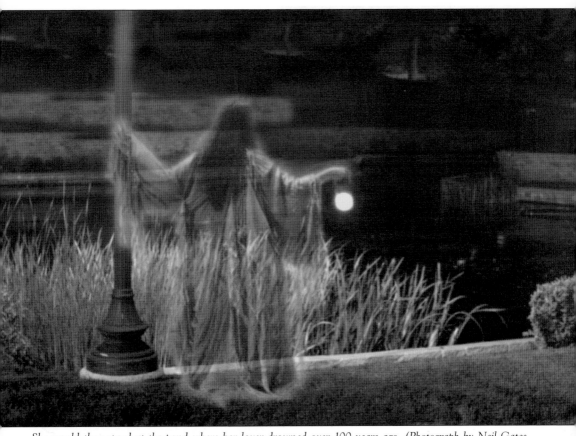

She would then stand at the pond where her lover drowned over 100 years ago. (Photograph by Neil Gates Photography, courtesy of Historic Ghost Tours of Naperville.)

HAUNTED NAPERVILLE

All of Naperville-town saw her shame on that day, for her cruel lover had flown.
He stole her heart and he stole their gold
And she stood at the altar alone, still as bone,
She stood at the altar alone.

Her mother implored her, her father cajoled her, but Bonnie refused to leave.
"He'll be here," Bonnie cried, "To make his heart's vow."
So firmly she did believe, believe,
That her lover would never deceive.

Day crept into night, yet her vigil wore on as she knelt at the altar and prayed.
Hope drained like blood with each hour that passed
And the truth she could no more evade, afraid
Of the terrible price she had paid.

The bell tolled midnight the very same moment her wretched heart finally was torn.
She made scarcely a sound, a mere whisper of breath
As her soul wished she'd never been born, a storm
of grief that she had been born.

She walked from the church like a dreamer entrapped in a nightmare that would never die.
Awaiting her there was the misty-white mare
And clouds veiled the moon like an eye, up high
Veiled the moon like a blind man's eye,

She rode through the streets at a funeral pace, wedding train dragging over the mud.
The misty-white mare shook its head and sighed
As rose petals dripped down like blood, heart's blood,
Spilled from its mane like blood.

They found her that morn, blue and frozen with cold, frost shining like tears on her face.
The doctor was called, but all was in vain
For she welcomed Death's embrace, embrace,
The bride welcomed Death's embrace.

When the moon is as white as a blind's man eye and frost turns the leaves ruddy brown
The Weeping Bride still rides her misty-white mare
Through the streets of Naperville-town, down
Through the oldest streets of the town.

To hear the hooves of the misty-white mare, to see the ghost on her ride
Then to find a petal from a blood-red rose
Means you never shall be a bride, testified
By the ghost of the Weeping Bride.

One last note to this story: In 2003, the Naperville Sun interviewed me about local ghosts for its Halloween issue. The article highlighted my eerie, personal encounter with the Weeping Bride. That day, a woman who lived on School Street a few doors up from me at the time called to let me know that on two separate occasions both she and her husband have heard the horse's

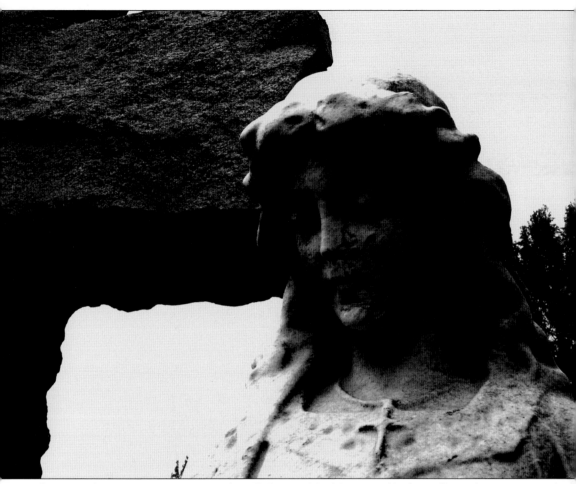

This statue of a grieving young woman stands in SS. Peter and Paul Cemetery. (Author's collection.)

hoofbeats very late at night. But when they looked out the window, there was never anything there. She was relieved to hear that they were not the only ones to have experienced this strange phenomenon. I, too, was very glad to hear that I am not crazy!

THE RESTLESS PRIEST OF SS. PETER AND PAUL

A longtime Naperville resident and friend of mine, Marybeth McCarthy told me this true story of a terrifying experience she had as a little girl in the basement of SS. Peter and Paul Church.

Grandly dominating the corner of Benton Avenue and Ellsworth Street, the architecture of SS. Peter and Paul Catholic Church was inspired after Notre Dame Cathedral in Paris, France—from the ornately carved masonry and magnificent stained-glass windows right up to the gargoyles on the bell tower that has so splendidly predominated Naperville's skyline for generations.

This is not the first church built on this site, however. St. Raphael Church stood there from 1846 to 1864. Then the first SS. Peter and Paul was built in 1864, during the bloody devastation of the Civil War. The graceful wood-and-stone structure burned to the ground on June 4, 1922, under mysterious circumstances. Before then, a rumor had already been going around that Naperville was harboring a serial arsonist who may have started a number of spectacularly large fires of unknown or suspicious origin during that decade. These included the SS. Peter and Paul parochial school building fire on August 24, 1911, and the inferno that leveled Judge J. S. Goodwin's mansion, Heatherton, on March 14, 1920, curiously on the very night of his death in a Chicago hotel room. No foul play was ever proven in these instances, but the firebug rumors persisted. After the SS. Peter and Paul fire, speculation was that the arsonist had been trapped in his own fire and burned to death because it had gone up in flames so quickly—consumed in less than 30 minutes—and so justice was served by the Catholic church. But again, this is all hearsay and rumor, as no evidence—or charred bones—were ever found to support the grisly story. Days later, rumors of a Naperville arsonist flew again after the Grace Evangelical Church was damaged by a basement fire of unknown origin on June 15, 1923 (the SS. Peter and Paul fire was also started in the basement). Rumors flared again after a mysterious blaze devastated Nichols Gym on the North Central College campus on August 23, 1929.

Marybeth McCarthy attended school at SS. Peter and Paul Grade School across from the church on Ellsworth Street. Despite the 40 years that have passed since then, she still vividly recalls that stormy afternoon in the church basement with a shudder.

It happened when she was in first grade. Her classroom had filed across the street to the church to say confession, and they were waiting their turn in line outside the confessional. The children were more unruly than usual that day. Terrible black storm clouds had rolled in with alarming swiftness, swallowing the sun and blue sky and transforming day into darkness. Low, growling thunder rumbled and reverberated like a dozen hunting tigers. As the storm rapidly enveloped the church, a sudden blast of wind and a blinding flash of lightning summoned sheets of rain to lash the Gothic-arched stained-glass windows. The boys went wild with excitement, and the girls began to scream as the bursts of thunder followed closer and closer behind each brilliant crack of lightning.

Suddenly the biggest lightning bolt yet plunged the entire church into blackness as the electricity went out. Children screamed at the top of their lungs, some in terror, and others in adrenaline-fueled thrills. Fortunately, being Catholic, they had plenty of votive candles on hand, but the children were by now so out of control it was risky to let them hold open flame.

The kids' excitement turned to genuine fear when the tornado sirens went off from the fire station downtown. At the piercing, ear-splitting wail even the toughest boys stopped cheering and started whimpering. The priest and nuns immediately escorted the crying, screaming children down into the basement—a creepy place even in bright daylight, much less in a furious storm—and made everyone huddle down on the floor and cover their heads with their arms.

Built in 1864, the first SS. Peter and Paul church burned in a mysterious fire on June 4, 1922. (Author's collection.)

Two years before the SS. Peter and Paul blaze, the Heatherton mansion also burned down under mysterious circumstances on March 14, 1920—the same night that the owner died in Chicago. (Author's collection.)

During terrible storms the ghost rises from his crypt. This dramatic photograph appeared in the August 21, 1958, issue of the Naperville Sun *and won an award from the Independent Photographers Association. (Courtesy of the* Naperville Sun *and Fox Valley Publications.)*

By now the children had lost control. They were sobbing, crying for their mothers, screaming, "I wanna go home!" The sky was boiling with greenish-black clouds, rain lashed down in ceaseless, pounding sheets obliterating the view through the basement windows, and peals of thunder crashed and boomed constantly, reverberating from below their feet and up through their bodies. Bolts of lightning sizzled and cracked the air with charges of electricity over and over again, white-hot afterimages burning into the children's eyes. The wind howled, sirens shrieked, shadows leapt in the flickering candlelight, and kids were crying in sheer, stark terror.

And that is when the priest told them about the ghost.

He told them that down below their feet lie the crypts, where all the priests who have died in service to this parish are buried. But there is one priest who does not lie still in his tomb. And when the heavens open in terrible storms—why, like this one!—he rises up from his grave. He drifts across the entire length of the crypt, and then he rises up, up, up, through the ceiling, into the basement, to hunt down sinners and make them pay!

By golly, those kids were not afraid of the storm at all after that!

Lest you think the priest was being a little, er, devilish, he was actually a very wise man, very knowledgeable about child psychology. For when children experience a real fear, such as a scary thunderstorm, that canny priest knew to instead give them a "safe" fear that will not hurt them—like a spooky ghost story—to take their minds off the real fear. Sure enough, every single child abruptly stopped crying. Not one tear dropped from their very wide eyes. The basement was blessedly quiet until the storm passed by and the lights flickered back on.

And Marybeth McCarthy never forgot the ghost story of the Restless Priest in the basement of SS. Peter and Paul!

P.S. When I asked if there really were crypts under SS. Peter and Paul church, the priest merely smiled and gave me a wink.

HERE COMES THE FATHER OF THE BRIDE

The Century Memorial Chapel in Naper Settlement was originally known as St. John's Episcopal Church. This lovely, Gothic Revival church was built in 1864 on Jefferson Street, just east of Washington Street. However, in 1969, the property on which the historic structure sat was slated for commercial redevelopment. A group of concerned residents, who did not want to see this fine example of a country Gothic Revival church razed, banded together to form the Naperville Heritage Society. Together they raised the money to have the church moved to land donated to the City of Naperville by Caroline Martin Mitchell. It was a splendid show for Napervillians to watch the 105-year-old church grandly sailing down the streets to its new location just off Aurora Avenue and east of the former Martin Mitchell mansion. The Century Memorial Chapel was the first building moved to the future site of Naper Settlement.

The Century Memorial Chapel is a very popular place for weddings, with its incredibly beautiful architecture, rich wood, magnificent stained-glass windows (original to the church), and timeless atmosphere of happiness, romance, and reverent peace. Any bride married at Century Memorial Chapel is surely heaven-blessed—and also blessed, perhaps, by yet another supernatural presence that some folk say resides in spirit there.

Modern Naperville lore tells the story of a sad ghost associated with Century Memorial Chapel. The legend goes that a father's only daughter was getting married at the chapel on a glorious June day. He had lost his wife a few years earlier and knew his health was bad enough that he would soon be joining her. His one great concern was for his beloved daughter, who would be alone in the world. So he was overjoyed beyond words that his daughter was marrying a truly wonderful man who would love her, cherish her, and take good care of her after he was gone.

On the hour of the wedding the proud father waited at the chapel door to escort his daughter down the aisle to tenderly give her into the care of the man she so loved. He waited and waited,

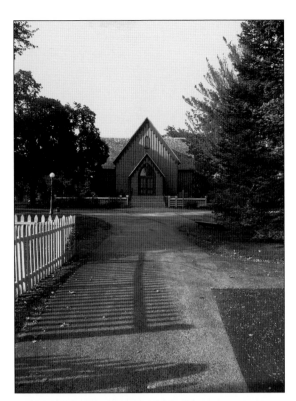

The Century Memorial Chapel is located on the grounds of Naper Settlement. (Author's collection.)

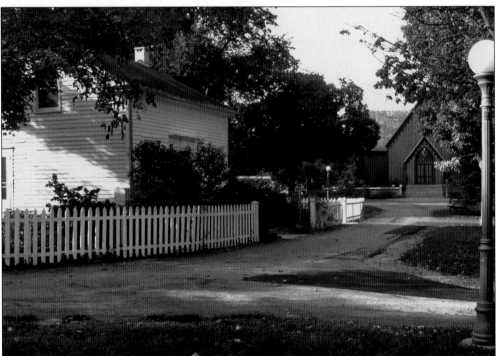

Does the ghost of an anxious father pace down this road from the Murray House (left) to the Century Memorial Chapel (right) waiting for his daughter on her wedding day? (Author's collection.)

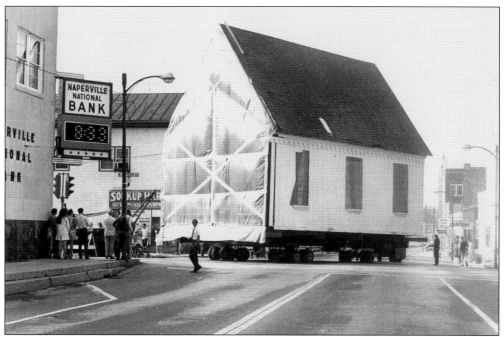

In 1969, St. John's Episcopal Church made quite a grand sight as the building was moved from its original location on Jefferson Street to the grounds of the Martin Mitchell Museum. (Courtesy of the Naperville Heritage Society Collection at Naper Settlement.)

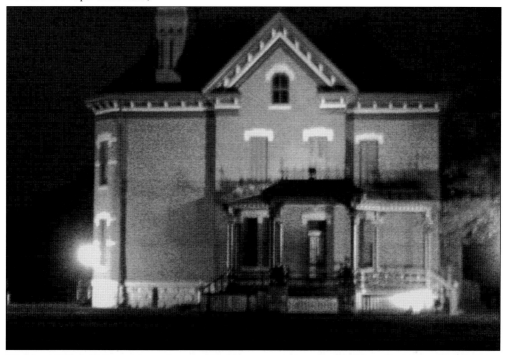

The Martin Mitchell Museum is seen here at night. The management and staff of Naper Settlement officially do not support, endorse, promote, or acknowledge these ghost stories in any way; though they do appreciate that recording local folklore is an important part in understanding and preserving cultural history. (Author's collection.)

pacing the sidewalk between the chapel and the settlement's Murray House with increasing anxiety; but she was never destined to arrive. For on her way to the church her automobile was in a terrible accident, and she was killed despite all the valiant efforts of the emergency room doctors at Edward Hospital. It did not take long before the traumatized father joined his daughter and wife in death. But there are some who say he does not rest in peace. He has left unfinished business behind, and in his ethereal plane of existence, his daughter still is not wed.

Wedding guests at Century Memorial Chapel have claimed to witness a man dressed in a formal tuxedo and tails walking up the road from the Murray House to the steps of the chapel, where he vanishes on the last step before entering the doors. It is not uncommon for a misty "white statue" to appear alongside or just behind the wedding party in the photographs taken outside with the picturesque chapel as a backdrop. It could easily be a normal white streak on the film—until someone notices that the mysterious figure appears in the exact same position on separate photographs taken simultaneously by both the wedding photographer and friends.

Truly blessed is the bride who marries at Century Memorial Chapel, for if the ghost appears in the wedding photographs, it is said that he showers the radiant blessings of a loving father's spirit on the happy bride, just as if she were his own beloved, dearest daughter married at last.

Two

Haunted Homes and Mansions
The Ghost Next Door

A house is never still in darkness to those who listen intently; there is a whispering in distant chambers, an unearthly hand presses the snib of the window, the latch rises.
Ghosts were created when the first man awoke in the night.
—J. M. Barrie in *Little Minister*

Well, if I were going to haunt anybody,
this would certainly be the house I'd do it in.
—Lance Schroeder in *The House on Haunted Hill* by Robb White and William Castle

Lurker In the Murray House

One thing is for certain—the sad ghost of the bride's father is not the same sinister entity that many visitors have sensed up in the second floor of the Murray House. But who—or what—could it be?

The four-bedroom Greek Revival Murray House was built around 1845 on Main Street by John Murray. John later sold it to his son and his new wife, Robert and Louisa Murray. As one of Naperville's earliest settlers, having arrived at the age of 17 with Capt. Joseph Naper, Robert Murray became a hotel proprietor, lawyer, sheriff, and a DuPage County judge. He was one of the lawyers in the wildly notorious Burch divorce case of 1860, which brought national attention to the then-sleepy rural town. Robert and Louisa were devoted friends of the famous legislator and chief opponent to Abraham Lincoln, Stephen A. Douglas, and earned local fame by hosting him in their home on the snowy evening of September 27, 1856.

Throughout its long history, the house was moved two times and had three different locations—Main Street, Fremont Street, and finally Naper Settlement. It was a private dwelling, then a law office. During its final years on Main Street it served as home to a men's social group called the Limited Club. Some Naperville old-timers wink and say it was a brothel then, although there is absolutely no evidence whatsoever to support that rumor. Eventually the house was bought by the Naperville Historical Society and relocated to Naper Settlement in 1971.

Today psychics who have visited the Murray House believe that a dark, negative presence occasionally resides on the second floor. It does not occur often, but when it does, visitors say that a cold chill suddenly envelops them, and the powerful awareness that *something* is in the upstairs rooms with them raises the prickles on the back of the neck and discourages lingerers. Did some terrible tragedy happen up there sometime during its long history? The investigation continues.

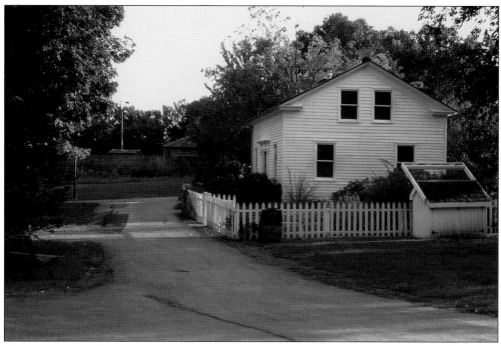

The Robert Murray house was later home to the Limited Club, a private men's club that may have served alcohol—and possibly other vices—during the Prohibition era. (Author's collection.)

What dark entity occasionally stirs on the second floor of the Murray House? (Author's collection.)

A HAUNTING AT HALFWAY HOUSE

The journey from Naperville to Aurora was a two-hour drive by horse-drawn carriage. Marking the halfway point between the two towns was a sturdy brick farmhouse owned by the Urbane D. Stanley family, which earned it the nickname Halfway House. Built in the 1840s of handmade bricks, this handsome two-story home was a welcome landmark to travelers, who knew their journey was half over when it came into sight. Today a Toys R Us store stands in the original location of the Halfway House, just southeast from the corner of New York Street and Commons Drive.

The history of the Halfway House was not always a happy one. Although history is vague on the subject, a woman hung herself from a ceiling fixture on the second floor. Whether it was a suicide or an accident is uncertain. Suicide victims were typically buried on unconsecrated ground for the unforgivable sin of taking their own lives. So that grieving families would not be shamed and their lost loved one could get a decent Christian burial, coroners, police, and newspapers often shared an unspoken compact to change or gloss over the cause of death from suicide to accident. This common practice took place from the early pioneer days even well into modern times.

When construction began on the Fox Valley Shopping Mall, the Halfway House was spared the wrecking ball and relocated to the Naper Settlement Living Museum in 1975. Local historian Helena Zentmyer Wackerlin struck a deal with the museum. She would bear the cost of moving the Halfway House to its new location in the settlement on the stipulation that nothing—absolutely nothing—inside the house would ever be moved, taken away, or otherwise changed in any way. This not only included her wonderful antique furniture, rugs, and portraits but also the teaspoons in the drawer, every knickknack and doodad, even Helena's personal hairbrush, comb, and toiletries on the dresser—nothing was to be removed, ever. Another stipulation on the contract was that Helena would be the living museum's docent or costumed guide for the Halfway House. Helena Zentmyer Wackerlin was a highly regarded and admired authority on local history, so there was no one better suited to the job than she. Ever since that day, the Halfway House has been suspended in time—and eventually, perhaps, Helena was too.

It is not surprising to wonder if Helena still happily abides in the house years after her mortal death. She loved the place so very much and loved her role as docent and Naperville historian. A visitor tells a curious tale of seeing a costumed guide passing by the open front door of the Halfway House early one fine day. He and a friend both saw her and decided to go in to hear her tour lecture. Stepping into the foyer, they saw her walking past the kitchen door at the back of the house, her long Victorian skirt briefly billowing, but they could not approach her. The rooms were divided by three-and-a-half-foot-tall sheets of Plexiglas installed in all the doorways. Two sheets of Plexiglas stood between them and the tour guide in the kitchen.

They called out for the guide to come over to give them a tour, but no one answered. As curious now as they were determined, they searched the kitchen—only to find the room empty and silent. The back kitchen door was still securely locked from the inside, and there was no other way out of the room. Then another mystery dawned on them: How on earth had the tour guide gone from the front door where they had first spotted her, crawled over both Plexiglas barriers (in a long Victorian gown, no less!), and gotten to the kitchen at the back of the house in the brief seconds it took for them to walk up the sidewalk to the front door? It was only later they learned that the devoted protector of the Halfway House, Helena Zentmyer Wackerlin, had passed away a few months before.

Did they see Helena's ghost? Why did she stipulate that nothing must ever be moved in the house? Some paranormal scholars believe that ghosts only "see" their environs as they existed in their own time. So they are often seen walking through walls that did not exist in their day or levitating inches off a floor that used to be on a higher level. Perhaps in life Helena had hoped

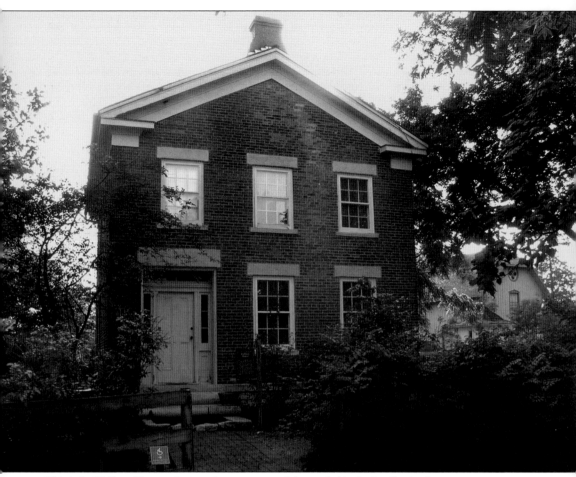

This is the Halfway House—in more than one sense of the word. (Author's collection.)

to return to her earthly home after her death. If so, certainly she would want everything to be in its proper place exactly as she remembered, so that her spirit would be comforted by familiar surroundings.

A ghost spending her afterlife in a house suspended in time as a museum exhibit? Truly it is a halfway house.

THE MOST HAUNTED HOUSE IN NAPERVILLE

I'm alone in the house, sitting in the living room, becoming more and more terrified. The anger in the house is building up again. I watch the back stairs, just off the kitchen, expecting at any moment to see his head appear above the back counter as he reaches the top of the stairs. He? It? What is there in the basement that has me so terrified? I'm afraid it will come up into the kitchen. It never has before; maybe it can't. It's as if some force were keeping it confined to the basement. But the atmosphere of malevolence is growing stronger, and I wonder how much longer it can be contained. "Get out!" a male voice says inside my head. It's a voice full of venom. The tone is menacing; it's more of a whispered threat, not a shout. Instinctively I turn and look towards the kitchen. No one is there. No one is in the room with me, and yet I heard him.

This is the bone-chilling beginning to one of the most remarkable, carefully documented accounts of a haunting I have ever read. But what makes *Agatha's Journey: 1828–1998* by Sandra Penrose really strike home for me is that the unnerving, oftentimes terrifying events took place in the perfectly ordinary, white frame house at 526 West Franklin Avenue. As a teenager I used to ride past it on my bike all the time from my house on Douglas Street, just a few blocks away. Back then, even the neighbors had no idea that it was the most haunted house in Naperville.

I have read a lot of true ghost stories, but very few have spooked me like this book. I am talking about a leave-the-lights-on-and-look-nervously-over-my-shoulder-for-days kind of spooked. The first half of *Agatha's Journey: 1828–1998* is a harrowing story documenting the disturbing, sometimes sinister, paranormal activity that the Penrose family endured for nearly 20 years since moving to Naperville from Canada in March 1980. The second half of the book is an account of a woman who sailed from Ireland to America with her husband and baby daughter in 1828. How does this story tie in with the Penroses'? This pioneer woman was one of the many ghosts who haunted the Penrose house and who relayed her life history telepathically to Sandra Penrose.

When Sandra and her husband Bill Penrose moved into the charming 1920s Sears catalog house with their children—Howard, 13; Roger, 11; and Heather, 8—the ghosts did not wait long to make their presence known. Bill, a biochemist, had just landed a job with Argonne Labs, and Sandra was a retired computer database specialist. Within a few days peculiar things started to happen that were at odds with their highly rational, advanced scientific training and instincts. As Bill said in a December 1, 1998, interview with a *Chicago Tribune* reporter after the release of *Agatha's Journey*, "If you take any single event, you can explain it as coincidence. But you put the whole lot together, it's not coincidence anymore. If I . . . say it did not happen, then I'm not being a scientist because I'm closing my mind."

At times Sandra would feel strangely unwelcome in various parts of the house. She astutely defined the unpleasant, electric sensation in the book. "The atmosphere was similar to the feelings I would get when entering a home where a terrible argument had just happened; no matter how friendly the hosts might be, the anger hung in the air. . . . This feeling would continue to build up until it was almost intolerable." Eventually the threatening atmosphere would grow so intense, the feeling of immediate danger so overwhelming, that it would run Sandra out of the house. She would sit on the front porch in the freezing cold waiting for a

45

family member to come home: feeling like a total fool but too genuinely terrified to go back inside alone.

The evil presence was especially powerful down in the basement, where they had the laundry, furnace, two spare bedrooms, and a recreation room for the children—which they never wanted to play in. Day or night, it did not matter, Sandra would feel as if someone were peering at her through the peg-board wall from the furnace room to where she worked on the laundry. She did not like to go into the basement unless she knew a family member was in the house. Even then, she would turn out one basement light and run to the next pool of light until she had finally reach the stairs. This final leg of her escape was also the most terrifying. Climbing the stairs, Sandra would get a vivid mental image of an ax hurtling through the air toward her back. The harrowing image would fade as soon as she would reach the landing, but she always kept running frantically anyway until she reached the kitchen. As Sandra wrote, "Forget determination; forget courage and dignity; *let me out of here!*"

As so many families do when living in a haunted house, the Penroses never spoke of their personal experiences to anyone—not even each other. They were each afraid the other family members would think they were nuts and dreaded the derision and laughter they were sure the others would heap on them if they even hinted that something supernatural was going on in the house. So none of them ever breathed a word of the frightening, unexplained events that happened so many times, often right before their eyes.

It was not until one evening in February 1984 that Bill broke the silence. Bill and Sandra were home alone, curled up on the sofa reading, when Bill quietly asked Sandra if she could see a shadowy man peering at them from the living room doorway. Sandra saw nothing. Bill explained he only saw the figure in his peripheral vision—it vanished when he would look at it directly—but he described the shadow as wearing a long overcoat and a fedora hat, "just like Dick Tracy." He confessed having seen it a number of times before, but only now did he finally get the courage to speak up and say anything since the kids were not home at the time. Sandra was relieved to finally unburden herself of the many bizarre impressions and events that she had experienced, and they both decided to document these mysterious goings-on using a scientific cause-and-effect methodology. They agreed to not discuss the subject with the kids unless their behavior indicated they would be ready to talk about it. Even then they would be sure that talk would be a private one.

Not long after that, Heather, who was 12 at the time, lost her temper at her mom and erupted that she hated the basement, hated the whole house, and most of all, was afraid of the man standing in the living room door who watched her whenever she was in the kitchen. Stunned, Sandra asked her daughter what the man looked like, and she described him as tall, slim, wearing a long coat that hung loosely with no belt, and wearing a hat like Dick Tracy—exactly how Bill had described the shadowy figure he kept seeing, standing in the living room door.

A few days later, Sandra had an opportunity to speak privately with 17-year-old Howard. She came right out and asked her son if anything odd had ever happened to him in the house. At first Howard was reluctant to answer, but upon hearing that his dad and sister had experienced some strangeness, he admitted to several weird things. These included a small closet door in the boys' bedroom opening by itself; a feeling that someone was in the library; and, most chilling to Sandra, Howard reported the sensation of an evil presence chasing him from the basement and throwing an ax at his back as he would run up the stairs.

The following Saturday morning, when everyone else was out running errands or with friends, Sandra told her 15-year-old son Roger everything that had been happening to the other family members. Roger too had witnessed the small closet door in their bedroom open for no reason. He too had seen the shadowy Dick Tracy, but sitting in the library lounge chair. He explained that he disliked going up to the second floor because of an unwelcoming presence up

there. And then he added that there had been many times he had the impression that someone was throwing something sharp at his back as he would run up the basement stairs in fear of an unseen threat lurking down there.

Everyone in the family at one point had experienced many of the exact same weird and frightening things, but they had never told anyone. Now that the truth had finally come out, there was no mistaking the fact that this was way more than coincidence—something paranormal was taking place in their home.

As the years passed, a veritable host of ghosts they called their "Other Family" made their presence known, including a giggling, blond-haired little boy who, because he ran all over the house, they christened the Track Star; several men dressed as Civil War soldiers, one of whom often appeared in the closet of the spare bedroom; a tall, malevolent man who purposely hid his face in the high collar of his black cloak, radiating a terrible evil presence; the threatening, angry entity in the basement who gave people the psychic impression he was throwing an ax or knife at their backs; a large dog whose eerie, mournful howls made their hair stand on end; an amorphous figure with frightening, staring eyes seen huddling in one of the spare bedrooms; Dick Tracy in the living room and library; an elderly woman in the master bedroom; a mysterious coffin-shaped bare spot in the lawn that kept reappearing despite the best efforts of professional lawn-care companies; and a middle-aged woman in a purple dress sitting in the window seat on the landing off the stairs leading to the second-floor bedrooms.

Daily life in that home on Franklin Street was filled with sudden frights, disembodied footsteps, unplugged lamps turning on, strange noises, invisible hands touching people, objects moving by themselves—the usual poltergeist activity times 10. Most ghosts, like the Track Star, the elderly woman, and especially the woman on the stairway window seat, brought a sense of benign calm, friendliness, and safety. These were welcome spirits. Others, like the ax-throwing farmer, the amorphous figure, and especially the dark-cloaked shadow, were terrible presences of bone-chilling, diabolical dread.

Finally a friend referred Sandra to an excellent psychic in Des Plaines who specialized in helping wayward spirits to move on into the light. To say Sandra was skeptical is an understatement, but she was willing to try anything by then. Visiting friends and family refused to stay overnight because of the ghosts; her sons had grown, married, and moved out; and Bill traveled on business a lot, leaving Sandra alone with a houseful of ghosts far too often for her liking. But of greatest concern to Sandra was that Heather had moved back in with her baby daughter, Alex. How would the ghosts react to the presence of an infant? Was baby Alex in danger? The Penroses did not want to risk it, so they gave the psychic a try.

Much to their amazed delight, the psychic was able to help them cleanse the house of most of the ghostly presences, including all the evil ones, and the incidents of paranormal phenomena dropped off considerably. The psychic was careful to explain that the scary ghosts were not genuinely evil but instead had been people who died under great stress, fear, or anger. For example, the psychic said that the terrifying, black-cloaked male ghost was afraid he would go to Hell, but when she called on her spirit guide to lead him into the light, he followed. The ghost who would angrily "throw an ax" at people on the basement stairs revealed himself to be a farmer who had died while still waiting for his son to return from World War I. He threw the ax simply because he thought they were intruders. The psychic convinced the farmer's ghost to meet with the spirit of his slain soldier son at the gazebo in Naperville's Central Park, and suddenly the basement was empty of paranormal activity from that time on.

But there was one spirit who refused to leave. The woman in the purple dress on the staircase window seat had always been a beneficent, kindly spirit. Even the evil ghosts seemed to hold her in great respect; whenever those entities would build in power, their malicious anger might flood the basement and first floor but never go up to the second. Her gentle spirit was formidable

enough to stop the threatening sensations from coming up the stairs, and the window seat became a place of sanctuary and calm in those times. Sandra also noticed that while this female phantom was normally serene and quiet, she would pound on doors and generally raise an alarm whenever a family member was in trouble. Of all the ghosts to stay behind, this one was most definitely welcome. Even baby Alex would coo and giggle at the window seat, her laughing eyes tracking an unseen presence. But Sandra could not help but wonder why this ghost in the purple dress did not depart.

The psychic suggested that Sandra sit near the window seat and try to mentally "tune in" to this ghost to see if she could communicate with her. Sandra did, and suddenly words and sentences about the life of one Agatha Wilson, Irish immigrant and pioneer, slowly began to come through to her. Agatha simply wanted to tell her story so that someone would know that she had once walked this earth—that she had once lived, loved, laughed, cried, suffered, celebrated, and died. Agatha wanted to be remembered. So over the next several years Sandra was the ghost's flesh-and-blood conduit to the written word, and in 1998, the Penroses published *Agatha's Journey: 1828–1998*. This fascinating, well-written book is still in print and on the shelves at local and online bookstores.

Sandra reported that Agatha, along with Agatha's husband and eight-year-old daughter, Sarah, had traveled from New York with a dream of getting free land in the wilderness beyond the Mississippi. Her husband died along the trek, and on reaching what is now Naperville, Sarah too fell ill and died. Agatha indicated that Sarah's remains were buried in the front yard—in precisely the same coffin-sized, bare spot that had confounded even lawn-care specialists. With the power of a mother's love, Agatha had stayed there even beyond her death, determined to never leave until a priest blessed her daughter's grave. Eerily, once the Penroses arranged for a priest to come and say a few words over the supposed grave site, the grass promptly grew over that spot.

The once hyperactively haunted house was quiet at last. Oddly, Agatha lingered on despite having her child's grave blessed and her life story told, although she no longer made her presence noticeably felt except for the occasional reminder that she was still there—and even those faded away. By 1999, when Sandra and Bill Penrose retired and moved to Arizona, the last ghost had left the most haunted house in Naperville.

The Penrose house stood empty and ghostless for several years until the property was sold to developers and the house was razed to the ground. Today a beautiful new home stands on the site, and Sandra feels strongly that the new homeowners will not have any pesky paranormal problems. For as the psychic had explained to her, the majority of the ghosts were not haunting the house at all—they were haunting Sandra because of her heretofore-unknown psychic abilities. Lost spirits were psychically drawn to Sandra in hopes she would help them move on to the great beyond. Even if the Penroses had moved soon after learning that their house on Franklin Street was haunted, the majority of the ghosts would have followed them to their new home.

When Sandra and Bill Penrose finally retired and moved from their Naperville house, they had assumed Agatha had already gone into the light and joined her husband and daughter at last. Much to their surprise, a few years later Agatha suddenly popped back into their lives again, indicating that she "Wants to help the family with something." Agatha had traveled out west with them to their new Arizona home! In my interview with Sandra, she said that Agatha had indeed been instrumental in helping the family through a recent crisis, just as she had promised. As of that interview, Agatha was still with them—no doubt happily keeping watch over the newest generation of the Penrose family.

THE GHOSTS OF PINE CRAIG

The handsome, brick red Victorian manor called Pine Craig stands at the bend of Aurora Avenue east of Naperville Central High School. It was built by George Martin II, owner of the brick and tile factory, limekilns, and the quarries now known as Paddleboat Pond and Centennial Beach. His fortune was assured after the Great Chicago Fire of 1871, when the fine brick tile and golden limestone from his quarries was much in demand to help rebuild the mighty metropolis by the lake.

In 1883, George II built this magnificent family manor home to reflect his hard-won wealth, but he enjoyed his magnificent mansion for only six years, passing away in 1889. One by one, each member of the Martin family died childless. The last surviving descendant of the Martin family was Caroline Martin, George's youngest daughter, who married Edward Grant Mitchell in 1896. Keenly aware that she was the last of her proud and distinguished family name, Caroline chose to sign her name Martin Mitchell after she married; although Edward's lineage was even more illustrious, tracing his ancestry to the same Grant clan of Scotland as Pres. Ulysses S. Grant.

It was well known in the town that Caroline took great pride in her beloved family home, and the knowledge that the Martin family line ended with her was very upsetting to Caroline. Living alone in the mansion the last seven years of her life, she became determined—some would say obsessed—with the idea that the Martin name and legacy should be preserved in Naperville for all time. When Caroline died in 1936, she bequeathed the entire Martin estate, including the mansion and 214 surrounding acres, to the City of Naperville on the condition that the house and all its furnishings would become a museum and the land be used for the good of the community. It was due to this generous gift that the city eventually built Naperville Central High School and practice fields, the community gardens, part of the Von Oven Scout Camp, Naperville Cemetery, Naper Settlement Living Museum, Centennial Beach, Rotary Hill Park, the Riverwalk, and Millennium Carillon.

Today, as it did over a century ago, the Martin Mitchell Museum still stands as a showpiece of Victorian wealth and splendor. Caroline had accomplished her dream of preserving her cherished mansion and proud family name forever. But obsessions can live on long after the dream—and sometimes even longer than the dreamer.

One of my first jobs as a teenager growing up in Naperville was as a tour guide at the Martin Mitchell Museum in 1975 and 1976. I recall certain dark, rainy days when visitors stayed home and we tour guides would gather in George Martin's old office and tell each other ghost stories. Our favorite was about the strange things that oftentimes occurred in the old Victorian mansion—footsteps moving back and forth on the second floor when no one is up there, a woman's voice in an empty room, shadows moving, and a tapping noise coming from the outside the upstairs parlor window as if someone were rapping on the glass, although nothing was there. None of us really believed in the stories—"Ghosts aren't real of course," we told ourselves—but it made for first-class entertainment on a dark and stormy afternoon in a spooky old Victorian mansion.

It was only years later, when I actively began to collect the varied ghost stories of Naperville, that I discovered that some of those ghost stories my fellow tour guides told each other long ago may not have been just stories.

In interviewing a host of people well familiar with the mansion, a surprising number of them recalled sensing an icy cold spot at the top of the grand staircase, where a huge gilt-framed mirror used to dominate the upper hall. A woman had a frightening experience one hot August day up in the attic of the old mansion. She was busy working on rotating the exhibits—storing antiques and bringing others down. She was kneeling over a large trunk when suddenly she felt a very cold draft at her back, like a freezing blast from an air-conditioner; but the museum was not air-conditioned back in those days. A heartbeat later she felt the distinct sensation of an icy cold hand coming to rest firmly on her shoulder. Frightened out of her wits, she jumped to her

feet and spun around—but no one was there. She never went back up in the old mansion's attic again unless someone was with her.

Most people think this unsettled spirit is the ghost of Caroline Martin Mitchell, still obsessively watching over her home to ensure her family name is preserved. But others think the ghost is Caroline's older sister, Elizabeth, fondly called Lizzie. Lizzie Martin never married because she was a dwarf. Having a dwarf in the family in Victorian times was considered shameful, and they were often hidden away and horribly abused. Contrary to rumors that she was mistreated by her family and locked away all her life, in truth Lizzie Martin was dearly loved and very active in her church and the community. In life, Lizzie Martin was quite mischievous even in her older years. It is said that whenever she was grounded in her room for misbehavior she would slip out the window, walk around the precarious porch roof, and rap on the window of her sister Caroline's room, now the upstairs blue parlor. Is this the source of the distinctive rapping that is still heard from time to time resounding from the north window in that room?

Does Lizzie's pet dog still curl up on the antique bed in her old room, waiting for his beloved mistress to come home? One woman related a puzzling experience she had one night when she was alone in the mansion. She was in the downstairs dining room when suddenly she heard a dog whining and growling, coming from one of the upstairs bedrooms. She followed the noise upstairs to the child's room, which formerly belonged to Lizzie. The growling suddenly stopped as soon as she got to the top of the stairs. Entering the child's room, she noticed that the quilt was mussed in the middle of the bed as if a small, invisible dog had curled up on it for an afternoon nap. No one was allowed to sit on the museum artifacts, and she knew that it had been smooth and neat the last time she was in the room just an hour before. She straightened the quilt and continued to search the second floor for the now-silent dog with no success. It was only when she peeked into Lizzie's room a second time and saw that the quilt was once again mussed as if by a small animal did she feel that it was time she got out of the house—quickly!

Hearing this experience took my breath away as I recalled one occasion when I worked as a tour guide in which I too had seen a circular impression in the middle of the quilt while conducting a tour in that particular room. I remember thinking irritably that someone must have sat on the fragile antique bed, and I ran a quick hand over the quilt to smooth it before moving the group on to the next room. But on my very next tour an hour later, the quilt was mussed again in the same circular pattern—as if a small dog had circled a few times before settling down in the middle of the bed for a nap.

It has long been whispered that the Martin mansion was a stop on the Underground Railroad, hiding escaped black slaves from bounty hunters who were paid well to drag them back to their southern masters in chains. However, since the mansion was built in 1883—two decades after the Emancipation Proclamation—the Underground Railroad was no longer active. However, this lore may allude to the first Martin house built by George I soon after emigrating from Scotland to Naperville in 1833. This small house, later called Century House, was purported to be the oldest frame building in DuPage County. Crafted of oak and walnut trees hand-cut on the site, the wood was turned out at the Naper sawmill. Century House was originally located across the road from where Pine Craig was later built, where Rotary Hill Park near the Millennium Carillon is today. The house stood as a Naperville landmark for 126 years before being destroyed by fire in 1958. Century House could certainly have held the distinction of being a station on the Underground Railroad; however, no solid evidence of this has ever come to light.

Recently the Martin Mitchell Museum was carefully restored back as it had been in its heyday in the early 1900s. Whoever or whatever may be haunting the place—Lizzie or Caroline or their dog—let us hope that after seeing the loving care and devotion it took to bring the mansion back to its glory days the ghosts will finally be reassured that their beloved family homestead and proud family name are in good hands.

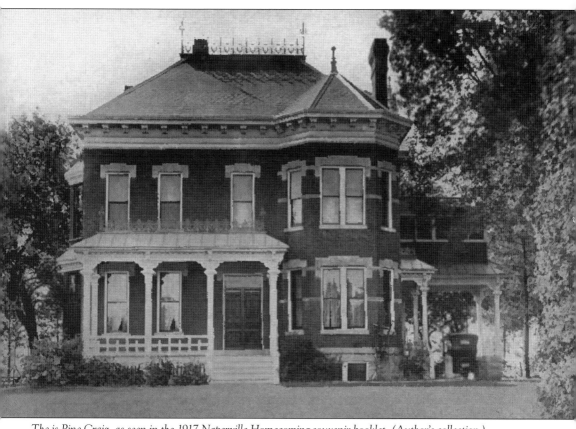

The is Pine Craig, as seen in the 1917 Naperville Homecoming souvenir booklet. (Author's collection.)

One mystery of the Martin Mitchell mansion is the curious positioning of an attic window. Why is the chimney completely blocking the window? What—or who—was hidden away up in the attic? (Author's collection.)

Caroline Martin Mitchell ensured the Martin family name would be remembered in Naperville for all time. (Courtesy of the Naperville Heritage Society Collection at Naper Settlement.)

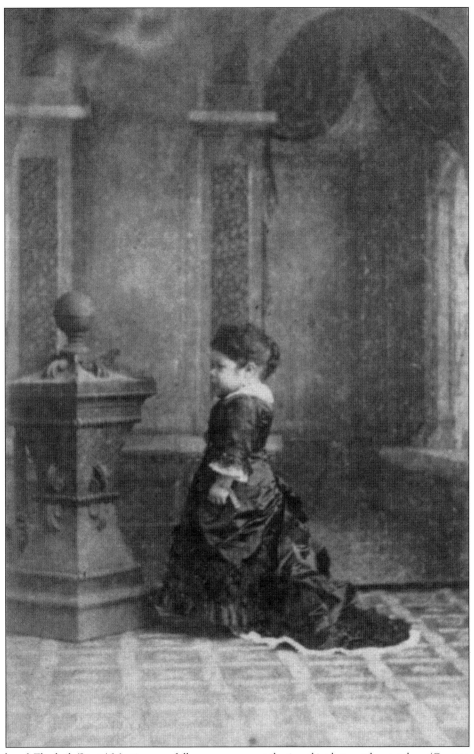

A dwarf, Elizabeth (Lizzie) Martin was a full-grown woman at the time this photograph was taken. (Courtesy of the Naperville Heritage Society Collection at Naper Settlement.)

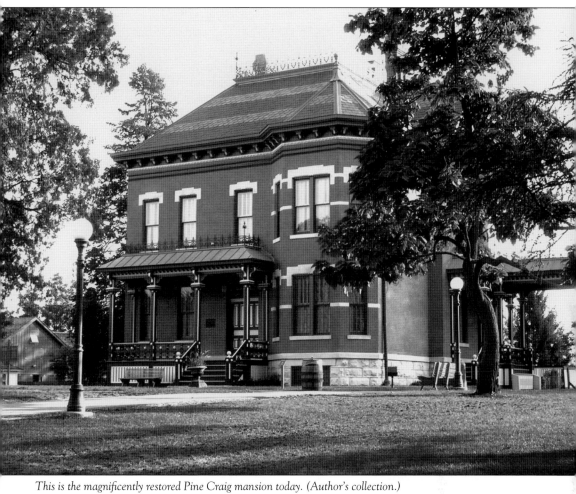

This is the magnificently restored Pine Craig mansion today. (Author's collection.)

THE BLOODY RED GERANIUM

In 1993, Joe and Kelly Tiberi had a dream—to open an art gallery, gift shop, and flower shop somewhere in downtown Naperville. The proliferation of megamalls like Fox Valley Mall in Aurora and the subsequent sprawl of strip shopping malls that sprang up virtually overnight had spelled economic doom to many downtown shopping areas. However, in the mid-1970s, Naperville's city council led by Chet Rybicki, mayor from 1975 to 1983, made a bold and controversial decision to tear out all the parking meters and entice shoppers downtown with the lure of free parking. The plan was a brilliant one. The downtown Naperville merchants not only survived the mass exodus of customers to the malls, they thrived.

So when the Tiberis laid eyes on the century-old, four-bedroom, white stucco cottage west of the Washington and Benton Streets intersection, they knew this was the place where they would make their dream come true.

They transformed the entire two-story cottage into an inviting little gift shop called the Red Geranium, named after Kelly's favorite flower and for the dozens of bright scarlet geraniums that spilled from hanging baskets and clay pots that lined the porch and steps. As an accomplished artist, Kelly saw the crisp white stucco walls as canvases that begged for murals, framed by wooden shutters and trim painted a deep forest green. A glorious English garden complete with climbing floral vines of honeysuckle and roses completed the Thomas Kinkade–style picture of cottage charm and romance.

For convenience, the Tiberis decided to live down in the basement that before them had been nicely finished and leased out to a long series of renters. Kelly's artistic touch soon made it into a cozy home; despite her bright decor, the room always carried a shadowy, chill atmosphere that depressed the spirit and occasionally gave them goose bumps for no particular reason. Their white Persian cat particularly despised it and needed a great deal of persuasion to go into the basement. In fact, their cat had undergone a dramatic personality change from the first day they moved in—from being sweet, serene, and well-behaved, to a yowling, fearful cat that would not use its litter box in the basement.

Within the first few weeks of moving in and the grand opening of their Red Geranium shop, the first dark cracks in their dream began to show. Objects would disappear only to reappear again in unexpected and unusual places. We have all experienced laying down our eyeglasses or pen and suddenly they are not where you left them. But at the Red Geranium, that common annoyance went to extremes. For example, Kelly might lay a pair of scissors down on a table, turn away for a moment to pick up the gift she intended to wrap, and when she turned back, the scissors would be gone. She would look on the floor, on the chairs, in her pockets, but they had simply vanished from a completely cleared tabletop. Later she would find the scissors in bizarre places, out of the room, down to the basement, and lying perfectly positioned in the middle of their bed.

The most dramatic disappearance was a large, 30-inch-by-30-inch painting of a garden landscape that Kelly had painted herself. They kept it on an easel in the front room of the shop hoping to sell it. One evening they went through their usual bedtime procedure of closing up the shop; locking doors, windows, and the cash register; turning off the lights; and heading downstairs to bed. Kelly distinctly recalls seeing the painting on the easel while she locked up. But when Joe and Kelly came upstairs to open the shop the next morning—the easel stood empty. The windows and doors were still locked, no signs of forced entry, the money was still in the cash register, nothing else in the entire shop was touched, but somehow Kelly's lovely garden landscape had mysteriously vanished in the night. They never saw it again.

Kelly began to occasionally glimpse a dark silhouette of a tall man lurking silently in the room just within the edge of her vision. But the moment she would turn to look at it fully, the shadowy figure would vanish. It gave her an alarming jolt each time, and at first she put it down to her eyes playing tricks on her. But a doctor's visit showed her eyes were fine. She always knew when the

tall shadow was in the room with her, standing in the corner just watching her, by the cold, awful sensation creeping and crawling over her skin. It would appear anywhere in the house at any time, day or night, but 9 times out of 10 she would glimpse it standing by the stove in the basement kitchen—watching her. Joe scoffed at her imagination, but there were times she would catch her husband glancing quickly over his shoulder toward the stove, his fists white-knuckled and jaw tight. The shadow was just one in a long list of disagreements that Kelly and her husband had started having since they moved in. They argued heatedly over the tiniest, most insignificant things, which was completely out of character for their marriage until now—until the Red Geranium.

Kelly had a friend who was a specialist in feng shui, the ancient Chinese art of sensing negative and positive energy flows, then enhancing the positive energies by harmoniously arranging your environment. One summer's day this feng shui friend stopped by, and Kelly invited her in for a grand tour of her new shop. The moment this friend stepped foot inside the front door she stopped dead in her tracks. The tiny hairs on the back of her neck stood straight up, goose bumps swept up her arms, and she knew right then that there was something very wrong about this house—something very dark. But she did not say anything to Kelly right then, as she did not want to upset her. As she followed Kelly on the tour her unease grew from room to room, until Kelly went down into their basement apartment and toward the kitchen. The friend suddenly burst out, "Kelly, stop! I can't go any further!" At Kelly's astonished gaze she explained, "There's a black shadow—a highly negative presence—standing over there by the stove. It's so dark, so negative, I can't cleanse it. It's not going to go away. And I am *not* going to go any closer to it!"

Hearing her friend unknowingly verify her own sightings unnerved Kelly, so she contacted a psychic to walk through the Red Geranium. She did not tell the psychic what was going on there or what her feng shui friend said—she wanted the psychic to be entirely unbiased with no preconceptions. The moment the psychic stepped foot inside the front door of the Red Geranium, she too stopped dead in her tracks, just like the feng shui friend had. Then, without a word, the psychic brushed past Kelly and led her down the basement stairs. She marched directly to the kitchen area, pointed at the stove, and firmly declared, "A man committed suicide here. And I can tell that in the last moments of his life, he changed his mind. He realized what a stupid idea this was, and he tried to stop it, he wanted to live! But he was too late. His body was dead but his dark, despairing spirit was . . . and still is . . . fighting to live. And now he is trapped, grounded here in this house, unable to move on."

Kelly was greatly upset, but she refused to give up on her dream—her lovely Red Geranium gift shop and art gallery was showing success at last after so much hard work. So she contacted Kevin Frantz of the now-defunct Naperville Ghost Society and invited his team in to conduct a paranormal investigation of the Red Geranium. If they did not find anything with their scientific methods, then perhaps everything would be alright with the house.

Frantz was armed with a special video camcorder that uses infrared light and a "stop-down" or slow shutter. For this camera to be effective, the environment must be completely sealed off from any light. The camera emits an invisible infrared light that bounces off any object or energy it strikes and "paints" a picture of it on the viewfinder, which is then recorded on film. Watching the viewfinder also allows the investigator to see clearly in the pitch dark. Working on the theory that ghosts are a form of electrical-magnetic energy, paranormal investigators often use infrared videography in hopes of capturing the holy grail of ghost hunting—a full, whole-bodied apparition caught on film. For the infrared camcorder to work best the house had to be sealed off from any light. The team covered up the windows completely so streetlights and headlights could not shine in, and they started their investigation at 1:00 a.m. on a dark, moonless night.

They walked in the front door in a single file, Frantz in the lead with his video camera, Kelly third in line. They shuffled through the first room and into the hall in absolute darkness, relying on the camera's infrared vision to guide them.

This is the former Red Geranium gift shop. (Author's collection.)

As an accomplished artist, Kelly Tiberi saw the crisp white stucco walls as canvases that begged for murals. (Author's collection.)

The basement window above the kitchen stove was mysteriously broken from inside the locked house. (Author's collection.)

Less than 30 seconds into the investigation, Frantz called back, "Uh, Kelly? Is there anyone else in the house with us?" Kelly called out that her husband was on a business trip and no one else was there that night but for the team. "Why do you ask?" she said.

Frantz's excited voice came out of the heavy darkness. "Because there's a shadow of a tall man coming up the basement stairs right in front of me . . . and he's about to come into the room!"

Just as the words left his lips, the shadowy figure reached the top of the stairs and suddenly transformed into a bright orb of light. It zipped around the door, zipped back as if taking a second look at them, zipped around the corner again and darted up the stairs. A mere half hour later they captured that same orb of light in one of the upstairs rooms as it came out of a closet, zipped back into the closet, then out again, and swept by the entire line of ghost hunters, vanishing down the hallway.

One week after Kelly and Joe Tiberi saw the videotape, the Red Geranium was up for sale. They made a quick sale and moved out as fast as possible. The last proof they needed that they had made the right decision was their white Persian cat. As soon as they moved into their new house its personality changed back from being fearful and upset to the sweet, good-natured, and well-behaved pet they once knew.

Shortly after the move, Kelly got a call from the Naperville Police Department. While driving by the empty shop the night before, they noticed that a basement window had been broken. Obviously someone had tried to break in, and would she drive there to check the house out with them? Kelly did, and sure enough, the southeast basement window along the driveway was shattered. But Kelly noticed something strange—the broken glass was not inside the house, as it would be if someone had tried to break in. Instead the glass was lying outside the window, broken from the inside with such explosive force that glass was scattered clear across the driveway and well up into the next door parking lot, a distance of four or five yards. Someone, or something, had wanted out. But the house was still locked up securely with no sign of forced entry; how did the trespasser get inside in the first place? Stranger yet was that this window was right above where the stove in the basement kitchen used to be—the same spot that the psychic had claimed a man had committed suicide.

The psychic was partially correct. In 1984, a man did indeed take his own life in the basement of that house. I have withheld his name at the family's request, but his daughter wants the facts to be told. As a Vietnam vet he suffered severely from post traumatic stress disorder (PTSD), but in his day, it was an unknown condition that ravaged returning soldiers. Even harder for him was the knowledge that soon after he returned home to Naperville his entire platoon had been killed in action. PTSD and survivor's guilt were a horrific combination to bear, but amazingly he endured it for eight long years. His first, beloved wife had to leave him because of it. His second wife left him for another man, and he was living alone in the house when this gentle, big-hearted man at last gave in to his blackest, darkest despair. On the evening of October 15, 1984, he closed himself in the storage closet under the basement stairs, detached the gas dryer's exhaust tube, placed a bag over his head, and quietly died of carbon monoxide poisoning. The house did reek of gas, but, true to his nature, he carefully planned it so as not to endanger the lives of others by risking a spark from the stove. Interestingly, he was known to not like cats.

Kelly believes the ghost is trapped in the house, and had tried unsuccessfully to break out the window and follow her after they moved. However, his daughter believes he has chosen to stay because he had not finished renovating the upstairs and because he had promised her he would always be with her in spirit. Whatever the reason, a number of psychics have sensed his presence, and his shadow has been seen and photographed standing at the windows—watching.

Please note: Although the house has stood empty for years, the developer who owns it strictly forbids trespassing on the property and the curious will be prosecuted. The property has been rezoned as commercial and the Red Geranium will be torn down someday soon.

THE JANE SINDT HOUSE

Jackson Avenue comes to a dead end at the far west end of the Riverwalk. There, nestled amid a forest so thick that one feels a tranquil sense of wilderness solitude in the busy, bustling heart of downtown Naperville, lies the former home of the Sindt family. The last to live there was Jane Sindt, the regal grande dame of Naperville High Society and culture until her peaceful death in that house on Christmas Eve 1995. Jane loved her idyllic garden home and forest haven with all her heart. She often told her friends that it was her own little piece of heaven on earth and that she was never, never leaving it—"Even after my death," she said. By the myriad inexplicable encounters and the sudden goose bumps people get just from walking into the house, it seems Jane kept her promise—she is still the caretaker of her own little piece of heaven on earth.

The charming ranch-style home may have originally been the site of a slaughterhouse in the 1890s, with a large icehouse conveniently close at hand. The Sindt family purchased the property in the late 1950s, and in 1996, it was donated to the Naperville Park District and DuPage Forest Preserve by the terms of Jane's last will and testament for use as a park office.

On Memorial Day 1996, a park district employee had come into the house after the parade to catch up on some work; but the computer was acting strangely. The cursor kept moving of its own accord to float over one particular file, marked "Birthday Sign"—though no hand was on the mouse. After struggling to move the cursor to the tulip sale file that the employee wanted to open, she clicked on it and was startled to see the Birthday Sign document open instead. The employee closed the document and tried again, and again, but no matter what file she pointed the cursor at, the Birthday Sign document was the only one to open. Feeling the tiny hairs prickling up on the back of her neck, she called out, "Jane, is that you? Is it your birthday?" On a hunch, the employee printed up the Birthday Sign document, after which the computer worked just fine. It was not Jane Sindt's birthday, but the employee figured that she just wanted to be remembered on Memorial Day.

Earlier that year the house had been refurbished to accommodate its new function, so now the main office took up what was formerly Jane's bedroom—the room she died in. One steamy hot summer day, an employee was sitting at the desk doing some paperwork when he felt a strangely cold breeze drift from the left to the right, just as if someone had passed by behind the desk chair, though he was alone in the house. But the worker noticed something even odder than that. The air-conditioner in that room always moved the air currents from right to left. What caused the air to reverse its usual flow? On impulse he called out, "Jane, how do you like what we've done to the place?" He was not too surprised that the cold breeze swept past again, from left to right, as if in approval of the new decor. It was not until later the employee remembered that on her deathbed, Jane had asked for all the doors to be opened, "So my last breath will be fresh air." Only when the doors were open did the breeze sometimes flow from left to right. But on this hot summer afternoon, the doors were closed.

THE RECTORY'S WOMAN IN BLUE

I received a telephone call one day from a woman who was very upset. She explained that every day she drove by the rectory for St. John's Episcopal Church on the triangle between Aurora Avenue, West Avenue, and Oswego Road, across from Central High School. And nearly every day she claimed to see the ghost of a "not young," sad woman in a blue dress and headscarf, either sitting on the door stoop, walking the lawn, or standing on the widow's walk balcony that, until recently, was on the east side of the splendid brick mansion. On the very day she called me, she had driven past the house again and saw the ghost as usual, sitting on the door stoop. Suddenly the ghost looked up and made eye contact with her, then leapt to her feet with an expression of such intense hope and desperation that it frightened the woman into stepping on the gas and getting out of there quickly. As a devout Catholic, she believes that ghosts are evil, and she

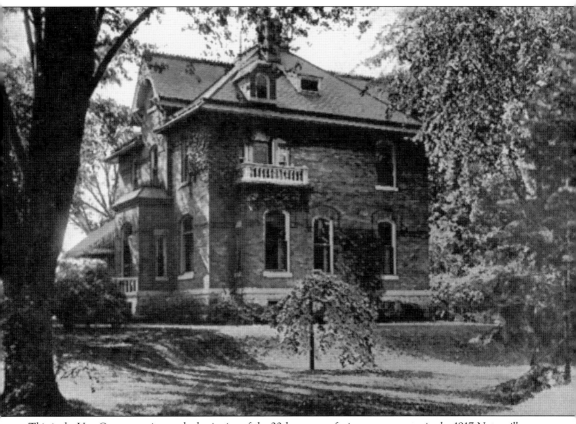

This is the Von Oven mansion at the beginning of the 20th century, facing west, as seen in the 1917 Naperville Homecoming souvenir booklet. (Author's collection.)

wanted to know if anyone else had ever seen a ghost there—and if not, was she being targeted by demons or just going crazy?

I assured her it was neither. The wife of a former minister at St. John's had often regaled her friends with great stories about their rectory ghost: a gentle, innocent soul somehow trapped between worlds and trying to get someone—anyone—to pay attention. The minister's wife was unable to help her move on before they transferred to Florida.

Perhaps this forlorn spirit is that of Helene Von Oven, who passed away suddenly in 1931, just two years after her brother Frederick. In addition to a partnership with George Martin II in the Naperville Tile and Brick Works, the Von Oven family also owned the successful Naperville Nurseries. Started by their father, Ernst Von Oven, in 1866, their beloved family-hobby-turned-business-venture thrived until Helene's sister and the last surviving family member, Emma Von Oven, closed it in 1954. Nearly 10 years later, Emma generously donated the former site of the tile and brick yard along West Avenue to the Boy Scouts of America, who christened it the Von Oven Boy Scout Reservation. The nursery retail shop was located on the very point of the triangle between Oswego Road and Aurora Avenue, where St. John's Episcopal Church now stands, although the business offices were in the mansion itself.

Helene was passionate about her flowers, especially perennials, and enjoyed a well-deserved national acclaim in the field. So why does she still haunt her old home? Perhaps she is wondering where all her flowers have gone—the flowers she may have loved more than life itself.

A HAUNTING ON EDGEWATER DRIVE

The first time he saw the ghost, "Joe" was working at the computer in his downstairs office. Two years ago he and his wife, "Mary," had purchased this sprawling, trilevel home built in 1964 on Edgewater Drive, with its postcard-perfect view of the DuPage River and reassuring proximity to Edward Hospital—a factor that was increasing in importance as they approached retirement age.

A sudden movement out of the corner of his right eye snagged Joe's attention from his work—a smooth, gliding motion and an instant's glimpse of a dark gray shape. Startled, he snapped around to look at it fully—but nothing was there. He rubbed his eyes, figuring that he must have been staring at the computer screen too long. But since the project was due he went back to work, promising to rest his eyes when he was done. Soon he was once again absorbed in his work, but another smoothly gliding shadow in the corner of his eye interrupted his concentration. Once again he turned to look, and once again there was nothing there. But this time as he turned back to the keyboard, he had the oddest sensation that someone was standing just over his right shoulder, watching everything he typed on the screen—as if genuinely curious as to what he was doing. This went on for half and hour until, exasperated and a little weirded out, Joe gave up, powered off the computer, and went upstairs for a bit of lunch and to rest his eyes.

Over the following days Joe would glimpse that grey shadow in his office several times a day. He never once felt threatened in any way, and soon he grew rather accustomed to his "friend" who dropped by now and then to check in on what he was doing. He did not mention anything to his wife, Mary. If he had, he would have been very surprised to hear that she was having her own encounters with the elusive shadow!

Mary was putting some towels away in the upstairs linen closet when she first noticed a slender, dark gray shadow darting up the stairs and into the second-floor bathroom. It was such a brief glimpse out of the corner of her eye that at first she assumed it was just a trick of the light. But she soon saw it again, and again over the next few months, sometimes coming out of the bathroom or the bedroom or on the stairs. It always dashed by so fast she could not get a good look at it, but now and then she turned quickly enough to spot what appeared to be a corner of a gray dress or cape fluttering by before vanishing. That tied in to Mary's strangely sure notion

that it was a female presence, and an adult, perhaps from the 1800s; and since Mary did not sense anything wrong or dangerous about it, she did not mention it to Joe. But eventually the shadowy specter made her presence most definitely known.

One evening during the winter of 2004, Joe was in the downstairs computer room and Mary was in the kitchen—no other living soul was in the house. Suddenly they both heard a loud bump coming from the living room on the first floor. Mary got there a moment before Joe and was bewildered to see one of their formal dining room chairs upside down in the middle of the living room—10 feet away from its usual place at the dining room table! After determining that neither of them had been anywhere near it, they searched the house for intruders but found no one. That is when they told each other about the unexplainable things they had experienced, and they came to a tentative conclusion—they had a ghost.

It was absurd, of course. Both Joe and Mary had advanced degrees and were greatly respected in their fields at the university. So what possible explanation could there be for what they had both seen and experienced?

I checked in with Joe and Mary just a few weeks ago, and as of this writing, their "friend" (as they call it) still lives with them in their home on Edgewater Drive. Joe frequently sees and senses her standing over his shoulder whenever he is at the computer, inquisitively watching what he is doing; and Mary will spy a gray blur dashing by on the second floor at least once a month. There are no cold or hot spots, and the poltergeist activity stopped after that single incident with the dining room chair. It is a fairly commonplace and benign haunting, but it does have one interesting twist—Joe only sees their shadow friend downstairs and never on the second floor, while Mary only sees her on the second floor and never in the downstairs office!

THE HAUNTED MANSION

Just up Aurora Avenue to the west of the Martin family's Pine Craig and the Von Oven mansion is the Manor at Willoway. Built in 1847 for Dr. James Lilly, the splendid, white-columned Georgian-style mansion was the showpiece of the area, the Willoway farm famed for its racehorses and the racetrack across the street. Countless parties were held there, and it often played host to the governor of Illinois and other celebrities of the mid- to late 1800s.

Oddly enough, the Manor at Willoway changed hands many times, from one prominent Naperville family name to another—Wright, Phillip, Lilly, Goodwin (who renamed the mansion Oakhurst), Callender, and the Polivka family, who renamed it Wil-O-Way Manor. It is unusual for such a beautiful, venerable mansion to not be a treasured family homestead, passed down from generation to generation. On the other hand, a parade of owners is a very common characteristic of a haunted house. In 1960, the estate was converted into the Willoway Manor Restaurant, but even then, ownership of Naperville's first formal fine dining restaurant changed hands four times up to the present day. In 1990, the manor was reopened as Mesón Sabika, a nationally recognized Spanish tapas restaurant. But numerous eyewitnesses—myself among them—believe that two former residents of the Manor at Willoway have never left their beautiful home.

The Lady in Blue

Legends say this active ghost used to be the lady of the house, though from which family is unknown. When her baby died unexpectedly in a crib death, the wildly grieving mother committed suicide—either by hanging herself by the central light fixture in the nursery (now the Marbella Room) or by tying a rope from her neck to the central balcony and then leaping off the second floor and coming to a short, sudden stop directly before the front door.

The Lady in Blue may have been my very first ghost. In 1971, when I was 10 years old, Willoway Manor was one of only a handful of fine-dining restaurants in Naperville at the time. I remember going upstairs to the lady's restroom. While primping in the antique, full-length mirror in the

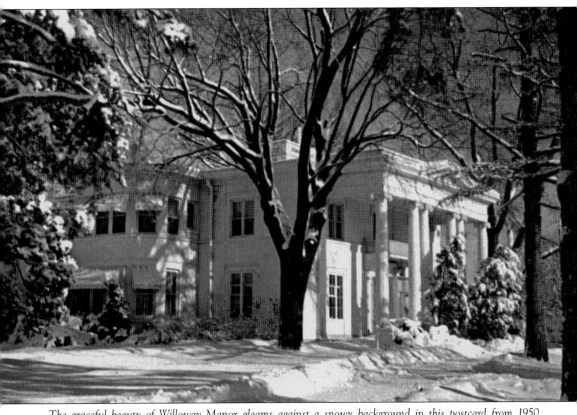

The graceful beauty of Willoway Manor gleams against a snowy background in this postcard from 1950. (Author's collection.)

ladies' restroom antechamber (now the Marbella Room), I saw a woman pass behind me wearing a flowing, floor-length, navy blue skirt. Since I was such a short child even among other girls my age, I only saw her from the waist down. Long maxi skirts were all the rage at the time, so I did not think anything of it—until I realized that I had not heard the wood door to the toilets swing open with its loud, unmistakable "whup-whup-whup" noise. I suddenly grew scared, wondering why this strange woman was hiding in the corner, just out of my line of sight from the mirror! I spun around—but I was alone in the room. I pushed open the swinging door into the toilet room for a peek—no one was there either. Puzzled, and wondering if I were going nuts, I walked from the ladies room and rejoined my family downstairs at our table. I was quiet the rest of the dinner, baffled and bemused by what I saw. I hate an unsolved mystery.

That curious incident niggled at my mind for years but remained unanswered until I attended an opening night party for the Summer Place Theater 1990 season held at Mesón Sabika. I was walking up the sweep of immaculately tended lawn toward the front door with friend and fellow Summer Place board member Sheri Davis, when she casually mentioned, "Did you know this building is supposed to be haunted by a lady in a gray dress?"

I stopped in my tracks so abruptly I almost fell over. Sheri stopped several paces ahead and looked back to see what must have been a most peculiar expression on my face. In a slow, stunned voice I said, "It's more blue than gray."

Turns out I'm not the only person to have had an encounter with the Lady in Blue—far from it. Numerous people have confessed to having uncanny experiences there, including the sense that someone was walking beside them in the second-floor hallway or a presence was trying to pass by them on the stairs. The sensation would be so strong they would actually stand aside to let the invisible lady go by!

One former waiter recounted one memorable evening that he was in a second-floor dining room, folding napkins to get ready for the next day. He was chatting casually with a coworker standing further down the room, whom he could see out of the corner of his eye as a dark blue figure, occasionally nodding and shifting from foot to foot. But when the waiter looked up from his task the coworker was not in sight. Not only was he alone in the room, he had been the only person on the entire second floor for the past 30 minutes!

An incident occurred in October 2006 during my Trolley of Terror ghost tour. At the "haunted mansion" stop we typically allowed the tour guests to step out to stretch their legs, photograph the gorgeously romantic gardens and Tara-like mansion, and take a bathroom break if necessary (with the gracious approval of the Mesón Sabika management, of course). But this night, one woman did not come back to the trolley for 20 minutes. Her husband and I both got off the trolley to search for her but had no luck. I was getting nervous since the trolley charged by the hour, so I was relieved to see her running down the sidewalk, waving her arm to get our attention. She stepped into the trolley breathless and excited and reported that she had been trapped in the upstairs bathroom, adjacent to the Marbella Room! She claimed the doorknob would not budge, as if someone had been holding it on the other side. Odder still, although she pounded on the door and called for help, no one seemed to be able to hear her! After 20 minutes the doorknob suddenly turned in her hand and the door swung open easily. Rather than being frightened, the woman was absolutely delighted with her adventure, announcing to the rest of the tour group, "I sure got my money's worth on this ghost tour!"

Not everyone who has an encounter with the mansion's Lady in Blue is as happy to see her. We do not know what one former manager witnessed late one night as he was working alone at the mansion. We do know that he ran screaming out of the mansion, ran to his car, peeled out of the parking lot, and the next day called his boss and quit his job.

In the summer of 2005, a busser encountered the Lady in Blue in the kitchen area of the second floor as he went about his nightly duties after closing time. She simply appeared in the room and

walked right by him, not even seeming to notice him. The busser was utterly terrified and ran downstairs to where his coworkers were closing up. "His face was ghastly white!" reported one witness. The poor man was so panic-stricken that before he could even utter a word, he vomited on the headwaiter's shoes. He stayed on the job for several more months but flatly refused to work at night. Eventually he chose to quit.

Happily, the current management of Mesón Sabika is quite comfortable having a resident haunt. Certainly in life she would have been quite the perfect hostess, enjoying a sterling reputation of holding the most popular social events of the town. What restaurant owner would not like having such a gracious, elegant hostess to ensure that every gala celebration held at the former Willoway Mansion is still a smashing success to cherish forever? The latest report is that the Lady in Blue has settled down considerably now that the construction of their grand new reception hall has been completed.

The Little Girl in Red, or Green, or White

Mesón Sabika is supposedly home to yet another ghost—that of a little girl, about 10 years old, running up and down the halls with gleeful energy, having a wonderful time. People have even stepped aside to make way for her in the first-floor corridor near the restrooms, sensing that a child was charging up on them, but no one is there. She has been seen and sensed all over the mansion, even in the areas of the building constructed since the 1960s after it became a restaurant.

No one knows who this charming little girl may be, but if sightings of her are to be believed, she changes her clothes regularly! She has been seen wearing a red, a green, and a white dress.

An employee who worked at Mesón Sabika for years had always scoffed to hear the stories of the ghost told by his coworkers. But in the summer of 2006 he actually saw the little girl ghost with his own disbelieving eyes. She was standing at the bottom of the back stairs that lead down from the second-floor kitchen to the employee door. It was very late at night, and only a couple of workers were still left in the building. The back door was locked, so there was no way a little girl could have wandered in. The little girl ghost looked up the stairs at him and simply vanished right before his shocked eyes. Ever since that astonishing experience he openly admits, "Now I believe in ghosts!"

Smashed Bananas
The Legend of the House at 105 Ellsworth Street

Long ago, a man and a woman lived and loved in the redbrick house at 105 Ellsworth Street for many years. Then the wife fell sick and, within a short period of time, died. The man was devastated. They had the funeral and buried her over at Naperville Cemetery, then, after the last memory was shared, the last hugs given by well-wishers, the man found himself back at his house, sitting alone at the kitchen table across from where he had shared so many meals with his wife.

And it was at that moment, they say, his mind snapped.

She had died from the disease, of that he had no doubt. But it occurred to him that the reason why his wife was *still* dead was that she had not had anything to eat for days! Ever since she died in their home she had either been in the morgue, or in the church, then the coffin—good heavens, she had not had anything to eat for days! That was why she was still dead, of course! If he could just get some food down her, why, she would come back to life again, she would be just fine! So at midnight, he got out his wheelbarrow, his lantern, and a shovel; went to the cemetery; and dug up the grave where they had buried her just that morning. He pried open the coffin, carefully gathered her body in his arms, and gently laid her into the wheelbarrow. Then he wheeled her home through the dark, quiet streets, brought her into the house, and sat her at her usual place at the kitchen table.

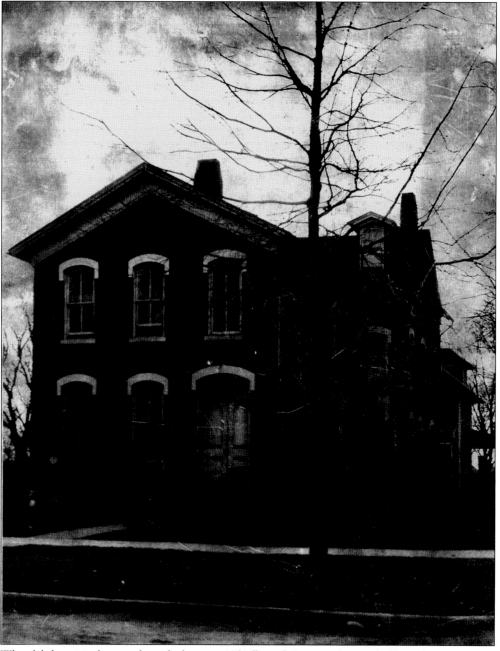

What did the original owner do in the house at 105 Ellsworth Street in the name of love? (Courtesy of the Naperville Sun and Fox Valley Publications.)

Then he wondered, what would a corpse want to eat? His eyes fell on a fruit basket with a bunch of ripe, sweet bananas that a neighbor had bought for the widower. Perfect! He took one of those bananas, peeled it, put it on a plate, and smashed it with a fork. When he had it all nicely smooth and slippery, he spooned it into his dead wife's gaping mouth, perhaps even tipping the chair back and giving it a little shake so it would slide down easily. He fed her an entire banana that way. Then the man cleaned her up after the meal and thought he saw a bit of pink coming back into her cheeks. It had been quite an exciting day for both of them, so he decided they should retire for the night.

He tenderly gathered his wife into his arms again and carried her up the stairs to their bedroom, just as he did many years ago when he was the groom and she was his bride. But she was no longer a slender, blushing bride, and he was no longer a strong, brawny groom, so he had some trouble getting her up the stairs, bumping against the banister, bumping against the wall, his footsteps thumping so heavily on the stairs. But he finally made it up the stairs and into their bedroom. He laid her down on her usual side of the bed. Then he curled up behind her, wrapped his arms around her, spooning her, trying to warm her cold, dead flesh with his own warm, living body.

Imagine the look of surprise on the faces of their grown children when they stopped by the house the next morning to check on dear old dad and saw dear old mom! With dad feeding her a piece of smashed banana, tipping the chair back and giving it a little shake, absolutely convinced that she was showing signs of life.

Needless to say, mom ended up back in the grave where she belonged; and dad ended up in a very special institution on the East Coast with nice padded walls where he belonged. But it has been said that anyone who has ever lived in that house on 105 Ellsworth Street since that bizarre event has been awakened deep in the dead of night by the sound of footsteps on the stairs; thumping footsteps, stumbling against the banister, bumping along the wall, almost as if someone were carrying something very heavy—yet very precious—in his arms. Perhaps a loving husband still yearning to bring his wife back from the dead?

Now, the *True* Story of the House at 105 Ellsworth Street

The beautiful, gabled house was built in 1870 by William Hillegas as a wedding present for his son Charles and daughter-in-law Sarah. William owned the hardware store in downtown Naperville, which is now Features Bar and Grill. Charles and Sarah had two sons and a daughter, and by all accounts they were a happy, well-to-do family. On December 18, 1898, Sarah Hillegas died after a short, sudden illness. Charles was devastated. And it was then that his mind snapped—and where the legend slightly deviates from the truth.

Charles was thought to be an amateur chemist. He loved mixing chemicals in the hope of creating formulas to benefit mankind. After Sarah's death, he vowed to create a formula that would bring his wife back from the dead. Every time he had a formula he felt hopeful about, he would bonk a chicken on the head, feed it some smashed banana on which he dribbled the formula (no doubt tipping the chicken back and giving it a little shake to slide it down); and then he would wait. When the chicken did not come back to life, he had Sunday supper.

But on one extraordinary day, Charles had a formula that he felt really good about. So he caught a chicken in the backyard, bonked it on the head, fed it some smashed banana on which he dribbled the formula (tipping the chicken back and giving it a little shake), and he waited. One minute later, that chicken jumped back on its feet, ruffled its feathers, and started pecking corn! Eureka! Charles Hillegas had found the secret of life! He could bring his wife Sarah back from the dead!

So, he got out his wheelbarrow, his lantern, and a shovel, went to the cemetery, and dug up his wife whom they had buried *18 years before*. He put (what was left of) her in his wheelbarrow

and brought her home to their house on Ellsworth Street and started feeding her the life-giving formula, dribbled on spoonfuls of smashed bananas.

Unlike the legend, no one discovered her the next day. It took over two weeks before somebody noticed that Charles had the long-dead corpse of his wife, Sarah, in the house. Sarah did indeed end up back in the grave where she belonged, and Charles, too, ended up in that very special institution on the East Coast with nice padded walls where he belonged. The house stood empty for several years until Prof. Harold E. White, owner of the *Naperville Sun* newspaper, bought it in 1920 at a public auction held in the street. Years later, Charles Hillegas was released and came home. The 1900 census lists him as being employed at the Naperville Lounge Factory, though he may have also worked as the local milkman. One thing is for sure—all the children in the town loved to tell his strange story around the campfire late at night.

Today the wonderful family who lives at 105 Ellsworth Street, though delighted to have learned of the quirky history of their house, has not heard any strange footsteps on the stairs in the night—no, they have not experienced anything paranormal at all.

Well, except that one time.

Soon after they had first moved in, they were awakened in the deepest part of the night by their state-of-the-art stereo system down in the living room, which inexplicably started playing at high volume, all by itself—a love song.

And that is the *true* story of the smashed bananas.

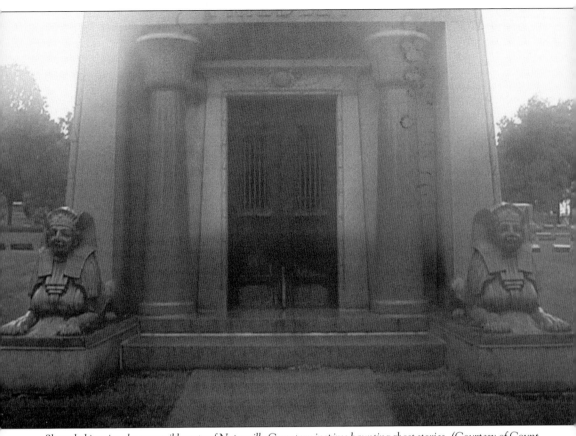

Shrouded in mist, the tranquil beauty of Naperville Cemetery inspires haunting ghost stories. (Courtesy of Count Midnight Monster Party, copyright 2008 Monster Party Productions, Inc.)

Three

HAUNTED CEMETERIES
WHERE THE DEAD SLEEP

Hi Diane; A very strange thing happened today with our interview footage. The beginning
of our interview, up until we got through the ghost stories, did not turn out. The tape was recording,
but it did not produce an image. Then all of a sudden your image started to fade in, and the rest of
the interview was present up until the point we walked over to Otto's headstone.
I would like to think that this was a supernatural occurrence, but something tells me
that it was a technical difficulty, like a dirty record head in the camera,
although myself, nor anyone else at NCTV has ever seen anything like it before.
—E-mail received from a reporter for the local cable access channel NCTV-17 just hours after
being interviewed in Naperville Cemetery for a Halloween program, October 2007.

During the day, cemeteries are peaceful sanctuaries blessed with a gentle quietude and the tranquility of nature. The simple beauty of warm sunlight, beautiful landscaping, and the singing of birds eases the sorrow that clings to every gravestone with the memory of a lost loved one, a life brimming with zest ended. In times past, entire families would picnic in the cemeteries alongside the graves of their dearly departed, honoring their memory as well as sharing precious family time together. We rightfully regard burial ground to be as sacred as the sanctuary of a church, so vandalism in cemeteries is harshly punished. This often surprises teenagers especially, who fail to understand that pushing over a 150-year-old gravestone and breaking it is a very serious crime. On June 3, 2006, a 19-year-old man in Richmond, Illinois, was sentenced to four years in prison and fined $37,460 for damaging cemetery headstones, some of which predated the Civil War. The reverence for which we hold our final resting places is undeniable—so desecrating them is unforgivable.

So why, when dusk falls, do we feel a deep, instinctive dread of these peaceful dwellings of the dead? Our fears of the restless dead and the dark are ancient and universal, stirring something deep within our elusive primordial memories that instinctively tells us to bury the dead deep, fix them to the earth with stones, then surround them with walls—not to keep the living out, but to keep the spirits of the dead within when night falls.

In cultures the world over, the most frightening ghost stories are set in graveyards. But this begs the question as to why would some ghosts choose to haunt the cemetery where their decaying body lay instead of the place where they met their death or places they loved best when alive? Perhaps these ghosts are also following society's traditions, lingering near their final resting place to mourn at their own tomb. Or, more gruesome yet, perhaps they are indeed haunting the place where they met a horrific death. Being buried alive was not uncommon in the days before modern medicine.

Even the beautifully landscaped, well-tended cemeteries in Naperville have inspired their fair share of spooky stories and strange, inexplicable encounters that leave the witnesses white-faced and bewildered. Let us now explore a few of these mysterious occurrences that have been reported at a few of Naperville's subdivisions of the dead.

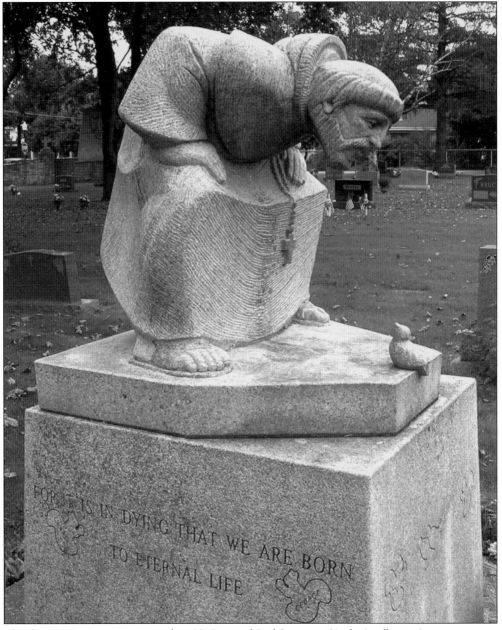

This charming St. Francis statue stands in SS. Peter and Paul Cemetery. (Author's collection.)

These views of SS. Peter and Paul Cemetery are from the 1917 Naperville Homecoming souvenir booklet. (Author's collection.)

SS. Peter and Paul Cemetery

The beauty and grace of SS. Peter and Paul Cemetery at the corner of Columbia Street and North Avenue is enough to make me wish I were Catholic. Who can resist the cheerful whimsy of the statue of St. Francis squatting down to say hello to a cute baby bird? Or the heavenly compassion on the face of the angel statue whose back can be seen along the Columbia Bridge arching over the Burlington Northern railroad tracks? Graceful deer graze within the peace of this cemetery at night. And once a year the paths are lined with hundreds of luminarias set up by dedicated church volunteers, the tiny flames inside the sand-weighted paper bags inviting people to come in after dark to honor the dead.

But ever since the early 1980s, Naperville teenagers would flock to this serene cemetery in hopes of seeing a supernatural phenomenon—the burning tombstone. So frequently did this eerie spectacle manifest that the cemetery gained quite a following of avid amateur ghost hunters and thrill seekers from around DuPage County.

The teenagers say that you must drive along North Avenue toward the quiet, dark back side of the cemetery. If you are lucky, you will glimpse one particular tombstone among many on the hill suddenly flare up in a fiery bonfire of light for several moments, then extinguish itself as abruptly as it began. The legend goes on to say that the burning gravestone was the final resting place of a Naperville man who died horribly in a fire and that his terrible death had been no accident. It was believed that the vengeful ghost caused his tombstone to burst into flame, demanding justice from beyond the grave.

In the spring of 1983, famed Chicago ghost hunter Richard Crowe heard of this intriguing glowing tombstone and took an impromptu group of ghost hunters out to Naperville late at night to investigate the phenomenon for themselves. He reported their experience in his book *Chicago's Street Guide to the Supernatural.*

It was 2:00 a.m., and Richard and his ghost hunters drove slowly down North Avenue. Suddenly they all saw a brilliant flash of orange light flaring up from one particular tombstone. They drove past three times, and each time the spectral flames burst from the stone for a few moments, then vanished.

Excited now, the investigators parked the car and walked eagerly toward the tombstone, cameras, recorders, and notepads at the ready. They were sure they were really onto something truly paranormal! To their fascinated delight, the gravestone was glowing steadily now in a strange orange aura, not going out as it had when they had driven past. They approached it, and suddenly the light vanished. A few steps closer and the enigmatic light flared up again. That was when Dr. Robert Ritholz, an avid ghost hunter and good friend of Richard Crowe, made a shrewd observation.

He noticed that the tombstone would go dark when someone stood directly between the stone and the street lamp partway down the road. Furthermore, the stone's glossy marble angles were perfectly positioned to reflect the light as brilliantly as a mirror, casting the distinctive orange hue of the vapor streetlight over the stone like a glowing flame. When driving by it would appear to flare up in a blaze of burning light that would just as suddenly extinguish itself as the car passed through that particular refracted light angle. Coincidentally, the glowing tombstone legend began about four years prior to their investigation—the same time the new orange vapor streetlights had been installed.

There are, no doubt, many former teenagers who will be disappointed by the bursting of this colorful Naperville legend. But the glowing tombstone is still a deliciously eerie spectacle to witness on some dark, moonless night while telling the vengeful ghost legend in hushed whispers. I invite you to give it try for yourself.

As Richard Crowe winds up his personal tale of the glowing tombstone, he writes, "Although I take pride in occasionally solving a colorful mystery, there are always more enigmas out there.

For every such report that I can find a logical answer to, there are many more still unsolved and perhaps unsolvable."

Such is the case with another haunted cemetery, just across town.

NAPERVILLE CEMETERY

Hide-and-Go-Seek Lights

Perhaps Richard Crowe's rational explanation for the glowing tombstone at SS. Peter and Paul is also sufficient to explain the mysterious dancing lights that have been reported for decades at Naperville Cemetery. Located at Hillside Road and Washington Street one block north of Edward Hospital, the original two acres of land were donated to the town for a cemetery in 1842 by George Martin II. But it was not until 1847 that the last of the graves at the first Naperville cemetery, on the northeast corner of Benton and Washington Streets—now considered the heart of downtown—were moved to their new eternal home. Some of these gravestones date back to the 1830s.

Numerous witnesses have claimed to see sparkling orbs of red, blue, yellow, and green light moving among the graves late at night, which some folk say are the cemetery's youngest residents playing hide-and-seek. There are certainly a large number of children buried in Naperville Cemetery—the mortality rate for children in the 1800s and early 1900s was distressingly high—so it is rather comforting to think of these young ghosts laughing, having fun, and playing games together in the afterlife. Guests on the Historic Ghost Tours of Naperville recently spotted the hide-and-seek lights during a special sanctioned cemetery visit on October 30, 2005, which made for an unforgettable Halloween for us all. Of course, the scientific, rational explanation for these dancing lights is the headlights of cars driving by reflecting off glossy marble tombstones—but personally, I prefer to imagine laughing ghost children chasing each other in a timeless, joyful game.

The Ghost of Mary Poppins

There are other mysterious events that have occurred in this old cemetery, however, that defy any rational explanation. Take, for example, the inexplicable encounter that Jim Shoger, a fourth-generation Napervillian, had early on a Saturday morning in July 2003. Jim Shoger's account is told in his own words, with only minor edits by the author.

I awoke around 4:30 a.m. realizing that I didn't water the flowers I planted on my grandparents' grave, so I had a cup of coffee and loaded up my buckets, and headed for the cemetery. I entered the cemetery off of Washington Street just as the sun was coming up, and stopped to fill my buckets at the main office. Buckets filled, I headed west up the drive saying to myself how cool it was to be the only one in the cemetery, and what a peaceful, warm, quiet morning it was with the sun streaming through the trees. As I arrived at my grandparents' graves I saw no one, and didn't expect to see anyone that early in the morning. I could easily see through the cemetery that I was really alone. Their graves are toward the back, just south of the drive that parallels Hillside Road. I was unloading two of my five-gallon buckets, and as I was walking to the grave I saw something move out of the corner of my eye.

I looked up and saw this middle aged lady dressed like Mary Poppins, wearing a long skirt or dress, a sweater, a small hat, carrying what looked like an old carpet bag, walking past my truck. It startled me, and my first reaction was just to say, "Good morning." She replied, "Good morning" in return. I continued to the graves, which were only a few feet away, and said to myself, "Who was that?" and "Where did she come from?" I set down the buckets and looked up to find her again, but she was gone! Vanished! In a matter of seconds! I immediately ran down [toward where she was walking] to the crest of the hill where you could see all the

Mysterious dancing lights, such as the unexplained red flash at the top of this photograph, have often been seen in Naperville Cemetery. Below is a close-up view of the moving red light. (Courtesy of Debra [last name withheld by request].)

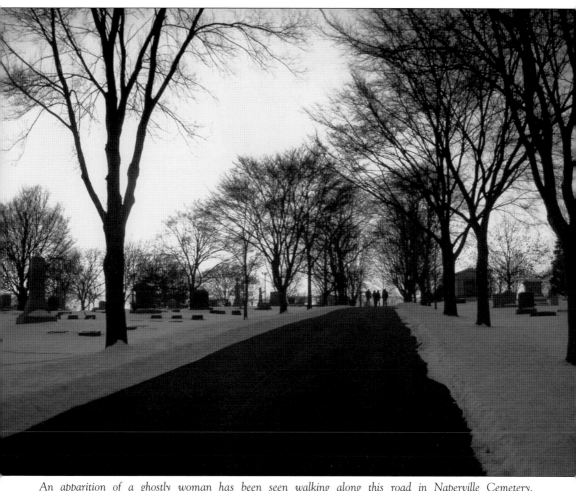

An apparition of a ghostly woman has been seen walking along this road in Naperville Cemetery. (Author's collection.)

way east down the drive to Washington Street, and looked around in all directions. She was really gone! At this point I had major goose bumps and was quite dumbfounded as to what just happened. Did I see a ghost? And did she really speak to me? As I walked back to the graves from the crest of the hill I timed my walk at 25 seconds. There is no possible way she could have made it to the crest of the hill or anywhere else in the cemetery where I couldn't see her in that space and time. To this day I truly feel it was a ghost or an angel I saw that morning. It's interesting to note that the cemetery has a fence around it, and as I stated previously when I arrived at the graves, I could see all around that I was alone . . . or was I?

Naperville Cemetery workers corroborated Jim Shoger's startling encounter with several reports of a strange mist that moves steadily along that inclined road even though there is no wind. Interestingly, this Mary Poppins apparition is reportedly seen only in the months of July, August, and September. We can only speculate as to why.

Barefoot in the Snow

Mary Poppins is not the only ghostly lady who has been sighted in Naperville Cemetery. Joyce Minogue, a Naperville business owner and resident for 25 years, tells of a bewildering encounter that occurred in the winter of 1995 or 1996. She had been working very late at her hair salon that Friday night and did not lock up until well after 10:00 p.m. Joyce states, "It was very cold outside and there was a trace of snow on the ground. I left the Naperville Salon suites and drove my car south on Washington, coming to Hillside in the right hand lane. It was late, and there was very little traffic on Washington. As I drove past the cemetery I noticed an old woman dressed in white." Joyce describes the outfit as loose and flowing down to the middle of her calves, with mid-length sleeves and a high neck. It was not exactly a hospital gown, more like a housecoat. But what shocked Joyce even more than an old woman wearing a light dress on a winter's night was the fact that the old woman was walking on the snowy sidewalk *barefoot*!

She was walking from the direction of Martin Avenue, and Joyce thought that perhaps she came from the nearby nursing home. She drove by slowly, getting a good long look at the elderly woman, thinking that she would stop and pick her up. Surely she was freezing in that housecoat and bare feet, poor confused thing! "As I slowly passed her," Joyce continues, "I looked in my rear view mirror to see where she was going but she wasn't there anymore." She checked her side mirror—no old woman. Bewildered, she turned her head and frantically searched out the window at the same spot on the sidewalk she had last seen the old woman. But the lady had vanished completely. Had she gone into the cemetery, hiding among the tombstones? There is no way that anyone, much less an old woman, could have moved so quickly from the sidewalk up the snow-slick incline to the first line of gravestones in the brief moments between when Joyce passed her to when she looked in her rear view mirror to find her gone.

In her e-mail to me, Joyce said she knew at the time that her encounter could have an unremarkable, if unlikely, explanation—that she simply saw an elderly resident of Martin Manor nursing home wandering confused late at night who could not readily be seen in the mirror angles at night. So I was stunned when a male guest on my Historic Ghost Tours of Naperville hesitantly asked me if anyone had ever mentioned seeing an old woman in white walking on Washington Street by the cemetery. Firsthand corroboration of a previously untold ghost sighting is always an amazing, unexpected thrill that can come out of left field and make your jaw drop to the ground.

"Rich's" account was remarkably similar to Joyce's. He was driving north along Washington Street late one night coming home from a party. Rich admitted he had had a few beers, so when he saw a police patrol car approaching in the opposite direction, he slowed down as he passed the light at Martin Avenue and neared Naperville Cemetery. It was a good thing, because just

then Rich saw a figure of a woman in a loose, flowing white dress walking down the middle of Washington Street!

No one in their right mind would think to take a stroll down Washington, the major artery through the heart of downtown Naperville. That particular stretch is a narrow four-lane road with no divider, and drivers often are tempted to go too fast despite the cemetery's grim reminder to drive safely.

But there she was, her back toward Rich, hobbling south, directly down the middle of the road. Her back was toward him so Rich could not see her face, and, when I asked, he admitted he did not notice her footwear or lack of it. Rich could hardly believe it and slowed down even further to get a better look. He felt a sense of relief—the police would not be at all interested in him. Surely they would stop to pick this woman up unless he did something stupid to get their attention like drive recklessly—or, God forbid, hit that crazy woman. He steered into the far right lane, just in case.

To Rich's utter bewilderment, the police patrol car rolled right on past the woman without pause, coming to within an arm's length of hitting her! The two officers did not even turn their heads to look at her as they passed—as if they did not see the woman at all! The officer behind the wheel cast a curious glance over at Rich's open-mouthed expression as they crisscrossed, causing his heart to pound, but they drove on. Rich's eyes were riveted to the police car in his rearview mirror as he passed by the strange woman, so he was not paying attention to her. It took a moment to register, but then a chilling observation struck him—where was the old woman? He did not see her reflection in the rearview mirror, although the stretch of road she had been on was clearly visible. He checked the side mirror, then twisted around in his seat to look back. The road behind him was empty but for the taillights of the police car rounding the bend at Edward Hospital.

Who was that old woman? Was she a confused, elderly patient who had slipped out of the Martin Avenue nursing home on a cold winter's night? Or was she a ghostly resident of Naperville's old cemetery out for a late-night stroll down the street and the "loose, flowing white gown" perhaps a burial shroud? Why did Joyce and Rich see her but not the police officers in the patrol car?

An unsettling footnote to this story is that two inexplicable accidents have occurred on that stretch of Washington Street in recent years, where drivers had suddenly swerved away from the curb and into incoming traffic as if to avoid hitting someone—or something. Had those drivers perhaps seen an elderly lady in white stepping into the road? We will never know. Tragically, no one survived to tell what they saw. So when you travel along Washington Street between Edward Hospital and Naperville Cemetery, remember the true experiences of Joyce and Rich and drive with extra care.

Roses for the Unknown Soldier

Other inexplicable events have been reported at the Naperville Cemetery, though not, perhaps, as in-your-face obvious as full-body appearances of solid-looking apparitions. Two women, formerly employees of the landscaping company that tends the Naperville Cemetery, were surprised to smell the strong fragrance of roses, though they were in the oldest section of the cemetery and no flowers had been placed at any of the graves. Curious, they literally followed their noses to locate the source of the perfume. They were astonished to discover that the heady rose fragrance was rising from the old Civil War/World War I veterans memorial monument, not rising from around it, but actually emitting from the marble stone itself, as if a large rose wreath were draped over it. But the really strange part is that the date was November 9, exactly two days before Veterans Day, the national holiday proclaimed by Pres. Woodrow Wilson in 1919 solemnly honoring those brave soldiers who died in our country's service.

Many visitors to the Civil War monument in Naperville Cemetery report the strong aroma of roses coming from the stone. (Author's collection.)

The Shadowman

In recent years, visitors and workers of Naperville Cemetery have claimed to see a dark shadowy figure of a man walking slowly among the tombstones, head down as if in deep thought or grief. In 2005, when Historic Ghost Tours of Naperville received special permission to conduct late-night tours of Naperville Cemetery, tour guests occasionally saw this forlorn, solitary figure in the distance. Mysteriously, upon closer inspection, no trace of any living human could be found.

I vividly remember my own possible encounter with the Shadowman during one such cemetery tour, on Halloween eve no less. I was standing at Otto Kline's grave relating his tragic tale (told later in this book) to an entire trolley-load of tour guests when suddenly all the hairs on the back of my neck stood up straight. Instinctively I darted a nervous glance over my shoulder and clearly saw the dark, murky silhouette of a man perhaps 15 or 20 feet away, striding slowly southward among the tombstones just within the edge of the lantern light—head down, shoulders slumped, hands in his pockets, directly in view of the entire tour. I dismissed it as a guest who was coming up behind me to get a better view of Otto's headstone and continued telling the ghost story, even though the sensation of a silent stranger at my back was a disquieting distraction.

As we guided the group to the veterans memorial monument, I asked my tour assistant to please make sure no one sneaks up behind me, "Like that guy walking back there at Otto's grave." She looked at me with a puzzled expression and asked, "What guy? There was nobody walking anywhere near behind you." It was not until later it dawned on me that the dark, indistinct figure I had seen had been carrying neither a flashlight nor EMF "Ghost Meter" as all my tour guests do. Had I seen the Shadowman?

Can the Shadowman take on forms other than that of a tall man? One woman recounted a peculiar incident she had while watching a baseball game with her husband, sitting on a blanket close to the Central High School sports field. Suddenly a large, black mist flowing with great speed over the ground inside the cemetery caught her attention. It leapt over the fence with a smooth, liquid motion, "Like a black panther, but it was more of a formless black cloud!" It raced across the grass and hid behind some trees. Astonished, she stared at the trees until her husband asked her what was wrong. She told him what she saw, and suddenly the black mist darted out from the trees, leapt the fence again, and disappeared into the cemetery. It is interesting to note that the sports field is actually cemetery property on loan to the high school until such time as the space is needed for more grave plots.

A chilling story about the Shadowman was reported from a former worker at the Troost Monument Building, located on the corner of Hillside Road and Washington Street within the cemetery. This person had been alone in the building late one winter's night when suddenly the office temperature dropped to icy-cold levels, and an inexplicable, terrible feeling of nameless dread swept over her. Every hair on her body stood up straight and goose bumps tingled in warning, but she could not say why she felt this overwhelming sensation of foreboding. She looked up from the desk just as a dense, deep black shadow walked slowly past the open office door. Roughly man-sized and man-shaped, he did not look up from his slumped posture and did not appear to notice her. She knew that all the doors had been securely locked and she was all alone. She thanked her lucky stars he had not seen her this time, but she knew he would be coming back—there were no exits out of the building down that hallway. Paralyzed with fright and freezing cold, she waited and waited, but he did not come back. Finally the icy-cold cloud around her faded, along with the awful feeling of dread. She gathered her courage and searched the entire building but found no one.

The Shadowman supposedly walks alone in Naperville Cemetery at night. Could this be a photograph of the Shadowman? Below is an enhanced close-up view of the mysterious figure moving in the cemetery. (Courtesy of Greg Novak.)

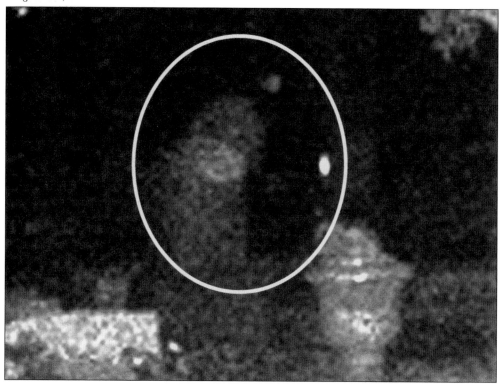

White Shadow

The Shadowman is not the only presence that this same woman encountered in the hallway of the Troost Monument Building, though this spirit is much more pleasant. Only a few nights after her uneasy experience with the Shadowman, she also witnessed a short, white shadow running past her office door and heard a little girl giggling happily!

Intrigued by these events, an informal paranormal investigation was held late one October. I was invited to tag along, although my personal expertise lies in historical ghost stories and supernatural folklore rather than ghost hunting. The team consisted of Alex Felix of the West Chicago Paranormal Society, Kevin Frantz of the now-defunct Naperville Ghost Society, and our host. Remarkable orb activity—mysterious floating balls of energy seeming to emit their own light—was captured simultaneously on both Alex and Kevin's night-vision cameras moving along the hall. Most intriguingly, the large orbs seemed to respond whenever I spoke to them, appearing from thin air to float purposefully down the length of the corridor to bob and dance in front of me before vanishing. They were not dust mites or insects illuminated by the infrared camera. No logical explanation for these independently moving orbs could be found. At one point, both Alex and I heard a little girl giggling. The sound came from nearby and yet, at the same time, from far away—like an echo without the reverb. The delightful, if otherworldly, sound was captured on both video cameras and a hand-held tape recorder.

The ghost had one more surprise in store for us that evening. The team decided to wrap up at midnight but discovered that the office door had been inexplicably locked behind us, trapping us inside. Our host (who fortunately had a key) was genuinely astonished and vowed the office door had been double-checked to make certain it was unlocked when we first entered. It was the kind of lock embedded in the doorknob that had to be pushed in and turned. On a wild hunch, I called out, "White Shadow, is that you? Did you lock us in? Do you want us to stay and play some more? If so, please lock the door again!" We spent another half hour eagerly urging the ghost to lock us in again, but the office door remained unlocked. So we packed up our gear and left for the night. But the excitement was not over.

The next morning I received an e-mail from our host that sent a bone-chilling thrill down my spine. They had just started the workday when an employee came up and asked, "Do you have the key to the kitchen? For some weird reason the door was locked this morning. It's never been locked before!" When we had asked the White Shadow to lock the door if she wanted us to stay, we had been standing right outside the kitchen door.

A Cowboy's Vision

Deep in the oldest section of the Naperville Cemetery stands a wonderfully sculpted grave marker that delights the little cowboy and cowgirl in us all. Standing a proud four feet tall, it is carved with a stone lariat rope looped on an outcropping, with a western-style boot and spur at the foot. A sculpted cowboy hat jauntily hangs on another edge. It looks for all the world as if some cowboy from the Old West had made camp there for the night during a cattle drive and had just stepped away for a moment to tend to his faithful horse. Sculpted flowers and horseshoes and other cowboy paraphernalia cover the ornate stone. The name Otto Kline is carved in bas-relief encircled by a lasso—no inscription, no dates—just the enigmatic name that is not even his real name.

This is the gravestone that sent Donna Haddad on an unexpected journey to discover the story of the fascinating man who, in life, had earned such a delightfully unique memorial. And it all began when she unknowingly placed her bare hand on the stone.

Donna was a Morton Arboretum volunteer working on a grant to catalog the tree species in the Naperville Cemetery. Her favorite place to explore was the southeast section of the graveyard, where the oldest, grandest, and most ornate tombstones can be found. She had spotted Otto

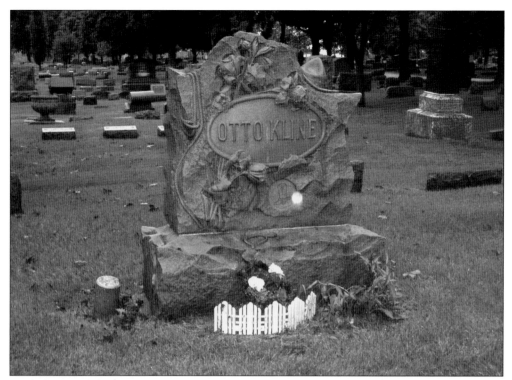

Numerous unexplained phenomena have occurred at Otto Kline's unusual monument, including disembodied voices, strange mists, and spectral orb lights like the one captured in this photograph. (Author's collection.)

Otto Kline was a fancy trick rider rodeo champion and circus star. The Winnipeg Theatre listings for June 16–21, 1913, said, "Otto Kline, a sinewy young 22-year old cowboy, who dwarfed into significance every other masculine contender at last year's stampede in Calgary. He won first prize for the trick and fancy riding, first in the Wild Horse race, third in the bronco busting and fourth in the steer bull dogging." (Courtesy of Linda Madden from the Winnipeg Vaudeville Archives.)

Kline's grave right off. Not only was it located on a prominent knoll, but something about it seemed to call out "Hey, look at me!" She wondered why some cowboy got a larger, more ostentatious tombstone than even some of Naperville's town fathers, but she soon dismissed it as a curiosity she could idly wonder about whenever she passed it by.

Donna had only worked at the cemetery for two weeks when it happened. On that particular fine day she was walking through the old section, conscientiously picking up windblown trash and thinking of nothing in particular. She bent over to pick up a candy wrapper by Otto Kline's grave and casually rested her bare hand on the stone—and suddenly vivid images exploded in her head, whirling in a burst of color and shapes. In her vision, Donna clearly saw a dusty, iron-shod horse's hoof coming straight for her face. She could smell sawdust, hear thousands of people screaming, and behind it all was the sense of a strong, vital male presence and a rush of myriad emotions—anguish, pain, and the sense of "How did this happen? Why me, why now?"

Donna fell back reeling, and the vision stopped as soon as her hand left the tombstone. But the image and the man's overwhelming grief still resonated in her like a gong. Donna had never in her entire life experienced anything like this before! She had never thought of herself as having psychic abilities. But there was no doubt in her mind that this Otto Kline, whoever he was, had been trying to communicate with her—and now Donna knew she had to find out who Otto Kline was and unearth the mystery behind this enigmatic, ornamented gravestone. Now this was in the days before Google, so it took her quite some time to research his history. But her supernaturally inspired investigation led her deep into a fascinating story of an extraordinary man.

Otto Kreinbrink was born in Germany in 1887 but grew up in Naperville at the ominous address of 666 West Jefferson Avenue (later changed to 240 West Jefferson, now the Nichols Library parking lot). Folks say he did indeed have a bit of the devil in him, a daredevil sense of reckless fun that he fully indulged by breaking in wild horses at the Pre-Emption House during the monthly horse fairs that Naperville was famous for. He would amaze onlookers with his trick riding and breathtaking acrobatics on horseback, quickly developing a reputation as a master horseman. That wild teenager could do stunts on the back of a galloping horse that most people could not do sitting on a rocking chair.

One day, somebody told him, "Boy, you could make a name for yourself. Why don't you compete in the rodeos out west with your fancy trick riding, or even join a circus?" Otto liked that idea. So, with his parent's blessing and the good wishes of all his friends, Otto moved out West to seek his fame and fortune.

Choosing the stage name Otto Kline, this Naperville boy become the greatest champion rodeo and circus trick rider in history. During the late 1800s and early 1900s, he amazed audiences with his daring, death-defying horsemanship as he toured North America, South America, and Europe as a star attraction in Buffalo Bill Cody's Wild West Show. He was prominently featured on billboards across the nation and was good friends with the great Annie Oakley, Frank Butler, and Chief Sitting Bull, most well-known from the Broadway musical and movie *Annie Get Your Gun*. Boyishly handsome, young Otto and his beloved yellow trick-riding horse, Buck, won the title of World Champion Trick and Fancy Rider two consecutive years in a row at the Olympics of rodeo riding—the Calgary Stampede competition—successfully competing against the finest, most sensational horsemen, roughriders, and cowboys in the world.

In 1914, Otto joined the renowned Ringling Brothers and Barnum and Bailey Circus, and it was there that he met the beautiful aerialist Tiny Duchée. It was love at first sight. They both shared that same reckless, daredevil spirit that was their passion and art, his on a galloping horse and hers flying down a cable at dizzying heights. Their courtship was mostly a long-distance one, since their work kept them on the road most of the time. Two years later they married, but after a romantic honeymoon of just one unforgettable day in New York City, the proud new Tiny Kline

had to go on the road with her troupe, while Otto's employer, Ringling Brothers and Barnum and Bailey Circus, was performing at Madison Square Garden. The separation was hard on the newlyweds, but they wrote each other every day. Their letters were filled with love, tenderness, and their hopes and dreams for the future together.

On April 20, 1915, Otto received a special letter from Tiny. She was leaving the road tour and coming to New York City! They could finally have a real honeymoon, and they could finally begin the rest of their lives together! Otto was so overjoyed that his fellow circus riders had to "duck his head in a bucket of water" just to settle him down!

The very next day—exactly five weeks after their wedding—Otto was performing in a matinee in front of an audience of 5,000 people at Madison Square Garden. He was doing the vault, his most dangerous stunt. Otto would hang on to the pommel and leap off the side of his horse, let his feet lightly touch the ground, then swing his body clear over the horse and touch the ground on the other side. He would do this nonstop all around the arena while in full gallop on his favorite trick horse, Buck, never once touching the seat of the saddle. He had done this trick hundreds, even thousands, of times before. But something went terribly wrong on this day. Perhaps his mind was on Tiny, dreaming of when she would step off the train and into his arms. Perhaps his hand, that he had badly gashed open on a loose tack the day before during his wild whooping and hollering, was hurting enough to distract him. Whatever the reason, as Otto vaulted, he slipped and fell and Buck's flying hoof came down on his head behind his right ear, crushing his skull before a horrified audience of 5,000 screaming people. Although he was whisked into surgery, he never regained consciousness. The tragedy was emblazoned on the front page of every major newspaper in New York. Otto Kline was only 28 years old.

To Otto, that final second of his life must have stretched like eternity as he watched that horse's hoof coming down toward his face, feeling the anguish of knowing all his bright plans for a long, full future with his beloved bride—the life that had scarcely begun—was now over. The last sight that Otto ever saw was the horse's hoof coming down for a lethal blow to his head; his last thoughts cry out in his mind, "How did this happen? Why me, why now?"—exactly like the astonishing vision Donna Haddad experienced while touching Otto's grave nearly 80 years later!

Devastated, Otto's widow, Tiny, brought his body to his beloved hometown and buried him in Naperville Cemetery. A small plaque for Otto Kreinbrink stands a few feet away and marks the actual resting place of Naperville's famous rodeo cowboy.

Shortly after, the editors of *Billboard*, the trade publication of all performers even to this day, suggested starting a fund to erect a monument. The idea caught on like wildfire. In a spontaneous outpouring of love from over 500 of Otto's grieving friends and associates in the worlds of the circus and stage—including such illustrious names as Will Rogers, Fred Stone, and Buffalo Bill Cody—they raised funds to commission the elaborate headstone that still stands in Naperville Cemetery. The long list of contributors' names were published weekly in *Billboard*, and a poem, "Otto Kline, In Memoriam" by Paul Case, appeared in the October 2, 1915, edition:

> A brave boy from our midst has gone,
> His place can ne'er be filled;
> His soul is boldly marching on
> Although his voice is stilled.
> No more he'll rubes and guys amaze
> Nor hardship's ranges ride;
> He's climbed the pass in deep'ning haze
> And crossed the Great Divide.

TO KLINE WORLD'S CHAMPION FANCY RIDER ON "BUCK" WINNIPEG STAMPEDE 191

Otto performs a daring stunt with his favorite horse, Buck, during the Winnipeg Stampede Rodeo in 1913. (Used with permission of Glenbow Archives, Calgary, Alberta, Canada.)

A daring cowboy to the last,
Whose heart beat ever true,
A champion—adroit and fast—
Trick rider through and through,
As countless thousands oft acclaimed
Who watched his daring ride.
How many know his grave's unnamed—
He—crossed the Great Divide.

Let's see his grave is marked, boys,
And keep it trim and green,
For grief is often salved with joys
And sore hearts turn serene
By duty; so let's write his name
On granite deep and wide,
And thus preserve one cowboy's fame
Who's crossed the Great Divide.

As recorded in *Circus Queen & Tinker Bell: The Memoirs of Tiny Kline*, edited by Janet M. Davis, Otto's overwhelmingly grateful widow described the stone in her diary:

The monument, of crudely carved granite, is of imposing proportions. The design, symbolic of his calling, depicts a sombrero over one corner at the top, a lasso looped over the other corner, and a spur lower down near the base. The center shows a floral design expressing a tribute from friends; over this is the polished tablet, letters "Otto Kline." Nothing more, yet it tells so much!

Sadly, less than a century later, this eloquent stone only told a riddle about a dearly loved, world-famous star whose name was diminished in time—but whose vibrant, electrifying spirit lingered behind to make certain his legacy would never die.

Donna Haddad went back to Otto's grave one day after her research was finished. She placed her hand on the sculpted stone cowboy hat (there were no more visions) and spoke aloud to the lonely cowboy. She told him all about his beloved wife, Tiny, and her life after him; how she never remarried after losing her wild rodeo cowboy lover and kept the name Tiny Kline. Donna told Otto how Tiny never lost that reckless, daredevil spirit that he loved so much in her, not even when she was 70 years old and performed as the first-ever Tinker Bell at Disneyland, flying down a cable every night to Sleeping Beauty's castle during the grand finale amid fireworks and cheering crowds below. And what a hit she was in 1932 New York, as thousands watched her soar across Times Square 500 feet up in the air, hanging on the wire only by her teeth in a never-to-be-equaled display of her famous Iron Jaw routine (though the New York Police Department was not thrilled and briefly arrested her, which no doubt made Otto's ghost howl with laughter). Donna then told Otto that Tiny was on his side of the veil now. And all he had to do to be reunited with her at last was to step into the light.

One final, curious note to end Donna's tale: Just as she finished with a quiet prayer for this rambunctious Naperville boy's soul, a magnificent hawk soared down from the trees, swooped over Otto's gravestone with mere inches to spare, then flew away over the woods and into the western sky beyond. Donna likes to think it was Otto, sending her his heartfelt thanks.

We can only hope that Otto took Donna's advice and went into the light. But sadly, that does not seem to be the case. Many inexplicable events have been reported at Otto's tomb in

The fascinating personal memoirs of Otto's beloved wife, Tiny Kline, make for a captivating story in the book Circus Queen & Tinker Bell, *edited by Janet M. Davis, University of Illinois Press. (Courtesy of Circus World Museum, Barboo, Wisconsin [BBK-np-Kline,Tiny-1].)*

recent times. Perhaps the eeriest event happened during one of my ghost tours in the Naperville Cemetery. We were standing by Otto's grave, and I was telling his story to the avid audience. One of my trainee ghost hosts was standing behind the group, taking notes. Just as I was getting to the part about the hawk swooping down, the trainee heard a man's voice say, "Tiny, I love you." The voice spoke softly, yet very clearly, from close behind her left shoulder. The trainee glanced around behind her, thinking that maybe one of the male tourists was getting a bit too much into the story. But there was no one standing behind her. No one was standing anywhere near her.

Perhaps Otto is waiting for his beloved Tiny to be buried at his side near that delightfully unique tombstone. But Tiny died at age 74 in the late 1960s and is buried in California. So if you ever pay a visit to Otto Kline's grave, rest your hand on the sculpted stone cowboy hat—a replica of his own black velvet sombrero—and whisper to him that if he would just walk into the light, up there above him he will find his dear Tiny at long last. Just walk into the light and he will step into her loving arms and they will spend the rest of eternity together.

NAPERVILLE'S FIRST CEMETERY

The northeast corner of Benton Avenue and Washington Street used to be the site of Naperville's first cemetery and Charles H. Kaylor's stone monument workshop. When the new Naperville Cemetery was established on Washington Street and Hillside Road, all the graves were moved to the new location. At least, they think they got them all.

Throughout America from the early pioneer times even on up through the Victorian era, vagrants, slaves, servants, suicides, and criminals did not commonly get any kind of marker for their graves, except for an occasional crude wooden cross or pile of stones. Such markers were easily destroyed by the elements within years. Accordingly, many final resting places were lost, or 100 years later a very surprised condominium developer's backhoe might accidentally dig them up.

One of the routes in my Historic Ghost Tours of Naperville passes directly by the site of Naperville's first cemetery. The EMF meters carried by our ghost guests during the tours have often—although inconsistently—become quite lively, flashing and beeping like mad. As any electrician can tell you, this indicates the presence of an electrical-magnetic energy field; and paranormal investigators theorize that ghosts may either consist of or utilize this form of energy in order to manifest. The fact that this activity is not at all consistent may rule out a man-made electrical source (although I have my suspicions about the street traffic lights—then again, the main EMF activity is perhaps 80 feet away from the corner). Also, the frequency of activity has steadily increased over the years. For the first year our ghost tours passed by the spot, I could count the number of EMF readings experienced on one hand, with fingers left over. By Halloween of this last year the readings were occurring every night, but if there were multiple tours that evening, it did not occur for every tour.

Several psychics have claimed to sense the presence of a child in his or her early teens. They each declare it is a very old ghost, who died so long ago that they cannot even detect if it is male or female. One psychic sensed that something had been wrong with this youth's legs; perhaps they had been damaged or even cut off at the thigh.

There is one last curious thing I have observed about this unusual EMF activity on the site of Naperville's old graveyard. When children ages 6 through 12 are on the ghost tour, this ancient child spirit reacts more enthusiastically than with any other group of people—just like any two ordinary children who meet and become instant friends. Somehow children can effortlessly reach across time and dimension to always find a new friend to play with.

VERMONT CEMETERY

The far southwest corner of Naperville in Wheatland Township is one of the last of the local rural farmlands to fall under the developer's bulldozer—but not for much longer. Even now cornfields and prairie meadows are being razed, replaced with the cookie-cutter dreariness of uninteresting, unvarying subdivisions and shopping malls. But there is a tiny cemetery on an isolated, lightless stretch of rural Normantown Road—about 400 yards south off Ninety-first Street and next to the Elgin, Joliet and Eastern Railroad tracks—that has not and will not ever fall to the relentless march of suburban progress. That is because Vermont Cemetery slumbers undisturbed behind a securely padlocked, 147-by-321-foot chain-link fence, thoroughly hidden in a tangled overgrowth of wild prairie grasses towering nearly six feet in height. A plaque on the fence indicates this enclosed half-acre is an official county ecological preserve—a locked and barred sanctuary to protect some of the last, most rare, surviving species of native North American prairie grasses that once blanketed the entire Great Plains.

Vermont Cemetery was "put to sleep" years ago, most of its gravestones laid flat and buried under earth, moss, and wildflowers. Only a few of the tallest tombstones can still be glimpsed over the swaying prairie grasses—broken markers, deeply weathered and shrouded by the impenetrably thick overgrowth. Carved on them are names of some of the earliest pioneer settlers in the region—names like the Book family and William Kinley, whose dates of 1794–1878 were nearly obliterated by 130 years of Illinois weather.

Desolate, abandoned, and lost to time and nature, Vermont Cemetery is not yet forgotten. Nor is its ghost, who has given quite a fright to the few travelers on Normantown Road ever since one unforgettable night back in 1880.

Longtime area resident Roger Matile first heard the ghost story from his grandmother, who claimed this hair-raising encounter happened to his great-grandparents. They owned a farm off Route 59, where the White Eagle subdivision is today, and had spent the day visiting relatives in Oswego. They got a later start home than they had expected, and shadows stretched long over the road in the vanishing twilight as they drove their horse and buggy over the dusty, rutted lane on what is now Normantown Road.

Roger Matile recounted the story in the October 30, 1994, Halloween issue of the *Naperville Sun.* "It was getting on toward dusk and they noticed someone walking along the road. As they got closer, it looked like a neighbor. When they got up even closer, they noticed that not only was it a neighbor, but it was one of their *deceased* neighbors who had been buried in the Vermont Cemetery! Stunned by what they saw, they tried to move along with their horse and buggy like nothing was wrong. The ghost walked into the cemetery and disappeared." Matile's grandmother asserted that other people had identical encounters with the wandering spirit at least two more times that she knew of, and at the same spot along the road.

Then in 1992, a Will County deputy sheriff was driving down Normantown Road near Vermont Cemetery, just as he had hundreds of times on his regular police beat. Although it was dusk and no streetlights lined the isolated, lonely road, the sky was clear and cloudless, the gathering night heavy with the scents of growing corn, meadow grasses, and the dust of the gravel that crunched under his tires. Suddenly he saw a woman wearing a headscarf step from the shadows into the beam of his headlights and walk directly in front of his car! There was no way he could stop in time, but he slammed his foot down on the brake anyway and the car lurched to a stop. To his horror, he could no longer see the lady in the windshield—had he hit her? Was she even now crumpled in a bloody, motionless heap underneath the grille of his car?

Shaking, sick with fear and dread, the deputy sheriff scrambled out the door and raced to the front of the car. No lady. He looked under the car—no blood, no body, no one. He grabbed his flashlight and hurried back down the road he had just traveled, sweeping the beam from side to side and searching for any sign of the woman he saw. He searched for almost 30 minutes but did

not find so much as a footprint in the dusty road. She had simply vanished—right outside the Vermont Cemetery.

That was not the only, or even the most unnerving, encounter this same deputy sheriff had with this mysterious ghost. He saw her on at least two more occasions, each time along the same stretch of Normantown Road by the cemetery and at dusk. The second time he saw her she was walking north on the shoulder of the road, her back to him. She was wearing the same clothes and headscarf as before. He approached warily, his car crawling at a snail's pace behind her. Abruptly she turned and stepped off the road, across the ditch, and vanished into the high thicket of growth inside the cemetery. He gunned his police cruiser to the spot where she had stepped off the road, then shined the car's side-attached floodlight along the chain-link fence, expecting to see a gate that she must have used to get inside. But there was no gate. Stunned, but unable to think of any rational explanation, the deputy sheriff realized that this strange lady had somehow walked right through the chain-link fence as if it was not there. He could scarcely believe it—his mystery woman was a ghost!

When he saw her yet a third time nearly a year later, the deputy sheriff thought he was ready for her. He had spent many hours musing on his two uncanny encounters and decided that he must have been mistaken—surely she was a real person and not a ghost! But just in case, he had carefully planned his moves when, or if, he ever saw her again. This time he was driving south along Normantown Road having turned off from Ninety-first Street, when in the gloomy semidarkness of nightfall he saw the familiar figure of the woman in the same headdress walking toward him at a steady pace on the east shoulder of the road. He slowed and turned on the flashing police lights, giving the siren a brief wail to attract her attention. She ignored him completely, not even breaking stride or glancing up at his approaching cruiser. Irritation overrode his uneasiness, and the deputy sheriff pulled into the left-hand lane of the deserted rural road up alongside her, determined to confront his mystery woman.

He stopped the car and was just about to roll down the window to speak when suddenly the woman moved with surprising speed off the shoulder toward the car. Before he could blink, she had placed one hand on the hood and the other flat on the windshield, then leaned very close to the glass, and stared in at him mere inches away, her face eerily illuminated from the dashboard lights below. That was frightening enough on a dark, isolated road, but what unnerved the deputy sheriff most was that the woman's face and eyes were utterly expressionless and unmoving, like a doll—or a corpse.

The deputy sheriff does not mention what happened next, and secondhand accounts differ. Some say the ghost simply turned away and walked through the chain-link fence to disappear into the abandoned graveyard. But an unlikely rumor has spread that the deputy sheriff saw the ghost abruptly turn into a fox and vanish into the graveyard. Maybe that is why he does not talk about it—people would think he is crazy!

But is it so unlikely? Foxes are indeed abundant in rural areas and are widely known to enjoy the human-free privacy of cemeteries. Perhaps the ghost merely vanished into thin air as ghosts do, just as a fox ran in the long grass and slipped inside a hole burrowed under the cemetery fence. But there is, perhaps, one other explanation. In Chinese folklore, all ghosts have the common ability to transform into foxes, haunting cemeteries at night, their expressionless eyes eerily luminous in the starlight.

In October 2006, I visited Vermont Cemetery at dusk with paranormal investigators Alex Felix and Sara Rohr of the West Chicago Paranormal Society. Our EMF meters were useless due to the massive power lines along the railroad tracks, but we did catch an interesting anomaly on our other equipment. As we stood on the shoulder of the road at the south end of the Vermont Cemetery fence, the temperature abruptly plummeted 20 degrees. It was a cool, dry night with no wind, so we could not account for the unexpected freezing air. The cold spot passed moments

Since 1880, the ghost of a woman wearing a headscarf has been seen walking along Normantown Road only to turn and vanish into Vermont Cemetery. (Author's collection.)

Vermont Cemetery is a formally dedicated sanctuary for native prairie plants and animals, preserving many rare species lost to time and the plow. Old pioneer cemeteries like Vermont often make excellent nature preserves because they were never plowed or grazed and thus closely resemble what the Illinois prairie truly looked like before the settlers arrived. (Author's collection.)

Early pioneers slumber beneath the tall prairie grasses. (Author's collection.)

Vermont Cemetery remains untouched amid growing suburban sprawl. (Author's collection.)

later, but as Sara took a few steps north, the cold air returned, and the thermometer reading dropped again. The warmer air returned, but a few steps north caused the phenomena to occur again. She continued to track this compact cloud of cold air down the road perhaps 40 feet, until she lost the cold spot at the midpoint along the Vermont Cemetery fence.

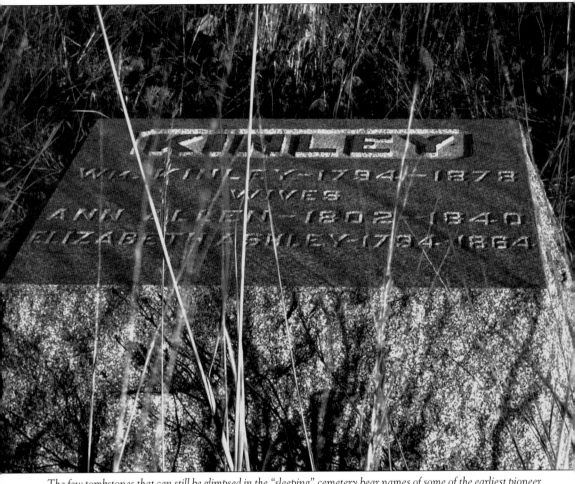

The few tombstones that can still be glimpsed in the "sleeping" cemetery bear names of some of the earliest pioneer settlers in Naperville. (Author's collection.)

How many tombstones can you spot in the tall prairie grass and brush of Vermont Cemetery? (Author's collection.)

The door to the other world is always open for business. (Author's collection.)

Four

HAUNTED ENTERPRISES
GHOSTS OF COMMERCE AND CIVIC CULTURE

*Business owners that don't promote their haunted history may be missing the boat here because
there are people who actively seek out these kinds of destinations throughout the year.*
—Kim T. Gordon, president, SmallBusinessNow.com

*They're afraid that if they promote it too much, it will hurt business or attract the wrong kind
of business. . . . In my experience, just the opposite happens. When you advertise
an authentically haunted place, your revenue will go up.*
—Al Tyas, founder of the Washington D.C. Metro Area Ghost Watchers

PHANTOMS OF PFEIFFER HALL

If you have ever read anything about ghosts, you know that there are certain rules in the
paranormal realm just as there are in the natural realm. Though we are in the dark as to the
whys or wherefores of such supernatural laws, one such otherworldly rule apparently is this:
Every theater must be haunted. Though this rule applies to performance theaters, it has also
stretched to a number of movie theaters too. Another rule is that every college campus must also
be haunted—ghostly legends of the school spirit, so to speak. So when these two rules combine,
you can just imagine how many ghosts might haunt the theater of a college campus. Built in
1926, the Barbara Pfeiffer Memorial Hall at North Central College can boast as many as seven
or eight ghosts in everlasting residence.

The Lady in White

The most famous phantom of Pfeiffer Hall is the Lady in White. The true events behind her
story occurred in the late 1950s. Bob Lewis, a playwright and alumni of North Central College
who had written several television scripts for the *Alfred Hitchcock Hour*, had written his first
musical—a singing and dancing version of *Mutiny on the Bounty*, including a song titled *Bly-Me!*
All of Naperville was thrilled that this destined-for-Broadway musical was having its world
premiere at North Central College's Pfeiffer Hall. It was the cultural event of the season, and
the house was packed to the rafters. The choice main-floor center section of the theater was
roped off for the playwright and his family. Among those attending was his great-aunt, a frail
lady said to be 92 years old, elegantly dressed all in white. She was understandably excited to see
her grandnephew's play and was fully enjoying her sudden celebrity among the community. She
was seated in seat G-42.

The lights dimmed. The audience hushed with anticipation. The orchestra began to play, the
curtain rose, and the elderly woman in seat G-42—died.

Dr. Donald "Doc" Shanower, at the time a relatively new professor in the theater department,
had been standing in the back of the house and noticed a commotion in row G. An elderly
woman had slumped over in her seat, seemingly unconscious. Doc Shanower called over to

The Barbara Pfeiffer Memorial Hall is seen in 1940. (Courtesy of North Central College Archives.)

The Lady in White is said to appear in seat G-42 after an elderly woman died there during a performance in the late 1950s. (Courtesy of North Central College Archives.)

This original floor plan of Pfeiffer Hall's second floor shows the tiny janitor's closet in the men's toilet where the ghost of Charlie Yellow Boots is often seen. The closet has since been closed up and bricked over. (Courtesy of North Central College Archives.)

Dr. Glenn Wolf (you will read about him later), and together they carried this poor woman out, thinking she had fainted. They laid her on the floor of the lobby, and it was there that Dr. Wolf determined that she had not fainted. She was dead.

Of course they immediately called for an ambulance. But in the meantime, they did not know what to do with her. They could not just leave her on the floor of the lobby; that was disrespectful! So they stashed her in the cloakroom. And there she lay: All during the first act, all through intermission as the audience mingled just outside the coat room door, and halfway through the second act until the ambulance arrived and took her away.

But now they say that, even to this day, if you come to Pfeiffer Hall to watch a play and you happen to be seated in seats G40 or G44 and there is a sweet little old lady seated next to you dressed all in white, applauding enthusiastically and enjoying the play but when the lights go up at intermission she has mysteriously disappeared from her seat, then you have had the great honor to have met Naperville's most famous ghost, the Lady in White.

Charlie Yellow Boots

Generations of college students loved hearing about the Lady in White, but perhaps none were as fascinated as Chris Schultz, class of 1981. Chris was president of the North Central College theater fraternity for three years and spent a great deal of time in Pfeiffer Hall at odd hours of the day and night. So many strange things had happened that Chris and his friends would often go ghost-busting late in the night or sometimes even during performances while waiting in the green room for their time on stage. Chris and his team recorded an impressive number of personal experiences at Pfeiffer Hall, including disembodied footsteps echoing throughout the mazelike halls, in the lobby, even in the upper reaches of the auditorium. They used whatever they could to try to contact the ghost—Ouija boards, séances, and once, during Chris's senior year, they hired a professional psychic to find out what she might pick up on. Chris and his friend "John" escorted the psychic, and they asked Doc Shanower to come along. Doc Shanower had always emphatically denied that the Lady in White haunted the theater, and yet he was still intrigued to hear what a psychic might have to say.

The four of them toured the building, but when they got up to the second-floor lobby the psychic stopped on the landing of the stairway outside the men's restroom and told them, "There's a presence of a man here—a very strong male presence dressed in workman's clothing." She went on to explain that he was the one who does many of the uncanny things that happen here. She said that, "In his breathing days," this man had spent a great deal of time in Pfeiffer Hall, and he loved the place and his job very much. But there was one thing that bothered him a great deal: Everyone always made fun of his footwear!"

At this, Chris and John looked at each other in dismay and thought, "Jeez, we paid how much for this psychic?" But Doc Shanower's jaw dropped, and he suddenly blurted out, "Oh, my God, you're talking about Charlie Yellow Boots!"

"Charlie Yellow Boots" was the nickname for a janitor who worked at North Central College for many years back in the 1940s and 1950s. He had earned his nickname because everyone teased him about the bright yellow rubber boots he always wore every day, rain or shine. Amazingly, the psychic had somehow picked up on this insignificant eccentricity of a man who walked the hallways of Pfeiffer and died nearly 40 years before! Even more intriguing was that the men's restroom where she had "seen" the ghost used to be the janitor's closet back in Charlie's day—the one room in the building he would surely have considered his "office" and undoubtedly spent a great deal of time there!

Charlie Yellow Boots is by far the most active of the Pfeiffer Hall ghosts. Students hear him all the time and in every area of the building, even up in the catwalks high above the audience. They have seen his shadow standing in the lobby, and they hear the unmistakable sound of

rubber boots squeaking on the tile or hear a bunch of keys jingling though no one is there. One student claims to have encountered, "A weird guy who gave me the creeps" wearing yellow boots and workman's clothing on the third floor while waiting for her violin lesson. She said he introduced himself as Chuck, which of course is a common nickname for Charles or Charlie. She had to ask him to please leave her alone, whereupon he nodded, smiled, shuffled off down the hall, and vanished.

Perhaps the scariest encounter supposedly happened to another employee of the college. A night janitor was just finishing up his shift as dawn began to lighten the sky. He was working at the far end of the long corridor that runs behind the stage, where professors' offices and the green room, prop room, studios, and practice rooms are located. At either end of the U-shaped corridor are brief steps leading down to the main floor. These stairs come up with such unexpected abruptness that many a distracted or hurrying student has taken a tumble down them.

Just then, the janitor saw the last ceiling light at the far end of the corridor suddenly go out. "Well, shoot," he said, "Now I gotta go change that lightbulb!" But no sooner had he thought that than the next light suddenly went out. The janitor thought, "That's strange, what are the chances that two lightbulbs right next to each other would burn out like that, one after the other? And if it were an electrical problem, wouldn't the whole bank of lights go out at once?" No sooner had the thought crossed his mind then the next light down the corridor went out—and heartbeats later, so did the next light.

It was then that he started to hear a sound approaching him down the hall—the unmistakable sound of rubber boots squeaking on the tile. Every time another light went out—the seventh light went out—the squeaky footsteps moved a little closer to the fear-stricken janitor, each time pausing to wait just within the edge of the shadow for the next bulb to go out. The sixth light went out, plunging the corridor deeper into darkness, and the boots came closer. The fifth light went out—the boots came closer. Soon there were only four lights left illuminating that black hallway. The fourth light went out—*squeak, squeak, squeak*—the third light went out—*squeak, squeak, squeak*—the second light went out—*squeak, squeak, squeak*. The last light went out, and the janitor went out! He broke from his terror-stricken paralysis, whirled around, and ran out the door screaming. When he got home he called his boss and quit, telling him, "I'm never coming to work there again!"

This suburban legend may have its garbled origins in the actual accounts of Terry McMahon, a former security guard at North Central College. He often told of his ghostly encounters in Pfeiffer Hall to his young nephew, eight-year-old Adam McMahon. Adam, in turn, reported the story to renowned Chicago ghost lore author and ghost tour operator Ursula Bielski, who included Adam's wide-eyed and earnest account word for word in her acclaimed 1998 book, *Chicago Haunts*. Adam told the author that his uncle Terry told him an electrician was perplexed that the bank of lights down that corridor had the tendency to turn on one at a time instead of all at once.

The Professor's Ghost

Charlie Yellow Boots is not the only lively haunt that Terry McMahon may have encountered. The most frequent occurrence to happen to the night security guard was to hear a piano being played beautifully in one of the third-floor practice rooms deep in the night, long after the building would be locked up and empty of all human life but for his own. He would go investigate, following the sound of the music to a practice room. The moment he would open the door, the music would abruptly stop. The typical music practice room is the size of a walk-in closet and furnished simply with a piano, bench, and a music stand. Terry would turn on the light, but the room would be mysteriously abandoned, with the wooden case securely covering the piano keys and keyboard, making it impossible to play.

105

Does the ghost of a music professor still play the piano late at night in the third-floor practice rooms of Pfeiffer Hall? (Courtesy of North Central College Archives.)

He would shrug, turn off the light, leave the room, shut the door behind him, walk down the hall, and from the same room he had just left would come the sounds of a piano being played, beautifully!

Legend has it there once was a professor at Pfeiffer Hall who was tragically diagnosed with an inoperable brain tumor and given three months to live. Knowing full well that enduring the disfiguring, agonizing cancer treatments of the day would make no difference to the Grim Reaper in three months, he chose to take his own way out. The professor locked himself in his garage, started the car, and breathed in the carbon monoxide fumes until he quietly, gently passed away. Supposedly the northeast corner office on the first floor had been his; and since then, visitors to that office have reported many bizarre happenings there.

In the spring of 1981, Chris Schultz (from the Charlie Yellow Boots story) and his ghost-busting friends were holding what they called a ghost party in the northeast corner office, which belonged at that time to Doc Shanower. They were not having any luck in communing with the dead, so they called it quits for now. Chris was last to file out the door, and suddenly he felt a man's hand on his back, shoving him out with such force that he crashed into his friends, and the heavy wooden door of the office irritably slammed shut behind them. As Chris later told to the February 23, 1992, issue of the North Central College *This Week* faculty/staff newsletter, "The door was still opened a foot, and this door slammed shut. A big-time slam. And there was nobody in this room. These were large, heavy doors. We used to go in and out of them all the time. When something like that moves like that, you have to wonder. We just jumped out of our skin."

After that incident, the ghost hunters decided their school spirit wanted to be left alone, and so they, for the most part, hung up their Ouija board, ceasing their investigations.

In the summer of 2007, a student actor was onstage rehearsing for a musical when he witnessed "The ghost of Colonel Sanders of Kentucky Fried Chicken" standing in the front-row balcony watching the show. White suit, white hair, goatee, cheery smile, it was the colonel to a T! The only difference was that the colonel's iconic black string tie was a bow tie instead. Blinking in momentary surprise, the actor turned to his fellow actors to recite his line, and when he looked out again seconds later, the colonel was gone. Whether the famed chicken franchiser Col. Harland David Sanders had any connection to North Central College is unknown—and highly unlikely. However, the music professor in the legend was reported to look like Colonel Sanders and got a kick out of seeing students' expressions whenever he dressed like the colonel—white suit, white hair, goatee, cheery smile—only the tie was different, for it was well known that the professor preferred a classic bow tie to a string tie.

Technical director Jack Phend told me that several times a year he would clearly hear footsteps resounding from room 25 in the early morning hours before sunrise. "I would hear distinct footsteps, heel-toe, heel-toe, from one end of the room to the other and back again." However, when he went to investigate, he was nonplussed to find a dark and empty room.

Who could this accomplished ghost be? Legend and history point to two men, both highly regarded and widely adored college professors who had their offices in Pfeiffer Hall. Prof. Glenn Reddick was a professor of speech and chairman of the Division of Creative Arts from 1952 until his tragic death by a possible suicide in late March or early April 1977. Dr. Frederick Toenniges was the music director of violin and band instruments and the director of the North Central College Band from 1930 to 1947. Perhaps the piano-playing ghost became a compilation of these two men's personal life stories, mingling and lingering like echoes in a theater auditorium down the years.

Could this be the same phantom known to protect actors and techies from accidents on stage, or is this yet another ghost at Pfeiffer Hall? One afternoon, acting students were

doing a visualization exercise on stage. Everyone was blindfolded and told to walk around and try not to bump into each other. It is an excellent exercise to learn how to extend and use all their sensory capabilities other than sight, but it is not such a smart idea to blindfold everybody on stage when there is a nine-foot drop into the orchestra pit. One female student abruptly discovered she had run out of stage and began to fall into the orchestra pit. She could have been badly hurt, perhaps even killed, landing on the metal music stands and concrete floor. But she swears to this day that she suddenly felt a man's hand on her chest, pushing her back onto the stage and to safety. She instantly ripped off her blindfold, but no one was standing anywhere near her. Furthermore, her rescuer would had to have been levitating in thin air over the orchestra pit to have been able to position his hand on her upper chest!

There was a similar "miracle" incident with an unwieldy, two-story stage set of the interior of a train. The script called for the train to be filled with young women, but the structure was so very unbalanced it took three strong stagehands hiding in the back of it to hold it upright. During one unforgettable performance the entire two-story train set started to fall backward. The stagehands struggled to lift it upright again, but it was too heavy. The heavy wood structure leaned and wavered dangerously, on the verge of keeling over and pitching the actresses headlong. Just when it seemed that disaster was inevitable, the stagehands were shocked to feel an invisible force lending remarkable strength and support to help them push it safely upright. Another miraculous save by the mysterious stage "hand"?

The Lady on the Stair

"I think I met the Lady in White!" said an excited young college student on one of my ghost tours. "I was running up the lobby stairs and being kinda loud when I suddenly heard a woman's voice saying, 'Shhh!' But there was nobody there! Do you think it was the Lady in White?"

Nope, that was not her. Pfeiffer Hall has yet another spectral lady in residence. Every night she walks the east stairs leading up to the second-floor lobby and shushes any student who disturbs her peace.

A former theater graduate student, "Karen," had an extraordinary encounter on the staircase that she will not ever forget. The play rehearsal was lasting deep into the night, so when she had a few minutes before going back onstage, Karen raced up the east lobby stair to use the ladies' restroom at the top of the steps.

A few minutes later, Karen stepped out from the ladies' restroom just in time to see a woman dressed in old-fashioned clothes start to walk down the stairs ahead of her. This is not an unusual sight in a theater, but Karen did not recognize the woman and knew she was not in the show. There were no other rehearsals going on—what was this lady doing here so late at night? And in full period costume no less? So Karen called out, "May I help you?"

The lady stopped on the landing, turned back to face Karen, made eye contact with her, bent forward slightly, raised a finger to her lips, and said, "Shhh!" Then—still holding that pose—the lady evaporated into nothingness before Karen's astonished eyes.

Remember the psychic who sensed Charlie Yellow Boots in the upstairs lobby outside the men's restroom? Interestingly enough, this lady on the stair was the only other ghost besides Charlie that the psychic could sense, declaring that there was a woman walking up and down the east stair. There are numerous reports of students and visitors feeling a cold spot on the landing, while others report a feeling of pressure, as if the air had turned to water. And noisy students running up the stairs may be scolded by a woman's voice saying "Shhh!" So that gloomily lit landing up on the east lobby stair? It is not as empty as it looks.

The Chicago Cubs Fan

This rowdy fellow sits in the balcony wearing his Cubs hat and jacket, cheering and clapping enthusiastically at the show. But, like the Lady in White in seat G-42 on the main floor, he too disappears at intermission. Rumor is he has not been seen ever since the White Sox won the World Series. Others say he has been seen, but he was sobbing in his hands. Perhaps next year the Chicago Cubs curse will lift and our undying fan will at last find peace.

The Lady in Blue

Sharing the balcony with the Cubs fan is a middle-aged lady impeccably dressed in a light blue suit. Although a more refined and elegant theater patron than the Cubs fan, she is also a scathing critic, often seen applauding the performance with a marked lack of enthusiasm before she too vanishes after the first act.

Tumblin' Jill

The newest ghost to reside in Pfeiffer Hall arose in the past three or four years. To my surprise, no less than four students separately told me about a terrifying encounter that the recently retired technical director, Jack Phend, had late one night in the back corridor of Pfeiffer Hall. I was eager to ask Jack about it, but the students warned me that it was such a horrifying, shocking experience that he refuses to speak of it. Nevertheless, I called Jack to arrange an interview on the phantoms of Pfeiffer Hall, and Jack was glad to tell the spooky legends as he knew them.

We had a great interview, walking all around the theater, taking photographs of seat G-42 and the men's restroom with its bricked-up janitor's closet door. Later as we sat in his office, Jack confessed to having witnessed and heard unusual things at Pfeiffer that he simply could not find any rational explanation for. I cautiously asked, "Unusual things like a ghostly little girl?" At first Jack stared at me, startled, but then he sighed and said, "I know what you're talking about. And you've no doubt heard that I don't talk about it. But Diane, I'll make you a deal. I'll tell you that story; but only if you promise to tell it to everybody, just like I'm telling it to you now, both in your book and on your ghost tours. Deal?" I agreed eagerly, and this is, more or less, the tale that Jack told me.

He was working alone at Pfeiffer Hall very late one night, desperately trying to finish building the set for a show that was going to open the next night. He was in his office getting something when, all of a sudden, he heard the most unexpected sound—a little girl calling, "Mommy! Mommy!" It was 3:00 in the morning. The entire building was dark and locked tight; he was the only person around—no one else should be there that night, especially not a little girl! Jack stepped into the hall, and, sure enough, there was a darling, sweet little girl, no more than four or five years old, standing at the drinking fountain—turning it on, turning it off, turning it on, turning it off, calling, "Mommy!"

Mystified, Jack spoke to the little girl, "May I help you?" She took one look at him, spun on her heel, and took off running down the hall as fast as her little legs could move. Jack ran after her, calling out, "Wait, I won't hurt you, what are you doing here?"

He remembered seeing her face as she got to the end of the hall and ran around the corner at full speed, looking back at him. She looked so scared, her face pale with fright. She ran out of his sight, and that is when Jack heard the most horrible sound in his life—that little girl's scream, cut short by a sickening thud. He raced to the end of the hallway, turned the corner, and stood at the head of the stairway that comes so suddenly around the corner, the flight of stairs that the little girl had not seen because she had been looking back at Jack. There, at the bottom of the last stair, was that pretty little girl—motionless, arms and legs twisted at unnatural angles, eyes wide and staring, lying in a spreading pool of blood. Before Jack could even think of what to do, she vanished—blood and all—as if she had never been.

Jack paused after telling the story to me and then said, "Diane, I want you to tell that story to everyone on your ghost tours, just like I told it to you just now. And when you do, you be sure to tell everybody that that story *never happened*! Some student dreamed up this wild story about how I witnessed the ghost of a little girl falling down the stairs, and that it was such a horrible experience that I never talk about it. No little girl ever died here, period. So please, tell everyone that story isn't true!"

Well Jack, I have kept my promise. The truth is finally in print. Though I doubt it will do anything to stem the tide of whispers and rumors. For you see, it is next to impossible to stop a good ghost story like that once it has been told. I have listened to a long litany of college students telling me how they have seen the drinking fountain turn on and off by itself, and heard the footsteps of a child pattering down the hall, or a little girl giggling down in the basement dressing rooms. Even funnier is when I tell them Jack's true story, the students will still shake their heads and insist the story is real! Thus the power of story shapes our history, and yet another *sub*urban legend is born in Naperville.

THE SEMINARIAN SPECTER OF SEYBERT HALL

One of the most enduring ghost stories of North Central College folklore is the mournful specter of a seminary student who reputedly haunts the third floor of Seybert Hall (pronounced *Sigh-bert*). Owned by the Evangelical United Brethren Theological Seminary, the charming, historic Seybert building served as its residence hall. Until 1974, the entire third floor was a bare, unfinished attic—a lonely, gloomy, isolated place where a deeply depressed seminary student might go to end it all.

Which is what supposedly happened sometime during the hall's early history. For decades, resident hall assistants at Seybert Hall have faithfully terrified new student residents with the tale of how a seminary student hung himself in the north wing of the third-floor attic. The woman he loved more than life itself had cruelly jilted him. In his broken-hearted despair he tied a rope to the rafters, fashioned a noose at the other end, and slipped his head in the loop. Then, perhaps with a prayer and a curse on his lips, he leapt from a chair to horribly strangle to death in that empty, desolate attic.

Curiously, this tale did not get its start until after 1974, when the seminary relocated and the college purchased Seybert Hall, then finished the third floor for additional dormitory rooms. In fact, there is no evidence that a seminary student ever died there to the best of living memory. But the whispered rumors persist, fueled by strange occurrences reported by students over the years: candles mysteriously light themselves; televisions, radios, or computers suddenly switch on in the middle of the night; small possessions disappear from their usual spots, only to later reappear in entirely unexpected places; and there are spooky creaks, murmurs, sighs, and strangled moans that might be just the wind on an old, historic building—or not.

There is unofficial scientific evidence that hints there may be something more to this ghost story. As an amateur ghost hunter, student Perry Tatooles, class of 2003, was thrilled to be assigned a room in Seybert Hall. While the other students listened to the grisly tale with wide eyes and nervous glances over their shoulders, he could hardly wait for night to fall so he could begin investigating the legend (we ghost hunters are weird like that). During his time as a resident in Seybert, Perry recorded numerous incidents of high paranormal electromagnetic energy readings that could not be traced to any known electrical device or wiring. His photo album is filled with ghostly images of spiraling vortexes zipping by the subject, unexplained mists, and floating globes of light—energies often invisible to the naked eye but captured on 35-millimeter film.

Oddly, there was a brief mention in the college archives that a female apparition had once been sighted in the third-floor attic. The ghost had always been assumed to be male since only men entered the seminary to become ministers. Could this seminary student have been a woman?

Seybert Hall was the dormitory for seminary students attending the Evangelical United Brethren Theological Seminary until 1974. (Courtesy of North Central College Archives.)

"Yearbook photos show that there were female students at the Seminary, but only a very few," states Kimberly Jacobsen Butler, archivist at North Central College. She went on to explain that up until contemporary times women were forbidden to become Protestant ministers—but they *were* permitted to do missionary work in isolated, primitive, and dangerous locales. A religious education, while not mandatory for these intrepid Christian ladies, would have been considered appropriate for women seeking to be missionaries at the time.

Although the ghost of the seminary student of Seybert Hall appears to be more fiction than fact, there is just enough baffling evidence and reports of strange incidents to keep the third-floor student residents huddled under their blankets in the middle of the night, listening to the despairing sighs and strangled moans of the specter of Seybert Hall.

THANK YOU FOR HAUNTING AT WAL-MART

Ghosts do not always haunt creaky old houses or graveyards. Today's contemporary ghosts can turn up even in bright, modern surroundings such as shopping malls. Naperville's Wal-Mart on Route 59 is supposedly haunted. Can you think of a better place to shop for Halloween?

Sara

When the Wal-Mart on Route 59 at the far west end of Naperville was first opened, a startling encounter occurred to four employees taking inventory overnight. By mutual agreement they took a break at 3:00 a.m. and met in the intersection of two main aisles to chat and stretch their aching backs to keep themselves awake. Suddenly they heard the click-click-click of high heels approaching them. It was only later that they realized the sound had not gradually grown louder from a distance but started up at full volume from very close by—as if the person had just appeared from thin air. They turned to see a woman dressed all in white walking briskly toward them down the center of the aisle. Lady in White ghosts are common, but what makes this one unusual is that she was not wearing a flowing, wispy funeral shroud, no—instead she was smartly styled in a fashionable white business suit. High heels and a briefcase completed the image of a dynamic young business executive. Stunned into silence, the four Wal-Mart employees parted to make way for her, wondering how this stranger had gotten in the locked building and what in the world she was doing there at 3:00 a.m.? One of them blurted, "Good evening" as the woman passed through their huddle in a drift of expensive perfume. She flashed a bright, gleaming smile at him and replied, "Good evening," then, without pause, continued walking past them and pushed her way through the big swinging doors leading into the warehouse. Dumbfounded, the four watched until the door swung closed behind her—turned to look at each other in astonishment—then scrambled at a dead run into the warehouse to catch the intruder. But the woman had vanished. The click-click-click of heels had stopped, and there was no drifting perfume lingering in the air even though they ran after her scant seconds after she stepped into the warehouse. They conducted a search for the trespasser, but found no sign of her whatsoever.

Sara, as they christened their executive ghost, continued to make her presence known by throwing boxes and merchandise off the highest shelves. Items would fly off the shelves— literally—with the force of an arm angrily sweeping them off. Sara's antics were centered most often in the baby department in the far southeast corner of the store, where most of the poltergeist activity has taken place.

It was here that a teenage girl was struck in the middle of her back with a value-sized package of baby wipes. She was unhurt but mystified. Who could have thrown it? She was the only person in the aisle. She quickly spotted where the package had come from, but that realization made the incident even weirder. Somehow the value-sized baby wipes pack had launched itself from the bottom shelf to strike her high up on her back!

Sara has quieted down considerably in the time since the store's lively first years. But one aisle in the baby department feels colder than the rest. And the last time I was back in the baby department prowling the aisles for Sara (and for a great price on a baby shower gift), I heard a thud coming from the chilly aisle I had just left. I walked back and saw a value-sized package of baby wipes lying on the floor of the deserted aisle.

The Girl Loves Shoes

Several employees of the Route 59 Wal-Mart have reported seeing a pretty little girl seated on the floor of the shoe aisle trying on a pair of shoes. It is such a commonplace sight that it takes a moment for the employee to remember that it is 2:00 in the morning and the store is closed! They step back to take another look, but the little girl is gone, though the shoes and shoebox are still on the floor.

Loading Dock Lurker

The third ghost to haunt the Route 59 Wal-Mart hovers at one of the warehouse loading docks. He has never been seen—this ghost is not so much an apparition as an uneasy feeling of a disgruntled masculine presence watching the men unloading the trucks. Workers unloading the trucks that pull up at that particular dock soon find themselves in a prickly, bad-tempered mood for no reason they can fathom. Yet when they finish and move away from the atmosphere, the inexplicable irritability quickly fades. It is such a strong feeling that truck drivers do not like to dock there, and if they do, the Wal-Mart workers unload and move to another dock as fast as they can.

Special thanks for this story goes to Ursula Bielski, noted author and owner of Chicago Hauntings Ghost Tours (www.ChicagoHauntings.com), who was the first to report on the Wal-Mart ghosts.

The Wal-Mart Corporation management officially does not support, endorse, promote, approve, or acknowledge this ghost story in any way.

OLD NICHOLS LIBRARY

James L. Nichols had a dream—to make books available for free to anybody who wished them. Upon his death in 1895, he had bequeathed $10,000 to the City of Naperville to build a library. The site of the former Clark residence was selected at Washington Street and Van Buren Avenue, immediately west of where the former DuPage County Courthouse used to stand in Central Park. Three years later, the James L. Nichols Public Library of Naperville opened to a grand gala—but without a single book on its shelves. The grand opening party became a book donation party, and nearly 300 books were gladly given to the new library from personal collections.

My personal memories of the old Nichols Library are both vivid and precious; pushing open the heavy swinging inner doors, the fragrance of old books and the ink used to date-stamp my selections for the week, the softly worn wood floors, the feeling of cozy, snug warmth as I slowly browsed my way through aisle after towering aisle of bookcases. Spectacular as the new Nichols Library on Jefferson Street is, I still yearn for the old place every time I gaze into the miniature replica of the first library display behind glass in the lobby of the new Nichols. Certainly the old Nichols Library had something special about it that the new library just does not have—a ghost.

Evenings in the original part of Nichols Library could get as lively as the days. Incidents included books being inexplicably found open on a table, or shelving themselves, and small objects vanishing and reappearing in unlikely places. Others reported the sensation of being watched, cold spots, strange white mists, or shadows that should not be there. Sometimes a librarian working late at night might catch a glimpse of someone moving among the bookshelves though the building was empty.

One night, the members of a ladies book club met the ghost in a most alarming manner. Their club met once a week in the original, main building after library hours. It was in the late autumn or winter months, so night had fallen though it was only 8:00 p.m. With coffee and cookies in hand, the book club got underway. They had scarcely taken their seats and opened their books when the room temperature suddenly plunged into an icy chill and a man winked into existence outside their circle of chairs. His clothes were the height of gentleman's fashion from the late 1800s—a classic Victorian morning coat with divided swallowtail-style coattails in the back, a patterned vest tightly buttoned over a slim torso, and a silk top hat, all in shades of gray. He strolled through their circle without a glance at the shocked ladies, headed into one of the book aisles, and vanished into thin air before their bewildered eyes! Needless to say, the ladies' book club adjourned very early that evening. Although they bravely came back the next week, everyone was too excited and jumpy all evening to discuss the book, so a new location for their meetings was agreed upon.

Who was this dapper gentleman haunting the old Nichols Library? It is tempting to say it was James Nichols, but it was built three years after his death. Perhaps his spirit peeks in anyway since it was his vision that brought the library to life in the first place.

The old Nichols Library is now the Truth Lutheran Church, offering services in both English and Mandarin. It is not known whether or not the ghost still makes his presence felt now and again. Perhaps he spirited over to the new Nichols Library on Jefferson Avenue, or maybe he haunts one of the new branch libraries on Naper Boulevard or Ninety-fifth Street? If so, he can be justifiably proud that Naperville Public Libraries have been named the number one top library in the entire nation—for an unprecedented ninth year in a row.

James Nichols would be so proud!

PHANTOMS IN THE FUNERAL HOME

It was a cold fall evening in 1983 when "Greg" first heard them. He and his business partner, "Owen," were working very late at their insurance agency office—one of several leased medical and business office spaces in the brick building on Van Buren Avenue. It was 11:00 p.m., and the building was empty but for the two insurance agents. The only sounds were the rustling of insurance forms, the scratch of their pens, and the occasional tired sigh from the overworked entrepreneurs—until several voices began speaking loudly out in the hall. Doors opened and slammed, and Greg and Owen could hear heavy footsteps climbing up and down the basement stairs. Had their landlord brought some friends down to the unfinished basement for some strange reason? Why so late at night?

Greg and Owen opened their office door and looked down the hall. Their office was situated at the end of the corridor that made up the eastern ell of the U-shaped building. The rear exit door was to their right, and the long hallway with its red carpet runner stretched to the left—but the hall was empty. They could still hear footsteps, slamming doors, and various muffled voices, but they could not make out what was being said. Suspicious now, Greg and Owen warily walked both east and west corridors and checked that all the main entrances and office doors were securely locked. Sure that no one had broken in, they opened the basement door. Now they could hear what sounded like furniture being moved around, and the voices were louder but no less indistinct. Although there was obviously a group of people down there, the basement was pitch black. No one had turned on the lights, though they must have been down there for a good five minutes now. Greg called down the basement stairs, "Hello? Who's there?"

The voices and sounds instantly fell silent. No reply, not a single noise, rose up from the dark, icy-cold basement. The hackles on the back of their necks stood up straight, and Greg quickly shut the basement door and slid home the flimsy bolt above the doorknob. "Stay here and guard the door!" Greg told Owen. "I'm calling the police!"

Moments later, two uniformed police officers stood at the front door (the police station was on the next block), and Greg let them in. They drew the bolt to the basement, turned on the lights, and called down. There was no answer and no sound. Drawing their guns, the police carefully crept down the stairs and carefully searched all around—but the basement was empty of people and of furniture, though the two agents had both unmistakably heard furniture being moved down there. Owen swore that he never budged from guarding the door, and no one had come up the basement stairs, which was the only exit. The police called the landlord, rousing him from bed to bring his keys so they could search every room in the entire building for the intruders.

Nothing and no one was found. Greg and Owen were utterly baffled, insisting that they had indeed heard voices, doors slamming, heavy footsteps on the stairs, and the sounds of furniture being moved around in the basement. It was only after the police left that their landlord hesitantly reminded the two men of something they had forgotten. This building used to be the Beidleman-Kunsch Funeral Home prior to building a new location a few doors down in 1966. The cold, unfinished basement is where they used to store the "customers" in their coffins until it came time to bring them upstairs to the parlor for their funeral.

Today the Van Buren parking garage stands on the same block as the former funeral home and medical office building. If you ever stand on the main level of the garage at 11:00 p.m. on an autumn night and pause to listen intently, just tell yourself those indistinct voices you hear coming from below are simply late-night revelers looking for where they parked their vehicle.

Yeah, sure, that is all it is.

T.G.I. Friday's Restaurant Ghost

It was Halloween, and the lovely waitress with the sunny smile was working past closing time to hang the spooky decorations to get the casual restaurant and bar into the spirit of the season. She was standing on a ladder that was precariously perched on a cooler, and she was stretching up to reach a stack of Halloween decorations from a raised storage area. Suddenly she lost her balance and plummeted 14 feet to the concrete floor, her neck snapping instantly on contact. She did not even have time to scream before she died. It all happened so fast, she did not even know she was dead.

Some say she still does not know she is dead.

That is the legend told at the T.G.I. Friday's Restaurant on Naper Boulevard and Ogden Avenue. Customers hoping for spooky thrills flock there on Halloween, hoping that the cheerful, pretty ghost will visit their table to take their food and drink orders, like the story goes. They say she looks real—not insubstantial or ghostly at all. You only know she is a ghost when she does not come back with your drinks. Catch another server passing by and tell them your waitress has vanished and they will simply nod knowingly, apologize, and gladly retake your order. Just be sure the flesh-and-blood server gets the tip!

It is just a good, fun, Halloween ghost story, right? Tragically, no. This story actually happened to a young Naperville woman named Christina, age 24. It was 2:00 a.m. in the early morning hours of Friday, October 28, 1994, when she had her terrible fall at the T.G.I. Friday's Restaurant where she had been employed for two and a half years. Now, many years later, the staff loves to whisper their stories of the ghost's shenanigans, and customers eat it up along with their juicy burgers, potato skins, and ribs.

Sure, ghost stories are fun to hear, and even more fun to tell, especially at Halloween. But, as with all ghost stories, let us not ever forget that there are real human beings behind these tales—wonderful, unforgettable, good-hearted people like Christina, whose life and dreams were cut short and who left behind grieving loved ones far too soon.

Please note that the T.G.I. Friday's Corporation management officially does not support, endorse, approve, promote, or acknowledge this ghost story in any way. Sleep well, Christina.

115

A highly credible eyewitness saw a ghost walk through this wall before the grand opening of Le Chocolat Bar. (Author's collection.)

LE CHOCOLAT BAR GHOST

One week before Christmas 2007, Cathy Bouchard and two friends were standing in the downstairs main room of Le Chocolat Bar, discussing the finishing touches they still needed to do before the new shop's grand opening in a few days. Their backs were toward the tall shop windows overlooking 129 South Washington Street, and although the winter sunlight was bright, the heavy craft paper covering the glass from top to bottom cast the room in gloom. Soon the craft paper would be torn down and curious passersby would finally be able to see the charming chocolate delights inside, as if the warmly decorated, candlelit, cozily old-fashioned shop and restaurant were a wrapped Christmas gift Cathy had made especially for Naperville.

Cathy and friends were deciding how to arrange the sumptuous chocolate gifts they would display in a corner showcase, when Cathy saw a man's reflection in the mirror-backed case striding unconcernedly along behind them.

"I remember he was average height, average weight, with sandy brown hair," stated Cathy. "There was nothing at all remarkable about him, except that he was wearing all white, like a carpenter's coverall, and there was a faint glow around him. I didn't pay much attention to him at the time. I thought he was just someone passing by on the sidewalk outside." In three casual strides the man was gone from view.

Cathy recalls feeling an excited thrill at the thought that soon customers like that man would be coming in the door, setting the bells to jingling. Shoppers would gaze around in delighted admiration at the colorful boxes and old-fashioned display cases of the finest chocolates imported from around the world. They would sit at the warmly gleaming café tables or comfy lounge chairs or belly up to the marble-topped bar for a martini glass of rich hot chocolate and a slice of molten truffle cake, a melting pot of glorious Belgian fondue, or . . . Whoa, wait just a minute. A sudden thought interrupted Cathy's sweet entrepreneurial daydream like a cold dunk in a snowbank. The windows were entirely covered in craft paper; there was not so much as a peephole to see through. No one on the sidewalk could see inside, but that also meant that no one within the shop could see the street outside. That man she saw in the display case mirror could not have been passing by outside—he had to be inside the room with them!

"Don't move! Don't anybody move!" Cathy ordered her bewildered friends and then cautiously searched around the shop. She called out to the second-floor loft, "Hello? Is anybody there?" hoping one of the construction guys was putting in an extra hour, even though she knew they were long gone. No reply. The shop was empty except for them. But who was that man in the white coveralls? Where had he come from—and, more significantly, where did he go?

Cathy was able to re-create his route exactly as she had witnessed it in the mirror, but it only deepened the mystery. He could not have come in through the front door; the three ladies would have seen him immediately. Somehow he would have had to appear in the middle of the room, stride behind them without making the tiniest sound, and then walk directly into the wall and vanish!

Soon after that incident, several other unexplained events occurred in Le Chocolate Bar. Display items mysteriously moved by themselves to another shelf or counter across the room. The glass doors of a newly arrived kitchen oven inexplicably shattered overnight, although the shop was locked, the oven was not even plugged in yet, and the glass was supposedly shatterproof in extremes of temperature (the mystified manufacturer swore it had never happened in all the 60 years they have been in business). The stereo system had a habit of suddenly blasting music, the volume control knob visibly rotating a turn and a half from a setting of 15 to 30 within a second, though no hand touched it.

Cathy Bouchard had never believed in ghosts until that day. She had been called crazy before when she was the first person nationwide to promote 70 percent dark cacao as a sweet relief from the pain of fibromyalgia, among other impressive health benefits. After countless studies,

scientists, chemists, and candy manufacturers alike began to sing the praises of dark chocolate, and no one called her crazy anymore. Instead they called her "visionary" and "inspiring" and showered her with awards, commendations, and invitations to public appearances.

Cathy Bouchard does not care if people call her crazy again for believing in ghosts. She knows what she saw that day in her shop right before Christmas—a full-bodied, supernatural apparition, seemingly as real and solid as any customer, who vanished into the wall without a sound. Was it a ghost she saw? Or, as some wistfully believe, perhaps he was a radiant Christmas angel all in white visiting the newest shop in downtown Naperville? After all, isn't a chocolate shop a little piece of heaven on earth?

Soon after my interview with Cathy Bouchard, I came across an old 1960s photograph of the shops that once lined that block of South Washington Street. Curiously, the same site where Le Chocolate Bar now stands used to be the storefront for H. J. Doolin and Company, real estate builders—certainly a place one might expect a spirit in white carpenter coveralls to linger in. On February 13, 2009, a psychic claimed to speak to a presence of a man named Ned who "works with his hands" and will not leave until he has "finished his job" on the brick wall. Attempts to find any records of this individual have so far been unsuccessful.

THE GHOST WOLF OF NAPERVILLE PLAZA

Naperville's first shopping mall was the Gartner (now Naperville) Plaza Shopping Center, an elbow-shaped strip center on south Washington and Gartner Streets, built in the 1960s by Naperville's developer king, Harold Moser, and Dr. Glenn Wolf, back when Naperville's population was a mere 18,000. A highly distinguished and beloved physician in Naperville, Dr. Wolf also played an integral role in converting the Edward Tuberculosis Sanitarium into Edward Hospital in 1955.

The stately redbrick, white-columned, corner building in the plaza center was designed to be Dr. Wolf's medical offices (now occupied by ReMax realtors and a Language Stars learning center). The mall's major retail anchor establishment was Grant's Dime Store, a general merchandise and hardware store, which is currently Trader Joe's. Even today many old-time Napervillians still refer to the vastly expanded shopping center interchangeably as Grant's Plaza or by its original name, Gartner Plaza.

Dr. Glenn Wolf's life was a blessed one. A country farm boy who put himself through medical school, he was an old-fashioned general family doctor who gladly made house calls at midnight to ease a child's cough or deliver a baby. He was a jovial, positive force in people's lives, freely giving a helping heart, healing hand, and funny jokes in equal measure.

But on the evening of July 17, 1974, Dr. Glenn Wolf went up to the roof of his medical office at the plaza and shot himself in the head. His motive remains a mystery even to this day. He never showed signs of depression or spoke about suicide, no note was found, and the entire incident was shockingly out of character for him. The general belief was that he must have discovered that he was terminally ill, perhaps with an inoperable brain tumor. He was a doctor; he knew the score. So rather than put himself and his family through a long, agonizing slide toward death, Dr. Wolf chose to die by his own hand, or so it was said. His secrets went to the grave with him. He was a greatly loved doctor in the community; a laughter-loving, charismatic man who helped so many; a healer who made such significant and lasting contributions to Naperville. Many wondered why he chose the roof of his clinic to commit his final, fatal act? Why not shoot himself in his office? We will never know, but one likely theory is that the roof was the best place to proudly view the entirety of his brick-and-mortar legacy one last time—the plaza, Edward Hospital, and the town that he so dearly loved.

It came as no surprise that his closed-casket funeral was one of the most well attended in Naperville's history. And considering the tragic drama of this local hero's departure, nor is it

surprising that rumors soon began to circulate. While Dr. Wolf was able to spare his family the suffering they surely would have gone through following his disease to its natural end, was he ever able to really "let go" of his beloved clinic? Residents of the West Highlands subdivision whispered that Dr. Wolf's ghost could sometimes be seen atop the former Wolf Medical Center roof, pacing back and forth, weeping and wringing his hands as he gathered courage in the moonlight to go into the eternal night.

In the summer of 2006, "Kathy" and a coworker were working the late-night Saturday shift at Trader Joe's. Kathy's coworker spotted an elderly man walk past the front of the store and pointed out to her that it was odd—though cool—to see "an old guy" walking around at such a late hour. The following Saturday night Kathy saw the old man for herself, ambling along the sidewalk at a curiously late hour of the night, long after the stores were closed and dark and the parking lot was empty. He was a fairly tall, lean, gray-haired man, wearing a gray or brownish-gray jacket and a hat that might have been a skullcap. He ambled rather than strolled, with a stooped, almost dejected demeanor down the length of the plaza sidewalk, his hands shoved deep inside his pockets.

Then in the early autumn of 2006, another employee—we will call him "Jason"—was finishing his work at Trader Joe's very late. As he walked out to the parking lot, Jason said he saw, "an old duffer shuffling along the sidewalk." Curious and somewhat suspicious as to why someone was out at such an unusually late hour, Jason got into his car and began to slowly follow the man as unobtrusively as he could in an empty parking lot. Jason was able to maintain visual contact until the subject of his surveillance got to the Empress Nail Salon at the end of the plaza and rounded the corner toward Catalpa Lane. Jason gunned his car to race to the spot where he had last seen him and looked down along the side of the building. The mysterious old man was gone. The area was an open, clear greenway—no shrubs, trees, or even a flowerbed for a man to hide. It was impossible, but Jason saw neither hide nor gray hair of the elderly man anywhere. Somehow the senior citizen would have had to shuffle along the full width of the building then duck behind the nail salon to have vanished within the mere seconds it took for Jason's car to reach the corner.

"Rachel" was a new manager at the Trader Joe's store and unaware of the whispers circulating about the mysterious elderly gentleman. One morning at 4:00, she had just started her shift and was assembling a display of new grocery items at the front of the store when she suddenly felt an icy chill at her back, raising goose bumps along her arms. She spun to see an old man in a brownish-gray jacket, standing just inside the store's *locked* front door. He did not say a word, he just stared at her. Rather unnerved by the unexpected intrusion, Rachel quickly glanced behind her to see if any other crew member was in the vicinity, but no one was near enough. Rachel turned back to tell the unwelcome visitor that the store was closed and he should not be in there, but he was gone. He had disappeared without making a sound, even though he had been standing just a few feet away. She immediately ran to notify her boss that there was a strange man in the store, and a search was conducted without finding any trace of him. They double-checked all the doors to be sure they were still locked and secured. How could he have escaped? How had he gotten inside in the first place? Rachel was so obviously shaken by her encounter that no one could doubt her story, and they asked her to describe what the man had looked like. She gave a startling description of the same mysteriously vanishing elderly gent seen weeks before by Kathy and Jason and by yet one other manager who stepped forward to admit having seen an old man of that description meandering past the store at odd hours. All four of them agreed—something very strange was happening in Naperville Plaza.

You can just imagine Kathy's shock when, not long after these encounters, she read a brief article in the October 2006 issue of the *Eerie E-News* (the online newsletter for my Historic Ghost Tours of Naperville) about the ghost appearing on the roof of Naperville Plaza. The article closed by asking local residents if they knew anything more about the alleged ghost.

Dr. Glenn Wolf is seen at his family farm—now the Target store on Route 59. (Courtesy of Norma Yeates.)

Kathy e-mailed me promptly with detailed descriptions of the recent encounters that she and her fellow coworkers at Trader Joe's had experienced. She wondered what Dr. Wolf looked like before he chose to end his life and asked me if I could find any photographs of him. Could he be their mysterious vanishing man? The following series of e-mails between Kathy and me, published here with very minor edits, unfolds a startling story of the paranormal that even today still has the thrilling power to raise the tiny hairs on the back of my neck:

Hi Kathy; Good news! I found a photo of Dr. Glenn Wolf! Not-so-good news: it was taken quite some time ago, so he's middle-aged in the photo. Hopefully you and your co-workers can tell if the man in the photo resembles the old man you've all seen. I'm dying to know. –Diane

Hi Diane; Please send the photo to me here at work. I can't wait to see it. I think I'll poop my pants if it's the same person I saw. Thanks for doing this. Kathy

Hi Kathy; I'll drop it in the mail tomorrow morning. Hmmm, are you sure you want to risk pooping your pants in the office? :-) Please drop me an email ASAP to let me know if the photo resembles your guy. I'm on pins and needles with anticipation! –Diane

Hi Diane; Now that I've cleaned up the area around my desk (after pooping in my pants), yes, I would definitely say that this could absolutely be a younger version of the gentleman that I saw strolling past Trader Joe's. The posture of the neck and the hand placement on the hips is also very reminiscent of the figure that I saw. Put some gray hair on this guy, and you've got your ghost. I work at Trader Joe's tonight, so I'll see if I can get any feedback on this. I'm not sure who's working tonight, so it may be a week or so before I get a response from the others who've seen our spook. Thanks for sending this. Kathy

Hi Kathy; Wow! That's incredible, thrilling and creepy all at once! Let me know ASAP what your fellow employees say about the photo. I can hardly wait! –Diane

Hi Diane! Official feedback from two of the folks at Trader Joe's who looked at the photo of Dr. Wolf: [Rachel], the Manager who witnessed the stranger inside the front doors of the store—"Yup. Put gray hair on this guy, and you've got your man." [Jason], the kid who first sighted the elderly gent and commented on how cool it was to see an "old guy" walking in front of the store so late at night—"Yeah, this looks just like the guy I saw, except with darker hair. Cool!" So, do we either have a real live human being who hangs out at the Gartner Plaza at crazy hours of the night who happens to look incredibly similar to our dear departed Dr. Wolf? Or do we really have Dr. Wolf himself? Coincidence? You decide. I'm not sure exactly what I believe myself. All I know is that it's pretty weird. Kathy

Hi Diane; Just to update you on the Ghost of Gartner Plaza; Nothing new to report. Back in April I posted Dr. Wolf's photo on the wall in the Break Room at Trader Joe's, and after that, sightings of him dried up completely. No one has seen hide nor hair of any elderly gents lurking about at strange hours of the night. My guess is that either we all spooked him (pun intended) by constantly being on the look-out for him at Trader Joe's, or he was not happy with me posting his photo and decided to take a hiatus for awhile. Either way, no more Dr. Wolf stories. A few days ago I took down his photo, so maybe he'll return. I'll let you know if there are any more sightings or strange happenings. Kathy

Beidelman Furniture building is seen around 1924, located on the corner of Washington Street and Jackson Avenue. (Courtesy of the Naperville Heritage Society Collection at Naper Settlement.)

Hi Kathy; Bummer news about the Doc. Here's a thought—maybe he only walks in certain months. That's fairly common. The Naperville Cemetery has a "Mary Poppins" lady ghost who prefers to walk in July, August and September. Gee, what a shame we can't get those two crazy kids to meet. They'd be a perfect couple! :-) –Diane

THE COFFIN-MAKER'S GHOST

On the northwest corner of the South Washington Street and Jackson Avenue stands one of Naperville's most venerable business establishments, Beidelman Furniture (the first two syllables rhyme with the German city Heidelberg). Erected in 1928 over the razed remains of the Fred Long undertaking and furniture store, Oliver "Dutch" Beidelman took over his uncle Fred's business and expanded it to become the last downtown business to survive virtually unchanged into the present day. Today stepping into Beidelman's furniture store is to step back into the grace and charm of a bygone era and yet be surrounded by the treasured, handcrafted furniture heirlooms of tomorrow.

At three stories high, Beidelman's was the tallest and most modern brick structure in 1920s Naperville. The first and second floors were where they sold the practical, stylish household furniture that master craftsmen built in the basement or in the narrow woodworking shop attached to the store along Jackson Avenue. The furniture shop did a brisk business, but it was their other line of work that provided the steadiest stream of income—undertaking.

In Victorian times, furniture builders commonly crafted wood coffins and caskets, so undertaking became a natural extension of their services. Row upon row of handsome, gleaming coffins were showcased on the third floor of Beidelman Furniture so grieving family members could browse for a loved one's final resting place with a degree of privacy. Beidelman's was full-service: it operated the only ambulance in town, a morgue stood discreetly tucked behind the woodworking shop on Jackson Avenue, and a funeral parlor and chapel were built onto the store along Washington Street (which is now Penzey's Spices). For the convenience of mourners, a children's playground stood on the strip of grass along Jackson to provide entertainment for the kiddies while their parents paid their respects in the funeral parlor.

Perhaps it is because of that playground that the rascally little boy ghost named Dutch came to haunt the decades-old furniture store, although no deaths have yet been found to have occurred there.

Naperville lore says that a little boy, who loves to run around after hours on the second and third floors, haunts this furniture shop. No one knows who he is, but some past employees fondly call the ghost Dutch, after Oliver "Dutch" Beidelman, who devotedly worked at his furniture store into his 90s. For decades, employees have heard a child's light footsteps running around the second floor. They can follow his flight from below simply by listening to the creaking and groaning of the upstairs wood floor from one end of the building to the other. If an unsuspecting visitor goes upstairs to investigate, the games begin! The footsteps will dash behind a sofa—then, as the visitor approaches it, they will suddenly be heard over by a chair, then perhaps from behind an armoire or a table, leading them on a merry chase. Apparently, Dutch loves to play hide-and-seek!

Dutch seems to prefer the upper floors as his playground, but late one dark October night in the 1980s, he came down to visit the first floor. A longtime employee was working on the accounting books alone in the store, seated behind the counter at the back of the main-floor showroom. Suddenly the heavy old wooden door to the back office swung open behind her with a long, drawn-out creak. She looked up, surprised that anyone else was still in the store with her—but no one came through the door. After a puzzled minute of waiting she got up to close the door and noticed the office inside was freezing cold—so cold she could see her breath as she stood in the doorway. She kept the door open to circulate some warm air into the office, then

Y. M. C. A. Naperville, Ill.

Naperville's YMCA, as seen in 1917, located on the intersection of South Washington and Van Buren Streets, is supposedly home to a vagabond ghost from the Great Depression era. (Courtesy of the Naperville Heritage Society Collection at Naper Settlement.)

shrugged the incident off and went back to the accounting books. After she finished the last calculation and stood up to stretch, to her total surprise she saw that the heavy wood office door was now shut tight. She had not heard it closing at all—no creak, no click of the latch or rattle of the brass doorknob, not even the thump of the door hitting the jamb. That heavy, thick wood door had somehow closed in total silence—without a living hand to move it! Needless to say, she hurried out of the shop and did not stay late alone after dark at the store anymore.

One last eerie note: deep in the basement of Beidelman's furniture shop, back past the closeout furniture and in the depths of a very dark, abandoned old workshop room—there lies a child's coffin. It is unused, of course, built long ago in hopes of displaying it in the third-floor showroom. The lid of the coffin is cut out to hold a pane of glass so the grieving Victorian family and friends could gaze on their dead child's body as it laid in its handsomely handcrafted, satin-lined, genuine Beidelman's coffin. The very sight of that tiny coffin evokes a feeling that is both achingly sad yet very, very creepy at the same time.

IT'S FUN TO STAY AT THE YMCA (FOREVER)

Naperville had a serious problem. The young folk in the town had nothing constructive to do with their evening hours, so they were spending all their time and money in Naperville's many downtown bars. Freely flowing liquor combined with heated talk of politics and sports generated a nightly epidemic of drunken brawls, public peeing and vomiting in alleyways and streets, vagabonds and wastrels sleeping it off in the gutters—it was an outrage and a disgrace that shocked the sober, churchgoing residents of Naperville.

A typical Saturday night for today's college students? No, it was 1909. Some things never change, especially bored teenagers looking for an excuse to ease the strain from the mountains of homework.

In March 1909, the minister of the Grace Evangelical Church on Ellsworth and Van Buren Streets proposed the town petition the Young Men's Christian Association—the YMCA—for a Naperville chapter of that decent, respectable establishment where young men could gather and participate in manly sporting endeavors. At first, the Chicago chapter of the YMCA said that Naperville, with less than 2,000 residents, was too small to support its own YMCA. But the citizens were determined and started a huge communitywide fund-raising drive that gathered over $26,000 in 15 days—a remarkable sum for a sleepy rural burg!

March 26, 1911, was the formal dedication of the Naperville YMCA on Washington and Van Buren Streets—the smallest community in the nation at that time to have its own YMCA. Uproar ensued in November of that year when women and girls fought to be allowed to enter the all-men's YMCA—but they won only one and a half hours every Wednesday afternoon.

The third floor was reserved for temporary low-cost rooms for men, mostly traveling salesmen or for good, teetotaling Christian men who refused to sleep in the rowdy saloons that seconded as hotels. During the Great Depression of the 1930s, more and more YMCA third-floor residents were poor, ragged men down on their luck, looking for a roof over their heads and food in their bellies while hoping to find a job.

One such homeless man—we do not know his name, where he was from, or his story, but we are sure his was a sad story—was a frequent resident of the Naperville YMCA. He would stay a few weeks, working odd jobs for a meal or a few pennies, then travel on to another town, another YMCA. He never stayed for long, but he always came back to Naperville. The townspeople were nice to him, on the whole, and the pride they took in their hard-won YMCA facility was evident in its cleanliness and in the clothes and other necessities the townsfolk generously donated, even though times were hard. The homeless drifter gladly helped out at the YMCA where he could, doing whatever was asked, though he had no job and no money. It was his way of giving back to the people who were so kind to him and to the place that was the only home he had. Despite

the vagabond lifestyle that poverty had forced on him, he was a quiet, hardworking man who never made a fuss, kept to himself most of the time, and was well liked by the staff and other YMCA residents.

During his last visit, this poor drifter fell sick. While recuperating he would spend his days looking out the third-floor windows for hours, watching the people pass, smiling and waving cheerfully, if weakly, at anyone who looked up. Then one morning, the cleaning staff found him in his room lying peacefully in the narrow bed. He had died in the night.

No one knew if he had family, so he was buried in a pauper's grave in Naperville Cemetery. But, just as in life, he did not stay there for long.

Soon after his burial, the YMCA staff and other residents began experiencing strange things on that third floor. Books would mysteriously move off their shelf, and board games set up for the current third-floor visitors to play would have game pieces and cards rearranged when no one was present. The men would see a man sitting by the street windows and assume he was just another vagrant seeking shelter—until one occasional resident recognized the drifter and, not knowing he was dead, approached him to say hello. To his shock, the drifter turned, smiled up at him, and vanished before his eyes! The story of the drifter's ghost spread, and others realized they had seen the ghost quite often: walking down the hall, entering one of the small bedrooms, and always gazing peacefully out the front windows.

Well into the 1980s, the Naperville YMCA allowed men who could not afford a hotel to stay up on the third floor. All the residents knew the story about the ghost, but they did not mind him. Why should they? He was one of their own, a drifter and a loner looking for a home.

Today the old bedrooms on the third floor of the YMCA are offices for the staff, yet strange things still happen up there every now and then. Employees have heard footsteps down the hall late at night when no one else is in the building. Some employees will not take their lunch breaks in the third-floor lounge because it feels "creepy" and "heavy," as if someone unseen is watching them.

It is rumored that one office in particular is quite lively, with things moving around on the desk, furniture shifting, and the door opening and closing by itself. Employees whisper it is the same room the old drifter had died in.

So if you look up at the third-story windows of the downtown Naperville YMCA, you just might catch a glimpse of a ragged man's thin, pale face gazing down at the street. If you do, do not be afraid. He is just a poor, down-on-his-luck drifter who at last found his true home up in heaven but who still likes to drop by now and then to stay at the Naperville YMCA.

QUIGLEY'S IRISH PUB

Step inside Quigley's Irish Pub at 43 East Jefferson Avenue and you will feel like you just stepped back a century or two into the cheerful, cozy warmth of a classically handsome Dublin pub. From its custom, hand-etched stained glass, antique fireplace, and smoking room lined with bookcases (all imported from Ireland) to the intimate snugs and the authentic Irish whiskey and ale, Quigley's is the essence of the Gaelic word craic—good friends, good food, good times—a heartwarming sense of belonging.

But turn immediately to your right, climb up two steps into another room, and suddenly it is Naperville around 1917 that you will step into. American history resides in the dark, hand-hewn wood beams along the low ceiling and in the rough-cut stone foundation walls of Quigley's Cottage Room. For these are the original building materials untouched from the days when it was the billiard room of Francis A. Kendall, mayor of Naperville from 1913 to 1917.

Now home to the Jefferson Hill Shops, this impressive colonnaded home first began as a plain, one-story cottage built in 1845. Francis A. Kendall came to Naperville in 1877 as a student of North Western College (now North Central College), studying education. After graduation,

he was superintendent of Naper Academy (now Naper Elementary School) and then principal of Lisle Graded School (now Ellsworth Elementary School). He met and married Linnie Mae Strubler, the granddaughter of one of Naperville's first pioneering families.

Kendall greatly expanded the cottage on the hill into the elegant white mansion we know today, inspired by the fashionable Greco-Roman architecture style he admired at the 1893 World's Columbian Exposition in Chicago. The mansion's classic revival–style architecture is beautifully showcased in the dentil molding and pediment along the new second story and the impressive portico with its Ionic columns and magnificent fanlight over the front door. The southwest corner of the original cottage's foundation became Kendall's beloved billiard room, where the most prominent gentlemen of Victorian Naperville society gathered to relax, smoke, drink, and discuss such important issues of the day as politics, women, philosophy, women, literature, women, sports, and, undoubtedly, women.

Perhaps the ghost that is said to haunt the Cottage Room at Quigley's Irish Pub is not the remnant of a single human entity but rather the lingering spirits of a Victorian gentleman's game room, its limestone walls and wood beams saturated with ghostly memories of good friends, good conversation, and good beer. A solitary ceiling light occasionally flickers off and on like Morse code, despite numerous attempts by electricians to fix the problem. Chairs are found pulled out from the tables long after everyone is gone, and sounds of murmurs, laughter, and billiard balls clacking together have been reported, though muffled and distant as if coming from faraway down a long, echoing hall.

The Cottage Room is not the only place in Quigley's where people have wondered if a supernatural presence makes its home. While closing up for the night, two female employees were startled to hear the motion-activated hand dryer in the ladies restroom suddenly going off—though no one was there.

In the Cottage Room is a door marked "employees only" that takes employees into the labyrinthine, low-ceilinged, narrow corridors directly beneath the mansion itself. Deep in this gloomy, 160-year-old basement of rough foundation stone and white-painted wood is where the manager's office is located. Every night—long after everyone has gone home and the entire building is securely locked and dark—the manager sits alone in that creepy, musty basement counting the day's take. And every night, sometime between the hours of 2:00 and 3:30 a.m., she will hear a door open and close, open and close, coming from somewhere inside the empty house. No matter how many times she has gone up through the mansion to carefully investigate what door is being opened (and who is opening it), she is unable to track the sound to any single door. And though she rattles the doorknobs to find that all of them are locked tight anyway, she can still hear a door open and close—the sound coming from nowhere on this plane of existence.

Could the source of this mysterious door sound be the tragic spirit of Naperville's own war hero, Oliver Julian "Judd" Kendall, walking through the house where he was born and raised? Born on December 30, 1888, Judd dearly loved his hometown Naperville. After spending a year at North Western College, he took a job working for the Chicago and Northwestern Railroad. But at the outbreak of World War I in 1917, Judd joined the army and was promptly dispatched to the bloody battle lines of France, where he earned the rank of first lieutenant of the First Engineers.

In the early-morning hours of May 25, 1918, Judd Kendall was in charge of a group assigned to dig and outfit trenches for a secret, carefully planned attack on the once-lovely village of Cantigny, France. Captured and strongly fortified by the German 18th Army during the great offensive that swept through France, the Battle of Cantigny was to be the first sustained American offensive in the war.

Suddenly incoming sniper fire from the enemy lines sent Judd and his men scattering for cover. They could not continue the work on the trenches, so Judd left a senior noncommissioned

The 1890s mansion of the former mayor of Naperville, Francis Kendall, and his heroic son, Judd, is now home to the shops of Jefferson Hill and Quigley's Irish Pub. (Author's collection.)

Oliver Julian "Judd" Kendall sacrificed his life to save his fellow soldiers in World War I. (Courtesy of the Naperville Heritage Society Collection at Naper Settlement.)

officer in charge. Then he snuck forward, hiding in the predawn shadows, to reconnoiter the enemy's position so his fellow soldiers could take the sniper nest down.

Judd Kendall never returned. A German raiding party captured him. Recognizing his officer status, he was taken prisoner to the German headquarters five miles behind enemy lines for three days of intense questioning and torture. Judd knew the details of the planned Allied attack on Cantigny—and the Germans did everything they could to make him talk.

"Everyone knew, if the Germans could gain the slightest information of the impending attack, they would have wiped out the First Division as it was forming for the attack," wrote Capt. Shipley Thomas of the First Division in a letter to the Kendall family. "Upon your son hung the lives of 12,000 infantry of the First Division."

The morning of the attack, May 28, 1918, the Americans hoped for the best but braced for the worst. Surely Judd must have told the Germans something of their attack plans. Who could stand up under sustained torture for three days? Everyone feared the enemy had wrung valuable information out of the captive and even believed that German soldiers lurked in hidden fortifications within the village ready to spring the Americans' trap.

It came as something of a surprise to discover that their attack against the German army at Cantigny was a success. After a two-hour advance artillery barrage, including heavy guns, trench mortars, flamethrower teams, and 12 tanks from the French, the American infantry took the village. The Germans counterattacked seven times over the next two days, but the U.S. forces held their position, capturing 100 German prisoners but suffering the loss of 1,067 casualties. One of those casualties was Judd Kendall. His body was found near the site of the German regimental headquarters outside Cantigny. His throat had been cut. Naperville's son, Judd Kendall had endured days of torture in German hands yet steadfastly refused to betray his country and regiment; by his courageous, unselfish sacrifice, he saved nearly 12,000 American lives. He was only 30 years old.

Judd never came home to his beloved town of Naperville. Instead he was buried alongside his brothers-in-arms in Somme American Cemetery in France. Memorials of Judd's courage, strength, and heroism are scattered throughout Naperville, including Kendall Park on Washington Street, the Judd Kendall VFW Post 3873, and, in August 1998, the Oliver J. Kendall School on Naperville's southwest side. On Memorial Day 1998, the 80th anniversary of Judd's death, he was posthumously presented with the Silver Star and Purple Heart medals, and, on behalf of a grateful French government, the World War I Victory Medal, the French Croix De Guerre Unit Citation, and the French Fourageres.

You can be sure that in those last terrible three days of his life, Judd Kendall's thoughts turned again and again to the people and places he so dearly loved in his hometown Naperville. Perhaps a bit of his indomitable, brave spirit still lingers in the corridors and rooms of his childhood home on the Jefferson Street hill. Perhaps he is one of the voices people say they hear, laughing and shooting pool in the Cottage Room at Quigley's Irish Pub. On the chance that it is him, raise a glass at Quigley's in a solemn toast to Judd—for being remembered is the greatest honor any war hero can ask for.

Naperville's Millennium Carillon is luminescent at night. (Author's collection.)

Five

HAUNTED MYSTERIES
THE UNEXPLAINED, UNCANNY, AND UNIDENTIFIED FLYING OBJECTS

Somewhere, something incredible is waiting to be known.
—Carl Sagan, U.S. astronomer and author of *Contact*

*I've been convinced for a long time that the flying saucers are real and interplanetary.
In other words, we are being watched by beings from outer space.*
—Albert M. Chop, deputy public relations director at NASA

*There is a theory which states that if ever anybody discovers exactly what the Universe is for
and why it is here, it will instantly disappear and be replaced by something even more bizarre and
inexplicable. There is another theory which states that this has already happened.*
—Douglas Adams, British author of *The Hitchhiker's Guide to the Galaxy*

LOST CHILDREN
Paddleboat Lake is a shining jewel along Naperville's Riverwalk, nestled between Eagle Street, Jackson Avenue, and Aurora Avenue. Laughing couples propel old-fashioned paddleboats over the serene, sparkling water in the summer months, and in the winter its frozen beauty makes a picture-postcard setting for children and families sledding down Rotary Hill to the west. All year long, the stately Millennium Carillon soars overhead, its dramatic accent lights shimmering on the water. It is a beautiful sight to delight both the eye and the soul; all of which makes it harder to believe that this lake at one time was the focus of one of the largest manhunts in midwestern history—a desperate search for two little lost children whose disappearance, to this day, remains a sorrowful mystery.

The last time anyone had seen Jean Petersen, age six, and Eddie Rosenstiel, age three, they were in Eddie's yard playing with the family cat, a black-and-white kitten named Kitty. It was cold that afternoon of December 7, 1952. Jean, sometimes called Jeannie, wore a bright red, parka-style wool coat, and Eddie wore white boots and a blue snowsuit so warm and puffy he could not lay his arms flat against his sides. A cowboy belt with toy holster and gun were wrapped around his waist. They lived next door to each other on Water Street along the DuPage River and were the best of friends. Christmas was approaching, and both kids were excited about the news reported in the *Naperville Clarion* that Santa was making a special pre-Christmas appearance in Naperville. Jean had even written him a letter asking for a new doll, doll bed, and buggy.

Every now and then Eddie's dad, Floyd Rosenstiel, owner of a shoe repair shop downtown, would peek out into the backyard just to make sure they were ok. But this was Naperville in 1952. It was a sleepy, peaceful little farm village of less than 2,000 people, where no one locked their doors at night and the worst crime to make the headlines was when a teenager was caught breaking a window at Highlands Elementary School. But all that changed on that cold December afternoon.

Paddleboat Lake and the Carillon are seen facing west from the Riverwalk off Eagle Street. In the winter of 1952, two children disappeared from here—a tragic mystery with lingering questions that remain unanswered to this day. (Author's collection.)

Floyd Rosenstiel called out for the kids to come in for Sunday supper. They did not come. He looked outside and saw that Jeannie, Eddie, and Kitty were nowhere in sight. He called up Jeannie's mother next door, the widow Mary Peterson, but the kids had not gone over there. Worried, they started searching, calling for the children. Their neighbors along Water Street heard the parents calling, heard the increasingly anxious note in their voices, and came out to join the search. Still the children were not found.

After two hours of fruitless searching they notified the police, who immediately put out a call for volunteers. Nearly 200 people responded, including the entire Naperville police force, firemen, war veterans, Boy Scouts, and the state police. Flashlights and lanterns swept the neighborhood all through the night without finding a trace of Jean and Eddie.

Monday dawned, and an invited, out-of-town guest arrived to a warm welcome—Bessie, a specially trained bloodhound owned by Roy Case of Sauk City, Wisconsin. She had earned a hero's reputation by successfully tracking missing persons in three out of four previous cases, including that of a drowned boy in the town of Sheridan. Hopes were high as Bessie sniffed one of Eddie's shoes to get the scent, then set off, nose to the ground. She went between the Rosenstiel and Peterson homes, combed the backyards, passed through a stone gateway heading down toward the DuPage, and then headed upriver. Bessie bayed briefly to indicate she found his trail and bayed again along the ledge on the far west side of the deep lake that was one of three former limestone quarries west of Eagle Street. She went around to the north side of this quarry along the river—and lost the scent. Too many well-meaning searchers—nearly 500 by then—had crisscrossed the area and churned the earth into mud, obliterating any lingering traces of Eddie's scent.

The searchers did not quite know what to make of Bessie's hunt. She seemed to indicate a possibility that the children might have fallen either into the quarry or the river. At Floyd Rosenstiel's request they brought in a second tracking dog, Jackie, a German Shepherd owned by trainer Louis Gessner near Chicago. Jackie followed the same route as Bessie but showed more activity alongside the DuPage River than the quarry and always ended up back at the Rosenstiel home. Bessie's owner, Roy Case, pointed out that both the bloodhound and Jackie had not gone to the water's edge either time, which proved to him that the children had stayed safely on land up to that point. Floyd Rosenstiel agreed, telling reporters, "little Edward was afraid of the water and then, too, I had warned him many, many times not to come here, and he was good about this."

To further deepen the mystery and ratchet up the anxiety levels, Bessie also seemed to scent Eddie by the Naperville Cemetery; and then a report came of a possible sighting of the children and small footprints in the cornfield at the William Hatch farm to the southeast. These clues led many to hope the children were merely lost. But after finding a green apple bobbing in the lake that matched others in the Peterson's kitchen, suspicion tilted back toward the quarry.

A brief history of the quarry is necessary here. Now called Paddleboat Lake, this limestone quarry was one of three in the area started by George Martin II in the 1850s, from land sold by Capt. Joe Naper to Martin's father. These quarries were known as Big Quarry, Little Quarry, and Paddleboat Lake.

Big Quarry is now Centennial Beach. George Martin II worked the main Big Quarry from 1856 until his death in 1889. His sisters ran it but eventually sold it to the Chicago and Naperville Stone Company. It was bought and turned into Centennial Beach in 1932 (Naperville's centennial was celebrated the year before). They had to move the DuPage River and take out a dam at the former millpond at Mill Street to accommodate the quarry operations. The bathhouse, Main Street bridge, and old Nichols Library are made of the golden limestone from Big Quarry.

Tucked away in today's Riverwalk woods just west of the Carillon, the smallest of the quarries, Little Quarry (now Netzley's Pond), was opened in the spring of 1884 by the Naperville Stone

Company, a joint venture of Ernst Von Oven and his nephew B. B. Boecker Sr. Twelve years later, Boecker's son, Arnold, died in an accident at the quarry. Grieving and dispirited, Boecker refused to work the quarry any longer, and the company eventually ceased its operations. They leased out to Dolese & Shepard out of Chicago, which by then was also operating the Big Quarry. Water seepage spelled the end for this tiniest Naperville quarry. Later the Netzley family, who owned the Chrysler car dealership on the corner of Chicago Avenue and Washington Street, built a lovely home overlooking the serenely beautiful, wooded lake, turning it into their private swimming hole greatly enjoyed by friends and family. Today the building is the visitor center for Millennium Carillon, offering tours and carillon lessons. Go around to the back to view this breathtakingly lovely pond from several vantage points.

Paddleboat Lake was also formerly called Little Quarry. George Martin II either sold or leased this quarry to Jacob Salfisberg who, strangely enough, variously spelled his name as Solfisberg/burg, Salisbury, and Salisberg in official records. It was a working quarry until 1917, when problems with water seepage and loss of manpower to the war effort caused it to be closed down. It soon filled with water and became an ugly, muddy fishing hole hidden by a growth of trees and brush, with a depth ranging from 50 to 90 feet deep in places.

After finding the apple in the quarry, everybody feared that one of three things had happened: Jeannie and Eddie had fallen into the quarry lake and drowned, they had fallen through the ice on the DuPage River and drowned, or they had been kidnapped. But since no ransom had yet been demanded the police suspected that they had been taken either by a "sexual degenerate" or a homeless "moron," as seriously mentally disturbed persons were referred to at the time. Someone voiced an opinion that a childless mother stole the kids away so she could have children on Christmas. It was to this hopeful, though unlikely, theory that the desperate parents clung.

The disappearance of Jean Peterson and Eddie Rosenstiel made the evening news on television that Monday night. As Tuesday dawned with still no sign of the missing children, volunteers began pouring in from a three-state area over the next few days to help in the search. The Salvation Army manned mobile relief stations to dispense hot coffee and soups, sandwiches, and baked goods, all donated by local Naperville restaurants, businesses, and churches. The U.S. Navy and Coast Guard dispatched crews and equipment to break the ice on the river and haul the blocks to shore to facilitate dozens of volunteers in hip boots wading in the freezing water, searching inch by inch for five miles up and five miles down the river. Airplanes of the DuPage County Civil Air Patrol and the Flying Farmers ranged over the sky, hoping to spot a flash of Eddie's blue snowsuit or Jean's bright red jacket from above. Naperville Saddle Club members combed the heavily wooded areas on horseback near the Edward Sanatorium, acting on yet another possible sighting. The Wilmette Life Boat Station probed the depths of the quarry with grappling equipment. All available state highway patrolmen, deputy sheriffs, and police from Aurora, Joliet, Downers Grove, West Chicago, and Elmhurst raced throughout a three-county area to follow up on reported sightings and tips called in by the hour. Teams of search parties conducted a house-by-house search of all cisterns, wells, barns, factories, and any other likely building where the children might be hiding. Television cameras and reporters from major news media nationwide descended on Naperville in droves to interview the volunteers and the anxiety-riddled parents, sending the harrowing story into homes around the country. But still there was no sign of Jean or Eddie.

John Magil drove down from Benton Harbor, Michigan, to offer his services as a professional deep-sea diver to explore the quarry. In sympathy for the distraught parents he waived his usual fee of $125 and charged only $1 to satisfy the requirements of his insurance. A raft from Centennial Beach was ferried overland to use as a diving stage, and employees of the diving equipment supplier Stanley Greer Company out of Chicago crewed Magil in the dangerous diving operation.

Nearly 200 people watched from shore as Magil plunged again and again off the raft and into the bitterly freezing water of the quarry. In "modern" diving gear weighting 190 pounds, he sank down as deep as 90 feet to search its murky depths as the crew above manned the air pump, massive air hoses, and a telephone cable to communicate with Magil. So muddy-black was the water that on his third dive Magil lost his bearings and became dangerously disoriented. It was only the experience of the crew on the raft who talked him through it that averted a second tragedy. The U.S. Navy promptly furnished powerful underwater lights, but even they could barely cut through the thick murk. As Magil told reporters, the quarry depths were "extremely treacherous, full of mud and loosened quarry stone which could easily trap a man." It was declared impossible to search the quarry, and Magil reluctantly ceased his diving operations.

That Tuesday night, December 9, the leaders of the search—including Mayor Charles Wellner, police chief Edward Otterpohl, and DuPage County sheriff Rollin Hall, among others—met with the Rosenstiels and Mary Peterson to discuss their grim options. Although no one had completely ruled out the possibility of a kidnapping, the overall consensus was that the children had fallen and drowned in the quarry. Someone had even given an old German superstition a try: that a loaf of bread with a candle in it would float directly over a drowned body. But the loaf moved only a foot or two. It appeared inevitable that the search would be called off. Just then, Marshall Erb, owner of a construction company and one of the first to volunteer in the search, spoke up. He offered all his company's excavating equipment at no charge to drain the quarry of water.

As a father himself, Erb knew the agony of uncertainty the parents were enduring, made all the worse by the upcoming Christmas holiday. He hoped that by draining the quarry they would learn the children's fate and give the parents peace of mind before Christmas. Erb's amazing offer was tearfully accepted, and Mayor Wellner immediately gave Erb total charge of the unprecedented task that was eventually called Operation America—a truly Herculean undertaking to empty the 300-square-foot, 90-foot-deep stone cavity of an estimated 81 million gallons of water.

By 7:00 a.m. Wednesday morning, Erb was on the telephone calling fellow contractors and area pumping outfits large and small. The response was overwhelming. Equipment, manpower, fuel, and supplies were willingly donated to the cause and began pouring in from as far away as Glenview and Rockford.

To clear a path for the heavy equipment, Erb used a bulldozer to cut and gravel a 100-foot road from the top of the quarry on Eagle Street along the DuPage River to the quarry's western edge. Today, decades later, visitors can stroll along that same path, now brick-paved and landscaped into part of the Riverwalk. By noon on Wednesday, 21 pumps lined the edge, ranging from the massive, industrial-sized behemoths of major dredging companies and two fire pump trucks to numerous smaller ones from local plumbers. Their incessant throbbing made a relentless, roaring din as the pumps gushed like 21 Old Faithful geysers into the DuPage River continuously for the next six days. Huge transformers and telephone equipment was brought in, and glaring searchlights were strung around the quarry so the operation could continue uninterrupted all night for five nights straight.

As the water level continued to drop it became apparent that the pumps could not draw water properly due to the extreme, 90-degree drop of the embankment. Erb brought in his massive clamshell to hew ledges from the solid rock sides. Platforms were built and conveyed by tractors and bulldozers to the site, and as each pump was lowered down by derrick, volunteers precariously stood on the frosty, slime-wet ledges to muscle the pumps into position and continue operations.

Welders cut and rewelded pipes on the spot to eliminate the high draft problem, as engineers managed the tremendous water flow from quarry depths to river through a hastily assembled

system of corrugated steel culverts. The powerful suction swept up hundreds of fish through one end and out the other, churning them into "fishburgers," as one worker called it, and tinting the river red with blood.

"This was one of the biggest pumping operations ever attempted in this part of the country," said Erb to a *Naperville Sun* reporter. "It was also one of the most hazardous jobs ever undertaken this time of the year in this part of the country. Ever present was the danger of men and equipment slipping down the embankments and into the quarry. We set up rope ladders for the workers and lowered some of them down with ropes."

Erb continued. "In reality, the biggest job wasn't pumping water, but moving the pumps down to the ledges of rock by manpower and machinery. Men risked their lives to do this, and yet there wasn't even a scratched finger, which is quite a feat, especially in view of the fact that so many of the men were inexperienced around machinery." The only reported casualty was Marshall Erb's voice after calling out orders for five days. He used a police whistle to get attention for the last days of Operation America.

A poem titled "The Pathos of Naperville" was printed in the newspaper, written by someone named only Wheaton's Heart, that eloquently spoke of a mother's anguish and the community's tremendous efforts on her behalf.

A Mother wild for a lost child
With eyes sad and red
In pity tones that would melt stones
Called out to me and said;—

"O, have you seen my little Jean
Here anywhere around?
She went away and people say
They fear she has been drowned!

Look everywhere with haste and care
'Neath star and moon and sun.
Look low and high and far and nigh
And find my little one!

Pause not to weep, question the deep
And ask of wood and tree
Till Heaven's King again shall bring
My little Jean to me!

O, strong, brave men go search again
The river, field and foam,
Till Jean is found, unharmed and sound
And safe back in her home!

Go Him implore who brought of yore
The lost sheep to the rest,
And on your knees with ceaseless pleas
Bring Jean back to my breast!

Your vigils keep and forsake sleep,
Nor list to song or sound,
Till field and glen are searched again
And little Jean is found!"

The best estimates put the total cost of the man-hours, equipment rental, fuel, food, and other supplies at $10,000 per day—a mind-boggling sum in 1952. But in an amazing spirit of compassion, everything was willingly donated by thousands of people to the common cause of finding Jean and Eddie. Newscasters kept a constant vigil of the operations, broadcasting nationwide on television and radio with stories of ordinary people going to extraordinary lengths—fighting the bitter cold, manning pumps and warming shelter fires around the clock, foregoing sleep for days, risking their lives performing dangerous, drudging labor for no compensation, no reward, at the dreary, bleak quarry. But despite all this misery, the volunteers worked without complaint, with only words of good cheer and encouragement on their lips. The eyes of America were fixed on this little midwestern town. Millions of hearts were deeply touched by the uplifting stories of the stupendous effort to find the lost children, as headlines and television newscasters proclaimed that the true meaning of Christmas is to be found in Naperville.

On Tuesday, December 16 the quarry was drained in its entirety, and in a record time of six days. And at the bottom of the quarry they found mud. Thick, black, stinking, smelly, disgusting, slippery sludge. Rising up waist deep in spots and extremely treacherous, the foul, fetid black slime trapped men and sucked their boots off even as they stumbled, gagging at the stench, over piles of sliding quarry rock underfoot.

Buried deep in the muck of the quarry floor they also found rusted old mine cars and iron rails discarded back when it was a working quarry. They did not, as Naperville legend would have it, find stolen cars filled with gin bottles dumped in the quarry back in Prohibition times, or fish-picked skeletons of former Al Capone rivals wearing cement shoes.

Nor did they find Jean or Eddie.

The next day, Wednesday, December 17, Erb lowered an earth-moving tractor into the bottom of the pit to scoop up the putrid muck into piles for searchers to go through, looking for the bodies or any trace of the lost children. Nothing was found.

Kidnapping was now the prime motive, and the FBI was called in. But without a ransom demand or any other evidence of a kidnapping, the FBI could not open a case. On Thursday, December 18, a massive new land hunt was organized, directed by Chief Deputy Sheriff Stanley Lynch. By Saturday, over 600 volunteers were scouring every inch of ground for miles around, desperately seeking any clue, any evidence, any inkling of where the children had gone.

After 10 long, grueling days and nights of nonstop searching, the police sadly called off the hunt. But they were quick to emphatically state that the case was still open, the search was ongoing, and they were constantly following leads that still came in from all over the country. Despite nearly 3,000 people systematically searching for 10 days—the largest, most extensive manhunt in midwestern history to date—there was absolutely no sign of the children.

There was one living being who knew what had happened to the lost children, but she was not talking. Twelve hours after the children were first reported missing, Kitty—the tiny black-and-white kitten that had accompanied them—dragged herself onto the Rosenstiel's back porch to their combined joy, terror, and anxiety. With the quarry empty, police theorized a kidnapper had picked up the children along Highway 65 (now Aurora Avenue) and put the cat out of the car after traveling some distance. Giving weight to the theory was the fact that the cat was so utterly exhausted it could scarcely walk—yet it mewed and cried so much it was almost as if she were trying to tell them where the children were.

Days passed. There was still no sign of the children. Trustee Fred Krienbrink returned money collected from the reward fund back to the many contributors. The news story moved from page 1, to page 4, and then page 15, until it vanished altogether, swallowed up by fresh tragedies. On December 27, Mary Peterson and the Rosenstiels all took and successfully passed lie detector tests, clearing them of any suspicion. The police were also interested in speaking with Mary Peterson's first husband, William Wagner, whom she had divorced in 1928 and whose last known address was in Indianapolis. Nothing came of that thin possibility either.

Yet the families desperately clutched to any scrap of hope, no matter how small. Floyd Rosenstiel admitted to the popular *Naperville Sun* columnist Genevieve Towsley, "We tried everything, even fortune tellers, although I never did put any stock in them. We went to two in Chicago and one in Aurora, but, of course, they couldn't help us. They were decent though, and wouldn't accept any money for their services."

Telephone calls and telegrams still poured in from people who thought they saw the children—in one way or the other. Ernest Muehle of Chicago claimed to have used a divining rod to seek out the children and claimed it placed them in the home of a Peterson relative near Naperville. This proved false, and poor Muehle endured several hours of intense police questioning until they were convinced he had nothing to do with the disappearances.

A fortune-teller from South Bend, Indiana, also contacted them, insisting she had "seen" the children in a vision. She sadly reported that they had indeed passed on to the other realm. Jean and Eddie's spirits asked her to tell their parents they were in the river, their bodies trapped in the roots of an old tree stump, so far below the water that no one could see them. As they had done countless times before, they searched the river yet again. They did find one such tree stump that the fortuneteller had described—but no children.

Then the Rosenstiels received a telegram from Richmond, Virginia, from a woman who claimed to have a psychic talking horse who had a vision that their children were still alive. Oh, the desperation of parents. Mrs. Rosenstiel and a friend traveled to Virginia to speak to the psychic talking horse. The owner of the horse first asked them a lot of questions, learning background information such as that they lived on the DuPage River. Then she asked her horse questions about the lost children. The horse "spoke" the answers through a combination of whinnying, hoof stamping, and mane tossing, and the owner "interpreted." After every three questions the horse would stop, and they had to pay the owner another dollar before she would prod the horse with a stick and make it continue. Ten dollars later, the talking psychic horse said Eddie and Jean were dead, that they were in a river trapped in the roots of a tree, and the river was called DuPage. It had been the cruelest of scams, and Mrs. Rosenstiel and her friend came back to Naperville angry, embarrassed, and despairing that they may never know what happened to Jean and Eddie.

Weeks passed. Christmas passed. The New Year 1953 dawned. There was no sign of the children. All hope was gone except in the hearts of the grief-stricken families. Jean and Eddie had simply vanished.

The morning of Tuesday, February 3, 1953—59 days after Jean and Eddie disappeared from their backyard—Richard Forrestal, a public service lineman from Aurora, was working along the riverbank making electrical installations with his crew. As he gingerly walked across the thick ice to the north bank he saw the face of a doll in a small hole in the ice, the big, china-blue eyes staring up at him under a thin coating of crystal clear ice. He felt a momentary pang at the thought that some unhappy little girl had lost her doll in the river—probably even got it as a Christmas gift and it was lost already, tsk, tsk—and walked on by. But something—an intuition, a sense that something just was not right—make him stop and walk back to take another look at that pretty, blue-eyed doll.

It was not a doll. It was Jean Peterson. Horrified, he immediately called the police. Chief of Police Edward Otterpohl positively identified her. They laid timbers on the ice to prevent it

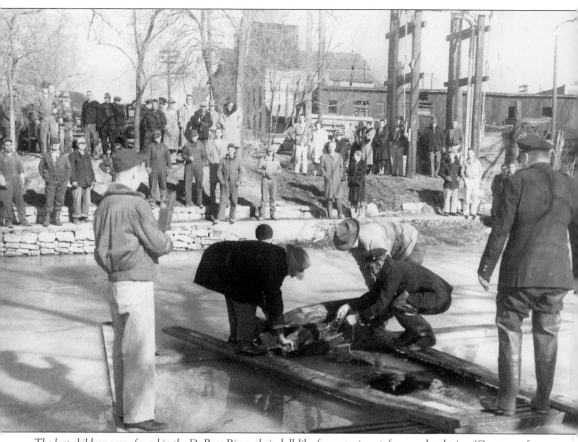

The lost children were found in the DuPage River, their doll-like faces staring up from under the ice. (Courtesy of the Naperville Sun and Fox Valley Publications.)

Today a charmingly nostalgic covered bridge spans the DuPage River. (Author's collection.)

Was it coincidence that it was built directly over the exact spot that the lost children were found? (Author's collection.)

from breaking as they chipped Jean's body from the frozen river. A crowd gathered along the river, and volunteers began searching for Eddie. It was not long before a farmer, Reuben Weber, saw Eddie's dead face staring up at him from under the frozen surface, just 56 feet away from his best friend in all the world. The bodies were remarkably well preserved—Jean was still wearing her bright red parka-type coat, and Eddie was in the blue snowsuit. The toy gun was still in its holster around his waist.

The lost children of Naperville were found at last. The official police analysis was that the children had been walking on the ice on the river when the ice broke and they fell in. The swift river current swept them underneath the ice, but amid the rushing water and slippery stones they could not get to their feet and break the ice above them—and so they drowned.

But their reappearance only raised more puzzling questions. How did they get into the river? They found no evidence of a break or hole in the river ice back when the children first vanished. However, on the day they were found, a quick search upstream revealed a hole in the ice directly in the middle of the river, large enough to fit two children. But it turned out the hole had been made by a young man who had tried to cross the river that morning but got a dunking when the ice broke out from under him. The police grilled him but determined he had no connection to the deaths.

The question of how was overshadowed by an even more baffling mystery. Despite the hundreds of times that search parties systematically combed every inch of the river, broke up the ice to wade hip deep in the freezing cold water, and meticulously searched every stone, root, and log for five miles in each direction—despite all that enormous human effort, the children were found in shallow, lightly flowing water less than half a block away from the Rosenstiels' backyard. General opinion held that there was no possible way the search parties could have overlooked them back in December. The search was too complete, too thorough. So where had the children's bodies been this whole time?

The authorities theorized that both bodies had been snagged by tree roots and held deep under the water, making them very hard to see. Oddly enough, this was exactly what both the fortuneteller from South Bend, Indiana, and the talking psychic horse had said back in December. They both "saw" that the children were dead and still in the river, caught under a large, old tree stump.

But others wondered, "Was the river all that deep that no one could catch a glimpse of a bright red jacket or blue snowsuit? And how likely is it that both children happened to have been caught by the same tree and slipped free at the same time two months later?" Such hushed-voiced questions remained unanswered, and for the lack of any other evidence, the case was closed.

It is simple human nature: life goes on. The deep scars in Naperville's psyche were quietly covered over. Now that the quarry had been drained and cleaned out, grand plans were made to transform the idyllic scene into a picnic spot with a footbridge leading to Centennial Beach. But the plan faltered to a halt shortly after a high chain-link cyclone fence was installed around the quarry, with keep out signs posted along it every few yards. Brush and trees grew thickly around the quarry until it was completely hidden from view. Soon newcomers to Naperville had no idea that a deep, beautiful lake sparkled just behind the trees and forbidding chain-link fence along Eagle Street and Aurora Avenue.

Where once the lost children had been the talk of the town—even the nation—now they were spoken of only in sorrowful whispers and choked-up throats before abruptly changing the conversation to a less painful topic. Where once town leaders had vowed that the names of Jean Peterson and Eddie Rosenstiel would never be forgotten, no memorial was ever raised to remember their tragic story, no bronze statue to commemorate the extraordinary chronicle of one of the largest, most heroic manhunts in our history. In less than a decade, more Naperville residents than not were completely unaware of the heartrending events of the winter of 1952

Since its construction in 1981, some people say they have seen two ghostly children on this covered bridge. (Author's collection.)

and 1953. Most books on Naperville's history make absolutely no mention of the incident. As time passed, the lost children became lost a second time, buried and forgotten in the silence of polite society.

All that remained was the ghost story.

I first heard the spooky tale at a girls' slumber party in the early 1970s, though I cannot recall which of my friends was the storyteller. I still remember the goose bumps rushing over my skin as I listened intently to the ghost stories whispered in the dark living room shrouded in sleeping bags. The flashlight was passed to each girl in turn to relate another bloodcurdling tale, each storyteller tucking the flashlight under her chin to cast her face in eerie, elongated shadow and each beginning their story by swearing that the following events were absolutely true.

> Two kids once drowned in the DuPage River. And they say that even now, if you dare go to the river in the dead of winter and look down at your reflection in the water at the stroke of midnight you just might see two ghostly little doll-like faces staring back at you from under the ice.

I have never forgotten that creepy story or how the storyteller got irked at me for pestering her with questions about it. "Who were they? How did they drown? When did this happen? Is it really true?" When she could not answer any of my questions, I assumed she had made the story up—until one afternoon 35 years later.

I was at the downtown Nichols Library idly browsing through microfilm tapes of archived editions of the *Naperville Clarion* newspaper while researching this book. I came across a headline for Thursday, February 5, 1953: "Search Ends For Two Children—Found In River; Indications Point Toward Accidental Drowning."

Suddenly I remembered that long-ago slumber party and the hair-raising story told that night: "You just might see two ghostly little doll-like faces staring back up at you."

If there is any silver lining to be found in this terrible tragedy, it was that it planted the seeds of what later became the Naperville Riverwalk. Where Marshall Erb's massive bulldozers had once carved a path on the strip of land off Eagle Street between the quarry and the river to make way for dozens of pumps, now the handsome, brick-paved Riverwalk winds its way past a tranquil, postcard-perfect scene. The whimsically unique Dandelion Fountain sprays refreshing mist and rainbows at the head of a quaint covered footbridge—which, coincidentally, spans right over the place in the river that the lost children were found. If you stand on the northwest side of that covered bridge in winter and look straight down, perhaps you will see the faces of Naperville's lost children. Still others say they have seen the small, shadowy figures of two young children standing on that bridge, holding each other's mittened hands and staring solemnly at you, before vanishing in the night.

To this day, the tragedy of Naperville's lost children remains an unsolved mystery.

LIONS AND TIGERS AND CHUPACABRAS, OH MY!

Everyone knows there are no such things as monsters, right? Surely, in these modern times, science has neatly categorized all the creatures on the planet. And in the well-populated suburban streets of a town like Naperville, no unusual creature could possibly stay undetected for long, right?

Anyone who ever sat in a doctor's office and heard the phrase "We really don't know what's wrong with you," has received an unwelcome jolt of appreciation for the vast immensity for all that science does not yet understand. Despite our arrogance in believing we know all the species on the earth, the truth is that hundreds of new species are being discovered every year. And established science can be dead wrong. Anthropologists sneered at the sightings and legends of a hairy man-type beast in the mountains of Rwanda and the Congo, until explorer Robert

von Beringe dropped the carcass of a mountain gorilla on a dissecting table in 1907—just over 100 years ago—to the utter astonishment of the scientific community.

There are still many places in the continental United States—including areas within busy Naperville—that are virtually untouched by human influence. Places of dark, old forest, tangled marsh, and lonely rural fields where you can easily envision some nightmarish creature watching you with glowing eyes from the thick underbrush some moonless night. But monsters in *Naperville?*

Before you dismiss it out of hand, consider the strange experience of Tim B., who was walking home late one night in 1988 or 1989 from a friend's house. He was 14 or 15 years old at the time and admitted that he had been drinking beer illegally. But the unearthly creature that he encountered on his way home sobered him up fast.

Tim's route took him across a large meadow, over a hill, and across some railroad tracks—a dark, isolated journey for a tipsy teenager so late on a moonless night. Home was in sight, up another hill on the far side of the tracks. Tim was crossing the railroad tracks when he stopped dead, stricken with a paralyzing fright. About a quarter of the way up the hill, crouching in some brush, was a terrifying creature no more than 20 feet away.

It stood only three to four feet tall. Its paws—hands?—were tipped in long, razor-sharp claws, and its head was totally bald. But the most extraordinary feature that held Tim's attention was its horrible eyes—enormous, burning eyes that made it hard to make out any other features on its face. It was completely unlike any other creature he had ever seen in his life. "A demon," Tim later called it.

He described what happened next: "I was so scared it took everything I had to just run. I have never run as fast in my life. I ran by him up the hill, never once looking back."

Tim never saw the creature again, although he could not forget his terrifying encounter. Over a decade later, he was recalling his experience to his sister-in-law, and she grew excited at his description. It sounded as if Tim had had an honest-to-God run-in with *el chupacabra*, the blood-sucking monster of myth and legend!

Although at first he might have scoffed at the notion of such a monster in Naperville, Tim stopped laughing when she told him the legend. Since the 1950s, thousands of sightings have been reported of a bizarre beast that drains the blood of goats, chickens, and other livestock but leaves the rest of the body intact. There are many theories as to the origins of the chupacabra monster, including left-behind "pets" of space aliens, unsuccessful NASA alien/animal crossbreeds that escaped their laboratories, genetically altered vampire bats, or simply wild dogs. Reported descriptions vary somewhat, but there are several unique characteristics that pop up again and again. Eyewitnesses usually describe a monster that stands between three to five feet tall, with an oval-shaped head, frog- or lizard-like skin, and huge, alien eyes that glow either red or yellow.

A rash of reported attacks came from Puerto Rico in 1995 where hundreds of mysterious livestock exsanguinations were attributed to the bloodthirsty chupacabra, whose name literally translates to "goat-sucker." The first recorded instance of a chupacabra sighting in North America was in Arizona in 1956. Since then, remarkably identical sightings and attacks have been reported from Chile, Brazil, and Mexico, all the way up to Oregon, Michigan, New Jersey, and, yes, Illinois.

As reported by Troy Taylor in *Weird Illinois*, Illinois holds a special place in the hearts of monster hunters, storytellers, and cryptozoologists (scientists who study animals that may or may not be myths). There are more Bigfoot sightings in Illinois than in any other state east of the Mississippi. And let us not forget Illinois's own massive, thick-furred Cohomo beast, the Murphysboro Mud Monster, the man-eating Piasa bird, the Stump Pond Monster, and the prehistoric winged Thunderbirds of Native American legend and of modern-day eyewitness accounts. But the two officially recorded Illinois monster sightings that are uncannily similar to Tim's Naperville experience are the Farmer City Monster and the Enfield Horror.

The Farmer City Monster

In July 1970, dozens of residents of rural downstate Farmer City reported seeing a crouching black shape, about the size of a dog but moving rapidly on two legs like a human or ape. But there was one detail that everyone commented on time and time again: its huge, gleaming, yellow eyes. The police, who had originally been skeptical of the sightings, began to take it more seriously when officer Robert Hayslip, charged with investigating the reports, had his own hair-raising encounter in the early morning of July 15. He spotted the beast moving among the trees, and as it turned in his direction, he clearly saw its enormous, glowing yellow eyes. The police closed off the area, but by then it appeared to have moved on farther west, since the next reported incident was south of Bloomington. Sightings continued farther south throughout August, near Heyworth and then Waynesville, where construction workers saw it run across a highway in front of their truck before vanishing in the woods.

The Enfield Horror

The creepy little critter known as the Enfield Horror terrified the tiny southeastern Illinois community of Enfield in April 1973. It started on the evening of April 25, when local resident Henry McDaniel heard someone pounding on his door. He opened it to see a creature right out of a Halloween trick-or-treat costume store. "It had three legs on it," McDaniel described, "a short body, two little short arms coming out of its breast area, and two pink eyes as big as flashlights. It stood four and a half to five feet tall and was grayish colored. It was trying to get into the house."

McDaniel ran to get his gun, kicked open the screen door, and started shooting. The monster made a strange, hissing cry and bounded off with amazing agility, covering 75 feet in three enormous leaps before disappearing into the heavy brush along the railroad tracks. McDaniel called the police, and the state troopers found tracks like they had never seen before on any animal—doglike footprints of a three-legged creature, with two of the prints four inches across and the third slightly smaller. Stranger still, each of the "paws" had six toes.

As the state troopers interviewed the neighbors during their investigation, they learned that the deformed beast had attacked a young boy, Greg Garrett, who lived right behind McDaniel's house, just a half hour before McDaniel got an unexpected visitor at his door. Greg reported that he had been playing in his backyard when suddenly a horribly malformed creature leapt out and slashed at the boy's feet with razor-sharp claws, shredding his tennis shoes to bits. Greg escaped and ran into the house screaming and crying in hysterical terror.

Two weeks later, McDaniel saw the beast again. Awakened late at night by barking neighborhood dogs, he looked out his door to see the unmistakable misshapen figure shambling along the railroad tracks. This time McDaniel did not try to shoot it—just watched warily as the creature moved away down the tracks and vanished into the dark night.

Other sightings of the Enfield Horror included five hunters who opened fire on a gray thing they spotted in the underbrush on May 8. It sped off, hissing, but not before two of the men thought they had hit it. Rick Rainbow, news director for radio station WWKI in Kokomo, Indiana, and three other people also saw the Enfield Horror by an abandoned house near McDaniel's place. They were able to record the weird hissing cry that many others had heard near the railroad tracks.

Nothing more has ever been seen or heard of the Enfield Horror since that time. Did its frightening visit have something to do with the frequent reports of UFO activity in the area at that same time? Some people believe that chupacabra are alien pets—could the Enfield Horror have been some extraterrestrial's missing pet? One can only hope that they were happily reunited and made their way quickly home to another galaxy far, far away.

The Farmer City Monster, the Enfield Horror, and Tim's chupacabra encounter in Naperville all have striking similarities. Their short, crouching, deformed stature, the unusually large

glowing eyes, and the gray skin, all are roughly alike in each of the cases. And is there a reason why both the Enfield Horror and the Naperville chupacabra preferred to lurk close to railroad tracks in the dark of night? It is a mystery that both terrifies and intrigues the imagination. As Tim put it, "Facing that thing almost drove me crazy with fear. [But] I even kicked around the idea of going looking for the creature."

Perhaps you are still thinking, "Monsters in Naperville? Why, that's as likely as a UFO flying down Naper Boulevard!" Well, I hate to break it to you, but—read on.

WE ARE NOT ALONE: NAPERVILLE UFOS

A journey through Naperville's paranormal history would not be complete without turning our gaze to the night sky. Though appearing dim through the bright city lights of Naperville and Chicago, we can yet see stars shining remotely against the dark velvet background of the universe—and we wonder if the human race is alone in that unimaginably vast expanse.

As ephemeral and mysterious as ghosts, the stories of UFOs—unidentified flying objects—have stubbornly persisted despite all attempts by skeptics and governments alike to disprove the countless thousands of eyewitness testimonies. Strangely shaped lights in the skies moving like no other known object, eerily geometric patterns carved into farmers' fields, and the numerous terrifying accounts of alien encounters—such uncannily similar events and sightings have been reported for centuries, even in ancient cave paintings and in Egyptian pyramid art.

While Roswell, New Mexico, and Area 51 are practically synonymous with alien encounters, other locations around the world have become household names among ufologists: Rendlesham Forest, England; the plains of San Augustin, New Mexico; Tinley Park, Illinois; Tunguska, Siberia; Carteret, New Jersey; Phoenix, Arizona; Portage County, Ohio; New Berlin, Wisconsin; and Naperville, Illinois.

Yes, Naperville. Although certainly not ranking among the most famous UFO cases, Naperville proudly holds a rare and enviable distinction in the scientific annals of ufology. But first, a little background is necessary.

From late 1947 until 1969, the United States Air Force, working with the CIA, established a series of programs—Project Sign in 1947, Project Grudge in 1948, and Project Blue Book in 1952—in response to an explosion of "alien saucer" sightings in the United States that were threatening to turn into a national hysteria. The public purpose of these programs was twofold: to scientifically analyze UFO-related data and to determine if UFOs were a threat to national security.

The most famous of these programs was Project Blue Book. Originally headed by Capt. Edward J. Ruppelt and headquartered at Wright-Patterson Air Force Base in Ohio, the program was launched with the utmost scholarly intent and an unwavering dedication to pure scientific focus. The board of directors included an impressive roster of highly influential U.S. Air Force generals and the most preeminent scientific minds of the time, including noted astronomer Dr. J. Allen Hynek. That they were given unprecedented authority to interview any and all military personnel without following the chain of command is evidence that the Blue Book's investigation was taken very seriously.

While in operation, Project Blue Book investigated a total of 12,618 reports of UFOs from all across the nation. The investigative analysts were able to solve a majority of the cases by cataloging them as "misidentifications of natural phenomena." Surprisingly, only less than 10 percent of all the cases were declared solved under the catalog of "psychological factors"—in other words, less than 10 percent of these UFO sightings could be explained by mass hysteria, hoaxes, publicity seekers, and simple crackpots.

For a reported UFO case to be cataloged as being a genuine "Unknown unidentified flying object," it had to meet three stringent criteria: First, the report must come from staunchly

reliable, highly reputable sources, preferably from multiple sources and/or backed up by photographs, radar data, and other verifiable hard evidence. Second, the object must not bear any resemblance to airplanes, rockets, satellites, birds, clouds, stars, planets, balloons, helicopters, electrical phenomena, or anything else known to be in the sky or space. Third, all four of the investigative analysts on the case must independently and unanimously agree on the judgment of "unknown."

Sadly, the solemn scientific resolve and credibility of Project Blue Book eroded through the years due to slashed funding, incompetent predecessors, and subversive U.S. Air Force policy that focused on debunking, de-emphasizing, and openly ridiculing any findings. Science turned to cold war suspicion when the CIA recommended that public opinion on UFOs must be controlled through official propaganda; and that civilian UFO groups such as NICAP (National Investigations Committee on Aerial Phenomena) should be on the CIA's watch list because its "potentially great influence on mass thinking" and "apparent irresponsibility" might be used for subversive purposes. (No doubt they were thinking of the mass panic caused by the infamous *War of the Worlds* radio broadcast of October 31, 1938, in which millions of listeners believed martians had invaded Earth). Harsh new regulations were passed, including one that classified all unsolved UFO incidents as top secret so the public could not get the reports under the Freedom of Information Act. Another regulation made it a crime for any military personnel to give eyewitness accounts of UFOs to unauthorized persons, punishable with up to two years in prison and/or fines of up to $10,000. Stripped of all but the most trivial of investigative authority, and its credibility ruined beyond repair with accusations of unscrupulous research practices and governmental cover-ups, the Project Blue Book program was eventually terminated in December 1969.

In exploring our Naperville UFO case history, it is important to emphasize the questionable research practices that later Project Blue Book members were accused of perpetrating. This includes using grossly unscientific research and statistical methodologies, and stretching the definitions of "identified" flying objects far beyond the bounds of logic, evidence, or common sense. For example, Blue Book investigators would identify a wildly maneuvering disc clocked at Mach 3 speeds (a rate three times the speed of sound) as a simple aircraft; or explain away a bizarre formation of brightly lit red, green, or blue metallic discs as a flock of birds or oddly colored meteors. If a witness reported an unusual balloonlike object, it was documented as a balloon, period. These lame Blue Book investigative attempts at debunking devolved into total absurdity throughout the 1960s. In 1965, residents in Oklahoma, Texas, and Kansas reported a rash of UFO sightings, many of which were tracked by radar at both the National Weather Bureau and Tinker Air Force Base. Project Blue Book officially explained these incidents to be nothing more than sightings of Jupiter. It did not matter one bit to them when critics pointed out that planets are not picked up on radar, and Jupiter was on the opposite side of Earth from the midwestern United States at that time of year. In a blatant display of ignoring the obvious, Project Blue Book stamped each of these cases "solved," cataloged as misidentifications of natural phenomena.

Recently unclassified (though still heavily redacted) CIA documents admit that the later function of Project Blue Book was to downplay UFO phenomena for the public good—to make Americans feel that their skies were safe and secure from aliens as well as the Soviets during the cold war years. Is it any wonder that even today there is a heightened suspicion that the government does not want us to know the truth about UFOs?

One out of 701 "Unknowns"

Despite all the elaborate and even farcical debunking efforts done by Project Blue Book members on many of these cases, there are exactly 701 cases that withstood every attempt to

apply any explanation, no matter how far-fetched or ridiculous. In this handful of unique cases, the investigators openly admitted to having done their utmost to debunk and rationalize the phenomena—but failed.

Of these unfathomable 701 cases of UFOs still unsolved by Project Blue Book, investigation case No. 7841 took place in Naperville.

The official Blue Book report is tantalizingly succinct. On March 26, 1962, at 11:40 p.m., two Naperville women, Mrs. D. Wheeler and Claudine Milligan, witnessed a startling display in the night sky. Six or eight flying red balls of light, precisely arranged in a rectangular formation, suddenly melded together into two, brightly lit objects. The entire sighting lasted a full 15 minutes.

According to the investigators on Project Blue Book, the U.S. Air Force, and the CIA, there is no logical explanation for what Mrs. D. Wheeler and Claudine Milligan saw in the Naperville skies on that night. It is officially listed as "unknown."

The mystery gets even stranger. On exactly the same date and time as the Naperville sighting (taking into account the time change), two witnesses reported watching another flying red ball of light falling down then rising back up again for 10 minutes—in Westfield, Massachusetts! This went into the Project Blue Book records as case No. 7930 and is also marked "unknown."

To this day, the Project Blue Book Naperville UFO incident remains a mystery and a fascinating, puzzling piece of official UFO lore.

Crop Circle Found in Naperville Field

A startling discovery in a soybean field off Diehl Road in Naperville on July 2002 became an international news item by the next day. The first thing that Ed Corrigan noticed when he stepped out of his truck on that Saturday morning was the smell of freshly mown vegetation. A crop consultant, he had come to inspect the soybean field off Diehl Road in north Naperville for bugs and weeds—only to discover a mystery that caused the hair to rise on the back of his neck. Sweeping through the soybean field were wide paths of broken, concentric rings rippling out across the field in a precise geometric pattern.

Corrigan immediately called farmer Steve Berning, who raced out to the field to survey the strange scene. Bewildered and dismayed, they searched every inch of the damaged field but found no footprints, tracks, or any other clues that might lead them to find out who created these curious circles in Berning's soybean crop—or how they did it.

They contacted Bill Leone, the DuPage area investigator with the Illinois Mutual UFO Network (MUFON). He conducted a soil and plant analysis to determine whether aliens or humans carved these circles and destroyed about 10 percent of Berning's crop. After finding red and yellow flags stuck inside the borders of the design to mark the corners, and the analysis coming back completely normal, Leone declared the incident a hoax. There was no doubt the perpetrator was of this planet, especially considering that the incident took place only two weeks before the release of M. Night Shyamalan's hit movie *Signs*, starring Mel Gibson as a farmer who discovers alien crop circles cut into his cornfields.

Berning, a stoic midwestern American farmer to the core, bore the damage to his crops and to his pocketbook with fatalistic resignation, stating to a *Naperville Sun* reporter, "There's some damage, which upsets me. But I'm more curious than anything."

In an interesting side note, in 1994 Bill Leone had also investigated the mysterious circles cut into a field of cattails at Argonne National Laboratory in Lemont. For some reason that defies all explanation, the soil analysis detected unusually distinct genetic differences between the plants inside and outside the 84-foot-diameter circles.

Recent Naperville UFO Sightings

As one of the largest cities in the state of Illinois with over 140,000 residents, Naperville does not seem the kind of destination that would rank high on alien tourist itineraries. But the UFO sightings in the Naperville skies persist.

CASE 1

Several years ago, "John," a Naperville teen living in the Wood of Hobson Green subdivision, told me this true UFO sighting he had in the summer of 1996 or 1997. He was hanging out with three friends on Seventy-ninth Street in the Green Valley Forest Preserve. It was 1:00 or 2:00 a.m. on a hot, still summer night, and the teens were sitting on the front fender of their car, chatting and smoking. They were facing west, when suddenly all four of them saw large, pulsating flashes of brilliant red and green lights high in the night sky to the southwest, like nothing they had ever seen before. They listened for the boom of an explosion, but the night was perfectly still and quiet—the strange flashing lights were absolutely silent. The lights continued for at least 10 seconds, when suddenly all the lights in the entire subdivision went out. The teens hopped in their car and drove west on Seventy-fifth Street, hoping to find the source of these mysterious flashing lights in the sky. As they approached Wehrli Road, a deer suddenly darted out in front of them, running full out from the direction of the now-vanished lights, its eyes wide in obvious terror. They had to slam on the brakes to avoid hitting it. They got to Wehrli Road only to find the north side completely blocked off by police barriers. The police said a transformer had blown and the electric company was on its way—but why was there no explosion? What were those strange red and green lights high up in the sky over Wehrli Road, an area that was mostly undeveloped, isolated prairie at that time? And how had the police arrived so fast? The police refused to answer and told them to move along. All four teens agreed that what they saw was no blown transformer—so did John's brother, who witnessed the same mysterious flashes of red and green light from three miles away!

CASE 2

Reported: National UFO Reporting Center
Occurred: Approximately December 15, 1997, 3:30 a.m.
Location: Naperville, off Ogden Avenue
Shape of UFO: Disk
Duration: 5–10 minutes
Witness: Name withheld
Witness Report: "I was retiring for the night and got into bed. The room was dark and the window was slightly open. As I turned my head to the left as I was preparing to lay down, I saw a red circle . . . pulsating, about the shape of a dime, located right above the edge of the woodwork on the window on the right. I just stared and watched it pulsate. And then the red circle disappeared and reappeared on the opposite side, on the bottom of the window itself, and I thought to myself, 'Something is moving from right to left and is probing this room from the outside.' I heard nothing from the open window, and then realized I had to look behind the window shade to see what/if something was out there. I looked behind the window shade to the right and saw nothing. The sky was hazy and had thin, long, whitish clouds, like the kind you see in the winter, and the area was partially lit by streetlights. I then looked to the left behind the window shade and saw a saucer-shaped UFO moving up very slowly in a circular, loopy motion, at a 90-degree angle to the left. I saw only the bottom of the saucer because the top was behind the thin, white cloud. The entire bottom of the ship was pulsating a white light, dim and then bright, dim and bright. It kept moving in a circular, very slow, loopy motion and then it cleared the cloud and I saw the whole ship. It was a silvery color and saucer-shaped and continuing to ascend in a circular, loopy manner,

at an extreme left angle. I got scared and couldn't look at it any longer. I ran downstairs to tell my husband, who had headphones on and was reading. By the time I told him, the object could not [be] seen from the first floor or the second floor of our home. I know it was not [an] aircraft from this planet because of the extreme slow, circular, at-an-extreme-angle ascent it made, not to mention the saucer shape and that pulsating light. I cannot explain the two red laser–like lights on my bedroom wall and window shade which did come through the wall and window . . . it was no reflection of any kind! Definitely pulsating in the center. That is my report.

(NUFORC Note: Date is approximate. PD [Peter Davenport]).”

CASE 3
Reported: National UFO Reporting Center
Occurred: April 26, 2000, 9:30 p.m.
Location: Boughton Road east toward Naperville Road
Shape of UFO: Oval
Duration: 5 minutes
Witness: Masters degree–level social worker
Witness Report: “I was entering Boughton Road off of Kings going east toward Naperville Road and saw the UFO in the northeast sky and observed the street lights go out one at a time as I went past them. The UFO had white flashing lights at the base and they seemed to be rotating around the base. As I approached Canyon Drive (one block west of Naperville Road) I saw the UFO bank so that the base was upside down. It picked up speed and disappeared in the northeast sky. I was not afraid of the sighting. That night I dreamed about an implant being put into my right upper arm. In the dream I was not afraid and the humanoid alien who put the implant in was very friendly, and I felt no pain. The object in my arm was verified by three people, one of whom is my massage therapist who has worked with me twice a month for approx. two years.”

CASE 4
Reported: National UFO Reporting Center
Occurred: July 15, 2000, 8:25 p.m.
Location: Naperville, exact location unreported
Shape of UFO: Oval
Duration: 45–60 seconds
Witness: Unnamed, reported to Peter Davenport of National UFO Center
Witness Report: The witness stated, “I initially noticed a momentarily illuminated disk shaped object that was presumably lit up by the sun in western horizon. The disk was at approximately 3,000 to 5,000 feet moving silently in an east-northeast direction. Although the sky was somewhat hazy, [it appeared to be] a circular to oval shape or perhaps trapezoidal shape [with] dark areas on the bottom. When I stepped inside for set of binoculars, upon [my] return I got a passing glimpse of it as it banked south and disappeared. An opaque spotty haze/vapor formed around object as it disappeared.”

CASE 5
Reported: National UFO Reporting Center
Occurred: June 15, 2001, 3:00 p.m.
Location: Naperville, over 911 emergency station
Shape of UFO: Sphere
Duration: 5–8 minutes
Witness: Name withheld
Witness Report: “I'm not too sure of the exact date, but it was in warm weather. I was on break

(9-1-1 dispatcher) and it was quite breezy out, when I looked up between two trees and saw the chrome sphere motionless. It was at approximately a 30 degree angle above, and it seemed to be quite a-ways away from me, until a Cessna 172 series aircraft flew past it on the opposite side of me. So, the object was smaller and closer than what I had first perceived it. I knew it had to be a UFO because it was motionless and the wind was 5-15 mpg, shaking the trees pretty good! We have an airport nearby, so seeing the aircraft was no surprise."

CASE 6
Reported: National UFO Reporting Center
Occurred: September 6, 2001, 9:00 p.m.
Location: Naperville, Naperville Police Station
Shape of UFO: Light
Duration: 30 seconds
Witness: Name deleted
Witness Report: "During a thunderstorm with intense lightning, looking into the southern sky over the Naperville police station, I witnessed a strange object stationary in the dark sky. Very noticeable and very intense, it was a growing pulse of white light, that after about nine seconds shaded to a bright sea green, flaring into a dark blue eerie glow about 20 seconds later. The event ended with a shimmering-type display of dark blue light vanishing without a trace. I at first thought it was a meteor, but this object was not moving, and I have never witnessed a blue-colored meteor. I'd estimate the magnitude of the display of light to be about a 2 or 3, very bright. Unfortunately I failed to have my camera."

CASE 7
Reported: National UFO Reporting Center
Occurred: July 20, 2001, 5:00 p.m.
Location: Naperville, over Edwards Hospital
Shape of UFO: Oval
Duration: 15 minutes
Witness: Three names withheld and one unknown
Witness Report: "We were driving around, two friends and I, when I looked up at the sky and saw a white oval-shaped craft slowly floating above us, I'd say about 20,000 feet, just where the clouds began to get thick. I got the attention of the driver and the passenger to see it, they both confirmed it being there. Meanwhile, at a stop sign [and] still observing, I caught the attention of a motorcyclist to also see the object. We then parked and I just happened to carry my Sony Cybershot S30 camera with. I managed to take pictures of the direction the craft was in, but since the camera had no light filter the pictures are bright [and] the craft was hidden in a cloud over Edwards Hospital. I took as many pictures as I could . . . I even turned on the 'negative' camera effect to try and get the object to stand out in a few pictures."

CASE 8
Reported: www.MysticalUniverse.com
Occurred: November 18, 2002, 7:10 a.m.
Location: Naperville, Will County, Nequa Valley High School
Shape of UFO: Other
Duration: About 5 seconds
Witness: Nicholas M. and one other unidentified person
Witness Report: "It was November of my freshmen year at Nequa Valley High School. It was a Monday, and I was riding the bus to school, thinking about how crappy Mondays are. The road I

was on was about a mile or a mile and a half from the high school, and about a quarter of a mile from the middle school next to it. You could clearly see the school from the road. I was looking out my (bus) window and I noticed a silver, half-oval-shaped object hovering in the air. I looked at if for about five seconds and noticed that my friend was too. Everyone else was either talking or doing homework. It was hovering about 2 miles away and could be seen clearly, it was silver and completely smooth. Our first thought was that it was a blimp, but decided that that couldn't be. After seeing it for about 5 seconds we passed a local Blockbuster. In the second it took us to pass the small store it disappeared. There were no clouds and no tall buildings. It was simply gone. We knew it wasn't a plane because there were no wings and it was too large for the small Cessnas that are frequent in the area, but too low to be a jetliner."

CASE 9
Reported: UFOEvidence.org
Occurred: June 8, 2004, 11:57 p.m.
Location: Naperville, exact location unreported
Shape of UFO: Disc
Duration: Over 15 minutes
Witness: Taylor Heartman, age 32, and eight others
Witness Report: The witness stated he and eight companions saw a single disclike shape hovering high above the ground. It was large—about 50 yards squared—and shone with a blackish green light. Few features could be clearly made out due to the distance from the object. The witness claimed to have watched it for fully 15 minutes. The witness stated, "It was NOT an airplane or any other common day sighting. I know it was a UFO." (Attempts to reach Taylor Heartman or relatives were unsuccessful.)

CASE 10
Reported: National UFO Reporting Center
Occurred: July 13, 2004, 4:16 p.m.
Location: Naperville, exact location unreported
Shape of UFO: Triangle
Duration: Over 15 minutes
Witness: Multiple, names withheld
Witness Report: "It was a dull day, eerily calm with no wind, nor calling from birds. The clouds are what drew our attention outside, which looked like nothing I've ever seen before—bubbles, erupting downward like spheres, followed by uprising lines that resemble a fire shortly after. We did not see this UFO with our eyes because we were focusing on the clouds. I was taking pictures of the clouds, and as I went over them I noticed a strange silhouette of a black triangle, and thought to report it here (i.e. NUFOC website). I know it's not dust or nicks on the lens, for it was extremely humid that day, and as I walked out of the house with my camera, the lens fogged up twice. I therefore cleaned the lens outdoors looking at the clouds, twice."

CASE 11
Reported: National UFO Reporting Center
Occurred: July 22, 2004, 6:30 p.m.
Location: Naperville, exact location withheld
Shape of UFO: Triangle
Duration: 1 minute
Witness: One (name withheld), possibly two pilots
Witness Report: "I was outside on our brick deck, grilling, when I heard a loud rumbling jet

in the sky. Curious, I wandered in the grass to get a look. It was a regular airliner jet, blue in color with silver or gray wings, fairly low in the sky, about 15,000 feet? Flying an east-to-west flight path. Moments later, another passenger jetliner, red with white wings, intersected the path of the first jet but at a lower altitude of 9,000 feet, at a south-to-north path. I was fascinated they did not hit each other; it could be considered a near miss. Suddenly after the two jets safely started making their way from what appeared to be overlapping each other, I saw a glowing white outline of a sharp peaked triangle fly in between these two jetliners with a slightly northwest-to-southeast flight path, going the same speed as the two jets.

The bottom portion of the triangle did not appear to be there, there wasn't an outline like the two sides, which formed directly into the steep nose to the craft as if it did not need wings, and the middle of the triangle appeared to just be plain blue sky. The glow of the outline did not appear to be a form of light; just a hazy opaque white that gave the illusion it was glowing. Kind of what a piece of frosted glass looks like. If I were to estimate, it would be a 30-40 degree angle in the triangle's shape makeup. It was not cloudy in the portion of the sky, directly above my head where all the sightings took place. Although there were high, white puffy storm clouds on the eastern horizon. Not at all distorting any view of the events.

I instinctively ran in the house to grab a camera after an adrenaline rush from fascination, and came out to be disappointed with awe, as I could not find the flying white triangle any more. The two pilots of the jetliners HAD to have seen this craft, visually, AND on radar. So I am counting them as witnesses.

(NUFORC Note: We wonder whether the white, triangular object might have been a delta-winged, turboprop pusher, e.g. a LearStar, or a similar aircraft with swept wings. Just a guess. It is very difficult for an observer on the ground to determine an accurate range to an object of even known size. PD [Peter Davenport])."

CASE 12
Reported: National UFO Reporting Center
Occurred: Approximately November 6, 2006, 4:20 p.m.
Location: Naperville
Shape of UFO: Sphere
Duration: 3 minutes
Witness: Name withheld
Witness Report: "On either Nov. 6th or 7th of 2006 while parked in Naperville, facing east (toward Chicago) I watched a bulbous silver craft that I originally thought was a blimp, move from north to south at a speed that would be unattainable for a blimp. The craft was flying at a very low altitude. I watched it move to the south until it went out of sight. I placed a call to an off-duty policeman that I know, to ask if anyone else saw it or had reported it. I probably was not taken seriously. My father just sent me a copy of the UFO sighting at O'Hare [International Airport] on or around that date as reported in the *Chicago Tribune*. I couldn't believe the coincidence since the craft I watched was moving from the direction of O'Hare [toward] the south, and somewhat matched the description."

CASE 13
Reported: Paranormal News
Occurred: January 27, 2005, 4:15 p.m.
Location: Naperville, exact location unreported
Shape of UFO: U-shaped
Duration: 10 seconds
Witness: Unnamed
Witness Report: "I'm a 22 year old male, active sky watcher, and I was admiring the strange, glittery,

really fine powder snow that was falling at a steady rate on January 27, 2005, at 4:15 PM. Looking up, I saw a UFO literally in the shape of a U that was 90% invisible with a distinct outline of the craft. It had three opaque whitish spots at the rear lights(?). It traveled fairly slow, and it approached the moon. The light of the moon revealed the entire craft. The clouds were a dark purple hue above the craft. It was bigger than the full moon. The glow of the moon amplified the image of the craft, and actually revealed its outline further to about 80% visible. The U-shaped craft's direction was southwest. It was about three inches from the moon, and it took about 10 seconds for it to pass the moon, at which point I could no longer see it."

CASE 14

Reported: UFOEvidence.org
Occurred: August 25, 2006, 8:50 p.m.
Location: Naperville, Route 59. Residential area near grocery stores, gas stations, high schools, etc. In addition, it is not that far from cornfields.
Shape of UFO: Triangular
Duration: 1–2 minutes
Witness: At least six, names withheld. Primary witness background is account executive in the jewelry business. College educated.
Witness Report: "I was driving down Rt. 59 in Naperville when I saw something in the sky off in the distance. I thought at first that perhaps it was a blimp flying overhead in downtown Chicago since there was a Bears game that night. The next thing I know, the 'aircraft' is not that far in front of me, and it looks like what is multiple 'aircrafts' in the sky which had moved quickly and closer. The light turns red and there are multiple cars around me, and the couple in the car next to me honks their horn and ask the other car near us if they are seeing this too. Sure enough, he agrees and suggests that they follow it. Just as they say that, it looks as if the 'aircraft' is going to land over nearby townhomes, and multiple lights are lit underneath it. The lights can only be described as a grouping of maybe 20 bright lightbulbs. I thought perhaps there was a carnival in the nearby grocery story parking lot. Then before you know [it], the aircraft that was on the right hand side of the road is all of a sudden on the left of us and very far away."

Witness views on UFOs, before and after sighting: "I guess before I thought it could be a possibility, but I was skeptical and just thought it was overactive imaginations. After, I'm still a little freaked out and find it interesting that other people have seen things in the past as well, so I am not alone. I didn't know anything about any of this except silly things you see in the movies or occasionally some A&E special. I guess we are not alone after all."

CASE 15

Reported: National UFO Reporting Center
Occurred: May 18, 2007, 9:45 a.m.
Location: Naperville, half mile south of Seventy-fifth Street
Shape of UFO: Egg
Duration: 2 minutes
Witness: Multiple
Witness Report: "The object was an inverted (small end down) egg or teardrop shaped structure. Dark grey, no black, and was clearly reflective (eastern side appeared glossy as a consequence of sun). The color was reminiscent to that of a gun metal grey. Approximate altitude was 2000 ft., and as a guess, 1/2 mile south of 75th Street, and appeared stationary over the course of the observation. Clearly not a balloon. Another vehicle next to me with two men were looking at it as well. The car behind me tooted its horn as a consequence of both my and the other vehicle not moving when the light changed. Upon looking up to the light and in the rear view mirror at the tooting car (approx. 3 sec.)

the object vanished. The vehicle next to me must have noticed its disappearance as well because the driver lifted his hands and shrugged his shoulders."

CASE 16
Reported: National UFO Reporting Center
Occurred: August 9, 2007, 2:00 a.m.
Location: Naperville, exact location withheld
Shape of UFO: Sphere
Duration: Less than 5 seconds
Witness: Name withheld
Witness Report: "The incident occurred at night (around 2:00 AM) under a clear sky. I was walking back from my car toward my girlfriend's house when I happened to look up. As soon as I did, I witnessed a single bright orange ball moving extremely fast from west-to-east in a straight line, and the color did not appear to shift or become dimmer at any point. By the time I came around to the front of the house and tried to get a better look, I could no longer see the orb. The object was certainly not any sort of aircraft I have ever seen. It appeared to be solid, and its height did not appear to fluctuate. In other words, the motion was completely lateral—parallel to the surface of the Earth. There was no tail, so I immediately ruled out the possibility of a meteor or comet, not to mention the fact that the object was certainly not falling. If I were to wager a guess, I would say it was flying at an altitude of 1000-1500 feet. From my view, it was roughly the size of my thumbnail, probably a little larger, which suggests to me that it was naturally a great deal larger. The craft emitted no sound whatsoever, and there were no aircraft in the vicinity."

What Do You Believe?

Do you believe that we are not alone in space? That we receive visitors from other planets, other worlds, many light-years away from Earth? No matter how skeptical we are that aliens exist (and if they did, would they appear in our immaculately kept Naperville neighborhoods?), there continue to be persistent reports from your friends, family, and neighbors that defy rational explanation and our own cherished sense of security within the vast, unknown universe.

If you think you may have seen a UFO, you are far from alone. An estimated 5 to 7 percent of people nationwide in the last five decades have seen a UFO—equivalent to 15 to 20 million Americans. In all that time, only several hundred thousand have even been documented, since only a small percentage of eyewitnesses will ever report the sighting. The total number of UFO sightings worldwide may very well reach into the tens of thousands every year. And if the Project Blue Book percentages hold true, less than 10 percent of all sightings are determined to have "psychological factors" as their cause—in other words, if you think you see a UFO someday, chances are surprisingly good that you are not crazy!

If you would like to report a sighting, here is contact information to a few highly reputable UFO organizations. Oh, and if you are thinking how funny it would be to submit a joke or hoax report, do not bother. These people are astronomers, biotech scientists, geneticists, astrophysicists, biochemists—in other words, serious scholars and researchers with multiple degrees in fields most people cannot even pronounce, so please do not waste their time with hoaxes.

The J. Allen Hynek Center for UFO Studies
2457 West Peterson Street
Chicago, IL 60659
Telephone: 773-271-3611
Web site: www.CUFOS.org (UFO sighting report only available on downloadable form to mail)
Contact: Dr. Mark Rodeghier, scientific director

Illinois Mutual UFO Network (MUFON)
P.O. Box 2105
Orland Park, IL 60462
Telephone: 708-460-7606
E-mail: mufonsam@comcast.net
Web site: www.illinoismufon.com (good online UFO sighting report form, no download or printouts necessary)
Contact: Sam Maranto, state director

National UFO Reporting Center
P.O. Box 700
Davenport, Washington 99122
UFO Report Hotline: 206-722-3000 (use only if the sighting has occurred within the last week)
E-mail: director@ufocenter.com
Web site: www.nuforc.org (excellent online UFO sighting report form, no download or printouts necessary)
Contact: Peter Davenport, director

Diane Ladley, award-winning storyteller, local folklorist, public speaker, writer, and founding owner of Historic Ghost Tours of Naperville, is nationally renowned as "America's Ghost Storyteller" and locally renowned as the "Ghost Lady of Naperville." Her coast-to-coast reputation for masterfully told, spine-tingling tales is hailed by critics, storytellers, and ghost story lovers alike. A professional storyteller and freelance writer since 1992, Ladley has over 35 years of stage and broadcast experience. She was an approved State of Illinois Arts Council ArtsTour Artist for 2001/2003 and 2003/2005. Ladley's original adaptation of a classic folktale, "The Liver," from her CD recording Late Night Fright: Tales of Supernatural Terror and Macabre Mirth, won her a national Storytelling World Award for Best Story of the Year for Adolescents in 2003. She has performed nationwide at such notable venues as the World Horror Convention in 2002 and the National Storytelling Conference in 2004. She earned a bachelor of arts degree in communications at DePauw University in Greencastle. Ladley is the foremost authority on local supernatural lore and was the first to compile these authentic Naperville ghost stories over four decades of dedicated research and personal interviews. (Photograph by Dan Muir, A Shot in the Dark Studios.)

SELECTIVE BIBLIOGRAPHY

Bielski, Ursula. *Chicago Haunts*. Chicago: Lake Claremont Press, 1998.
———. *More Chicago Haunts*. Chicago: Lake Claremont Press, 2000.
Crowe, Richard, with Carol Mercado. *Chicago's Street Guide to the Supernatural*. Oak Park, IL: Carolando Press, 2000.
Fox Valley Publication Editorial Library/*Naperville Sun*.
Higgins, Jo Fredell. *Naperville, Illinois*. Charleston, SC: Arcadia Publishing, 2001.
Mackenbrock, Marcia, and Sharon Weber. *Postmark Naperville*. Naperville, IL: Enthusia Small, 2004.
Matter, Herb. *It's Naperville*. Naperville Sun Publications.
Naper Settlement Archives, www.napersettlement.org.
Naperville Centennial 1831–1931. Naperville Sun Publications, 1975.
Naperville Clarion.
Naperville Homecoming Souvenir. June 1917.
North Central College Archives, http://library.noctrl.edu/archives/index.shtml.
Newslibrary.com, http://nl.newsbank.com.
Penrose, Sandra. *Agatha's Journey: 1828–1998*. Naperville, IL: Custom Sensor Solutions, Inc., 1998.
Schrader, Lester. *Landmarks in Naperville 1831–1981*. Naperville, IL: Sun Printing Corporation, 1976.
Snapshots of Our Past. Naperville Sun Publications. Heritage House Publishing. Marceline, MO.
Taylor, Troy. *Weird Illinois*. New York: Sterling Publishing, 2005.
Towsley, Genevieve. *A View of Historic Naperville from the Sky-Lines*. Naperville, IL: Naperville Sun Publications, 1975.
Graveyards of Illinois, www.graveyards.com.
Positively Naperville, "Naperville Nostalgia." www.positivelynaperville.com/nostalgia.html.
Zymet, Matthew. "Haunted Businesses: Putting Your Ghost to Work." October 30, 2008. http://smallbusiness.aol.com/features/haunted-businesses.

www.arcadiapublishing.com

Discover books about the town where you grew up, the cities where your friends and families live, the town where your parents met, or even that retirement spot you've been dreaming about. Our Web site provides history lovers with exclusive deals, advanced notification about new titles, e-mail alerts of author events, and much more.

Find Your Place in History.